The Essence of Photography

BRUCE BARNBAUM

The Essence of Photography

Seeing and Creativity

rockynook

Bruce Barnbaum, www.barnbaum.com

Publisher: Gerhard Rossbach
Copyeditor: Jocelyn Howell
Layout and Type: Petra Strauch, hello@just-in-print.de
Cover Design: Helmut Kraus, www.exclam.de
Cover Photo: Bruce Barnbaum
Printer: Tara TPS
Printed in Korea

ISBN 978-1-937538-51-4

1st Edition
© 2015 by Bruce Barnbaum
All photography © Bruce Barnbaum (unless otherwise noted)

Rocky Nook Inc.
802 East Cota Street, 3rd Floor
Santa Barbara, CA 93103
www.rockynook.com

Image on page 35 used by permission.
Moonrise, Hernandez, New Mexico, 1941
Photograph by Ansel Adams
Collection Center for Creative Photography, University of Arizona
© 2013 The Ansel Adams Publishing Rights Trust

 Library of Congress Cataloging-in-Publication Data
Barnbaum, Bruce, 1943-
 The essence of photography : seeing and creativity / Bruce Barnbaum. -- 1st edition.
 pages cm
 ISBN 978-1-937538-51-4 (paperback)
1. Photography--Vocational guidance. 2. Photography--Technique. 3. Composition (Photography) I. Title.
 TR154.B37 2014
 770.23--dc23
 2014000426

To you, the reader,
Seeking meaning and creativity.
In hopes that this book
May be of assistance.

Bruce Barnbaum
31417 Mountain Loop Highway
Granite Falls, Washington 98252
USA
Phone or Fax: (360) 691-4105
barnbaum@aol.com
www.barnbaum.com

Table of Contents

Introduction

FOR THE PAST SEVERAL YEARS I have been conducting a workshop titled "The Art of Seeing and Creating Through the Camera." In many ways it's a scary topic because so many people feel that creativity cannot be taught or learned. That may or may not be true—I doubt that it can be proved or disproved—but it is a certainty that creativity can be properly promoted or sadly squelched.

Let's start with a simple example. In elementary school, children draw pictures of their family with crayons. A teacher who is supportive of creativity may look at one of those crayon drawings and ask, "Oh, is that your mom, and your dad, and is that your brother or sister...or is that *you?*" That question can encourage creativity on the part of the child. A teacher who squelches creativity may look at the same crayon drawing and ask, "Is your family really all *green?*"

Now, the child may have chosen a green crayon because he or she liked the color, or it happened to be the first crayon that came out of the box, or perhaps for no reason at all. But the first question encourages the child, while the second one implies that the kid did something wrong, something that needs to be addressed and corrected. The second question squelches creativity; the first helps to promote it.

My intent in my "Seeing and Creating" workshops, and now in this book, is to *promote* good seeing, to *promote* personal intuition, and to *promote* creativity. If it actually *teaches* any of those things, so much the better. I won't make the claim that it does, but I'll cling to the hope that it may. I approach those workshops, as well as this book, as more of a facilitator than an instructor. I have much to learn about creativity, and that's part of the impetus for the workshop and for this book. I'm always looking for ways to expand my own creative abilities.

I offer no formulas for success because none exist. This book is not meant to be followed in a step-by-step manner, as would be the case with a camera manual or instructional book. Instead, my hope is that the ideas discussed within the book may stimulate further thought on your part that can lead to new, creative approaches.

Because I have more than 40 years of experience in photography—doing my own work throughout that entire period, doing commercial work for the first 15 years, and teaching workshops for nearly my entire photographic career—I feel that my experiences and observations could be useful to others.

Some readers may view these experiences as little more than personal anecdotes that have little relevance to anyone but me. If so, ask yourself how you learn? You learn from books and lectures, but much of what you learn comes from personal experiences. Therefore, I feel that important lessons can be learned from those experiences if they are delved into as more than mere anecdotes, but as essential learning experiences, not only for me, but for a far wider audience. I present these experiences throughout the book in hopes that they can be instructive, but with a recognition that they might be viewed as little more than personal anecdotes. I hope the instructional aspects greatly outweigh the anecdotal.

So, here is what I intend for this book to be about, and what I intend for it not to be about:

1. It's about expressing yourself through photography in a way that is meaningful and even lasting.
2. It's about using photography as a visual research laboratory, whether you're using traditional film and a darkroom, digital sensors and computers, a combination of the two, or anything else that can lead to imagery.
3. It's about visual exploration, experimentation, and personal satisfaction.
4. It's about encountering a scene, created or found, and recognizing the potential for personal expression within it.
5. It's about creating photographic imagery that may have the lasting power of an Ansel Adams, an Edward or Brett Weston, a Cornell Capa, an Imogen Cunningham, or a Sabastião Salgado.
6. It's not about technical ideas that you can find in other books.
7. It's not about making images simply because you *can* with the tools or apps at your disposal.
8. Finally, it is a book that will require time, effort, and dedication on your part to put into practice. If you love photography as much as I do, you'll put in the time and effort necessary.

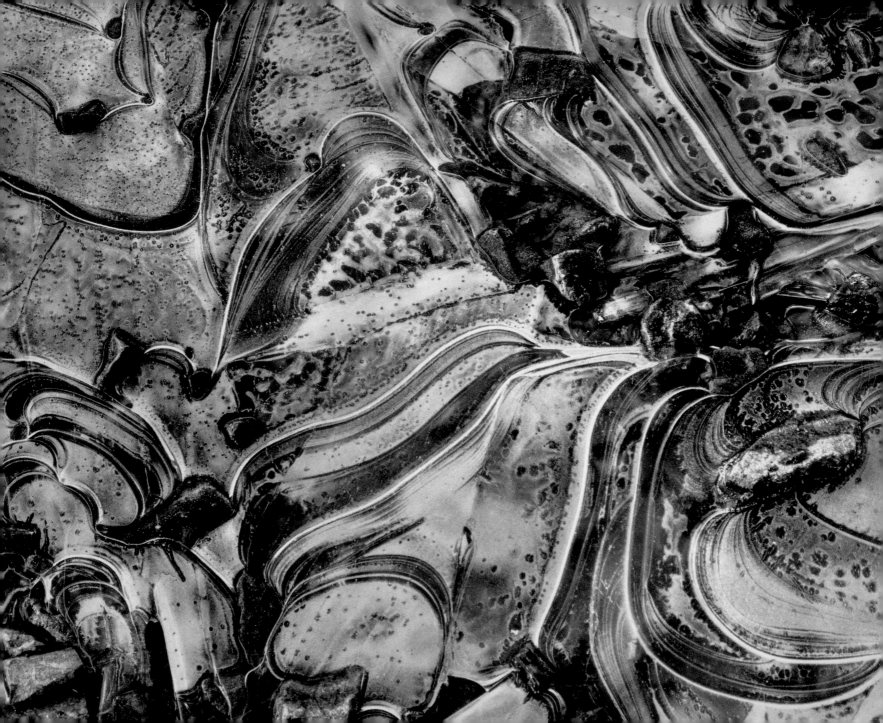

Chapter 1

Finding Your Groove

IT'S EASY TO LOOK AT THINGS. We do it constantly without giving it much thought. It gets us through the day. But how often do you stop to really *see* what you're looking at? By this I mean seeing something in depth, looking at it long enough and intently enough that you not only see that it's there, but you actually study it and learn something about it.

In my book *The Art of Photography,* I discuss the difference between an average person looking at a crime scene and a seasoned detective looking at the same scene. An average person may see a room with some obvious blood stains, but a detective would see a multitude of clues, some of which he would claim to be obvious. The average person would probably miss most of those clues entirely. This illustrates the difference between casual looking-and-seeing and in-depth looking-and-seeing. It also shows that there is a difference between an experienced and an inexperienced viewer. The detective has experience. He wouldn't have spotted all of the obvious clues his first day on the job, but years of experience have sharpened his vision and taught him to look for details that the casual observer—or even the first-year detective—could easily miss.

A photographer cannot be a casual observer. A photographer has to look for the relationships within a scene, whether that scene is a studio setup, a street scene, a landscape, an architectural setting, or any other scene you can conceive of. A photographer has to see the relationships among the numerous objects in the scene in terms of form, line, tone, and color, and he must see those relationships within the three-dimensional vista in front of his eyes. He must recognize how forms, lines, tones, and colors in the foreground work with those in the middle

◀ *Driveway Ice*
A puddle on my driveway, frozen solid during a winter cold snap

distance and in the background. A photographer has to notice that moving six inches to the right may create a better set of form relationships in the three-dimensional field in front of his eyes. A photographer has to see how a portrait subject may stand out against either a black or white background, or if he or she would perhaps look better against a more complex interior, exterior, or landscape background that may say more about the person than a simple, nondescript background.

A photographer has to see how the sunlight streaming through a dense forest could make a complete mess of a scene, negating any feeling of depth by turning everything into a blotchy cacophony of brilliant sunlight and deep shade randomly speckled on the trunks, branches, and foliage. But by simply looking in a different direction, that same light may produce clear separations between, let's say, the backlit trees and the sunlight streaming between them. A photographer has to recognize that every type of light has its merits and its problems. Light that is perfect for one type of scene may be inappropriate for another.

Recognizing the difference between light that enhances a scene and light that detracts from the scene takes experience. Because a camera—whether it's a traditional film camera or a digital camera—records only light, the photographer has to learn to see light, and understand how light brings out or destroys the lines, forms, tonalities, colors, dimensionality, and all other aspects of a scene. Learning to see light requires experience because we're really geared to see objects. That's what we've done since we were born. A baby learns to see mommy, daddy, and other things of importance as he grows, but he tends not to see mommy or anything else as a set of light levels. He doesn't learn to see relationships of lines or forms or shapes—for example, the oval of mommy's face in relationship to the oval of daddy's face—rather he learns to see and distinguish the features of the face itself. So learning to see objects in a given scene as light values and lines, forms, and shapes, and learning to see the relationships among

them, is clearly not a natural act. You really have to learn to see photographically.

This is difficult because our eyes do not see the way a camera sees. As you peruse a scene with your eyes, your irises open a bit to let in more light from the darkest parts of the scene, and close a bit to moderate the intensity from the brightest parts of the scene. So, in essence, you're viewing every scene at multiple apertures. But when you snap the shutter on a camera, the entire scene is recorded at the single aperture you set. Unless you understand the technical aspects of controlling contrast via the process you have chosen (traditional film exposure or digital capture), you may lose a lot of the information that you expect to see in your image.

The technical side of how you can fully record the scene is quite a challenge in itself. This is difficult not only in daylight, when you could be dealing with intensely bright sunlight and deep shadows, but also at night in a typical room in your home that is lit by a single lamp. In the latter situation, the inverse square law of light means that people farther from the lamp are much, much darker than those close by. You may not even notice the difference because your eye adjusts to a remarkable degree as it pans from the person closest to the lamp to the one farthest from it, but the drop in light is dramatic in the recorded image.

Complicating this issue further is the fact that a camera has a single lens, while your eyes see every scene with binocular vision, meaning that your left and right eye combine to recognize depth, which is not possible with a camera. Try looking at a complex scene with one eye closed and you'll see that the scene tends to lose a large degree of depth. If you want to convey a sense of depth in a photograph, you have to learn how the one-eyed camera sees the scene under various types of light, and recognize which type of light helps bring out that depth.

Another tricky factor is that if your goal is to make black-and-white photographs, you have to transform all colors to

their equivalent gray level. While a red cardinal may stand out clearly in color against the deep green foliage of the tree it's sitting in, both the bird and the leaves may be exactly the same shade of gray in black-and-white. You have to learn how to use filters when making the image to separate the two colors if you're using film, or how to separate them in a photo-editing program later if your choice is digital. I mention this because whenever anyone brings up the names of the greatest photographers in photography's nearly 200-year history, this list is still dominated by black-and-white photographers: Ansel Adams, Edward and Brett Weston, Imogen Cunningham, Sabastião Salgado, August Sander, Julia Margaret Cameron, Henri Cartier-Bresson, and so many more. This is not just because photography existed for nearly a century before color film was introduced, but because many more outstanding black-and-white photographs have been produced even after the advent of color film...and of course, well before the introduction of digital processes.

None of this is easy to learn. Amazingly, most folks feel that if you have a camera in hand—whether it's an old fashioned, large-format view camera like one I use or one of the cell phone cameras that virtually everyone in the world has today—you're a photographer. But that's like saying that everyone with a pen in hand is a writer. It's just not so.

Photography can be deceptively difficult. Some people may have innate talent, and it comes more easily to them. We're not all created equal, as much as we like to believe that statement. Some of us are tall, others are not; some of us are brilliant, others are lacking; some of us are athletic, others are not; why, if you look around, you'll notice that some are men and about an equal number are women. Now, I firmly believe that we should all be *treated* equally and *judged* equally, despite the fact that we're really not created equal at all. Bringing this back to photography, some can learn to be outstanding photographers, and some can do it quicker than others, but it takes time to learn. And doing it well requires both learning and practice. So whatever innate talent you bring with you, it's going to take some hard work to achieve your goals.

I have heard time and time again from people inquiring about my workshops, or from first time students, that they "have a good eye." Some people do. Most of the time they really mean that they can identify a beautiful scene. And while I hate to burst their bubble, it turns out that virtually anyone can spot a beautiful scene. Very few people going into Yosemite Valley for the first time fail to notice its beauty. But most people take this to mean that they have a good eye. Not so.

Having a good eye means that you can recognize relationships between forms that almost jump out at you when you look at a scene from one location, but that don't appear to be quite as strong from a slightly different location. Having a good eye means that you can recognize when certain lighting or weather conditions make a scene quite extraordinary, whereas other lighting or weather conditions render it rather ordinary. Having a good eye means you can quickly spot an unusual and particularly interesting scene on a busy street corner in the midst of the typical nondescript hustle and bustle that occurs most of the time. Having a good eye means you can see when a specific type and direction of lighting on a person's face, perhaps coupled with an interesting turn of the head, makes a powerful portrait, rather than the typical portrait we see from most commercial studios, or the portraits of "important people" giving an "important speech" shown on page 6 of your daily newspaper.

To create good photographs, you have to learn to see the light and the relationships within a scene. You have to learn to see with your two eyes the way a camera sees, with a single eye and a single aperture setting. It would be great if the camera could learn to see the way you do, but unfortunately, that's not an option.

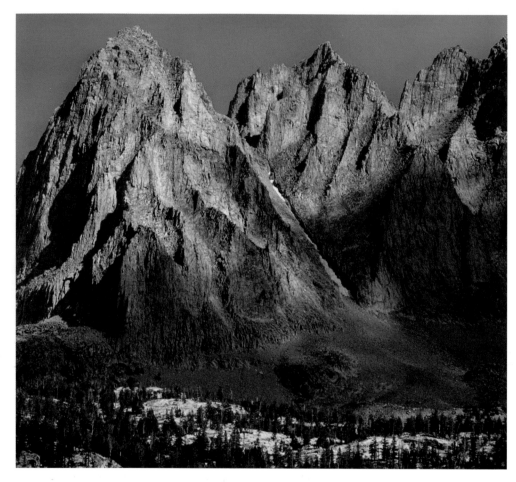

▲ *Figure 1–1: Ericsson Crags, Sierra Nevada*
The awesome granite walls and summits were what drew me to the high mountains for hiking and backpacking. Photography began as a pleasant hobby; nevertheless, it was important and meaningful.

Discovering and Developing Personal Interests

As you learn the ropes of seeing light and seeing relationships, you also have to find both your subject matter and your rhythm. Ansel Adams was drawn to the land, and more specifically to the mountains, and his best photographs are undoubtedly his powerful mountain and landscape images. He may have been a good portrait photographer, but it's unlikely he would have been as good as he was with landscapes, and he probably wouldn't have built the reputation he did. August Sander may have been a good landscape photographer, but it is his portraits of working-class Germans that are astounding, perturbing, penetrating images. These photographers and all of the other great photographers were drawn to specific subject matter that had heightened meaning to them, and they walked away from other subjects. That's why their work is so outstanding.

I started photographing in the early 1960s when I was still a college student. My goal was to show the places where I backpacked in California's Sierra Nevada. I was drawn to the power of the Sierra's huge granite walls topping out at summits above 14,000 feet (figure 1–1), the immense canyons (figure 1–2), the thundering rivers and waterfalls, the serene meadows and lakes (figure 1–3), the giant sequoia and sugar pine forests, and the innumerable little things that you can never expect in advance (figure 1–4). I began recording the scenes on 35mm color slides, and then with larger format cameras.

In the late 1960s, I was working as a computer programmer and a friend who worked down the hall from me asked if I'd like to learn how to shoot and develop black-and-white negatives and prints. My initial reaction was, "Hell, no!" I wanted to be in the luminous mountains, not in a dingy darkroom. Somewhere along the way I changed my mind and asked him to show me what it entailed. I found that it really wasn't ter-

ribly difficult, nor was it horribly dingy. I immediately bought a larger camera, somehow not wanting to shoot the small 35mm-negative size, and began photographing the landscape in black and white.

I was further drawn to landscape images when I looked at photographs by others, especially those of Ansel Adams, whose images seemed to be more powerful, more vivid, and more spectacular than any I had ever seen. His work came closest to depicting the landscape—specifically the mountains—as I saw it on my hikes. So in 1970, I took a two-week workshop that Adams conducted in Yosemite. I knew my interest: mountain landscapes. I felt I could learn to photograph this subject matter best from the person who I thought was doing it best.

Shortly after that workshop, I quit my programming job in the defense industry and went into photography. I had to turn to commercial architectural photography to stay afloat financially, but my personal interest remained with landscapes, which I continued to photograph whenever I could find the time.

Sometime during the mid- to late-1970s my interests began to expand and I started to become interested in more abstract images; not in place of landscapes, but in addition to them (figure 1–5). I immediately ran into a serious roadblock when I was met with a negative response from those who knew my photographic work best, who would look at one of my more abstract pieces and derisively ask, "Is this the same Bruce Barnbaum I *used to know?*" That response was enough to dissuade me from showing the image or even producing more abstract works—it's likely I just lacked the self-confidence to follow my own star—but I kept feeling the tug to do something a little more abstract.

All doubts vanished in August of 1979 when my workshop co-instructors, Ray McSavaney and John Sexton, and I took our workshop students to the home of Brett Weston in Carmel, California. (I started teaching workshops in 1975.) During this

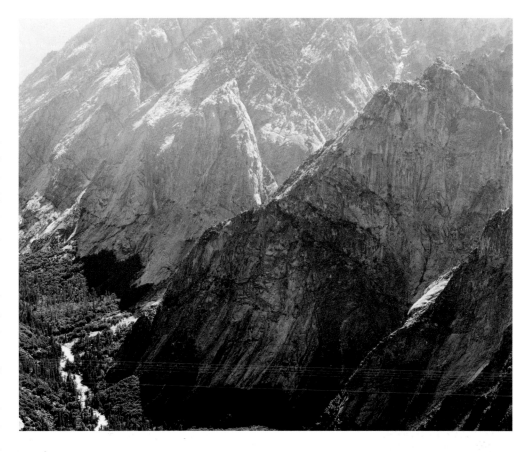

visit, Brett showed us an astonishing array of his images, most of which were abstract. I'll never forget walking out of his home and having one of the students grab me by the shoulder and ask, "What did you think of Brett's work?" I answered, "Nobody in this group got more out of it than I did." I knew then and there that his work had a profound influence on me.

Brett Weston had kicked the door of abstraction open for me. I realized that he had freed me up to do what I really wanted to do. What made that transition possible for me was an instant change in my attitude toward abstraction. Up until that time, the skeptical and negative reactions I had received from friends made me feel that presenting an abstract image was irritating to those who couldn't quickly identify

▲ *Figure 1–2:*
Tehipite Valley, North Fork of the Kings River
Viewed from Crown Valley, the gaping chasm seemed to go down endlessly, with the polished granite walls rising up in a rhythmic series of spikes. It seems to me that anyone seeing a sight like this would be overwhelmed by its magnificence.

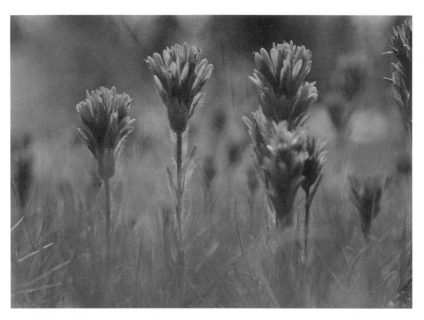

▲ *Figure 1–3: Indian Paintbrush, Evolution Valley*
By placing my 4×5 camera on the ground in the meadow's grass and flowers rather than on a tripod, I was able to create a gauzy, dreamlike feel in this photograph of the delicate Indian Paintbrush that dotted the meadow. It was a revelation that I could use the camera in an unorthodox manner to achieve a feel that I had never quite seen before.

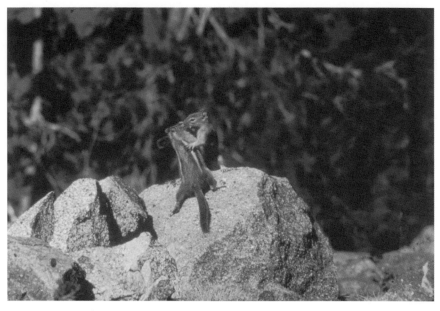

▲ *Figure 1–4: Chipmunk Kiss*
While sitting around the campsite, I would often hold my 35mm camera just in case something interesting happened nearby. In this case, it was amazing. I can't really say what they were doing, but it sure looked like a love affair to me.

the subject matter. But after seeing Brett's work, my attitude changed entirely. I now felt as if I were presenting a puzzle—a challenge, if you will—to the viewer. I would then step back to allow the viewer to solve the puzzle, or not. Instead of answering questions with a photograph, I was asking questions. I had suddenly determined that both were equally valid. If some people were irritated with abstraction, so be it; that was their problem, not mine.

On January 1, 1980, just four and a half months after that extraordinary visit to Brett Weston's home, I walked into Antelope Canyon, a place so abstract that I never could have imagined its existence. Without hesitation I began to photograph within its narrow confines. Just six months after that,

on my way to Norway, where I had been invited to teach a workshop for a hand-picked group of professional photographers, I "discovered" the English cathedrals. Prior to leaving home, I would have said that I had no interest in photographing churches, but these structures were so impressive, so monumental, so overwhelming, and so compelling to me that I felt I had no choice but to photograph them.

Within the short time span of six months, my interests expanded from landscapes alone to abstracts, and then to monumental ancient architecture. Throughout my photographic career I have continued to expand upon existing interests without losing my previous interests. This has worked well for me. Others take a very different approach. Some start

▼ *Figure 1–5: Dune Ridges at Sunrise, Death Valley*
The first abstract photograph I made (in 1976) was greeted with responses that were less than enthusiastic from my photographic friends. I remained hesitant to show it until I saw Brett Weston's photography in 1979. His images were exceedingly abstract, and entirely wonderful. From that viewing onward, I felt freed to show abstract images.

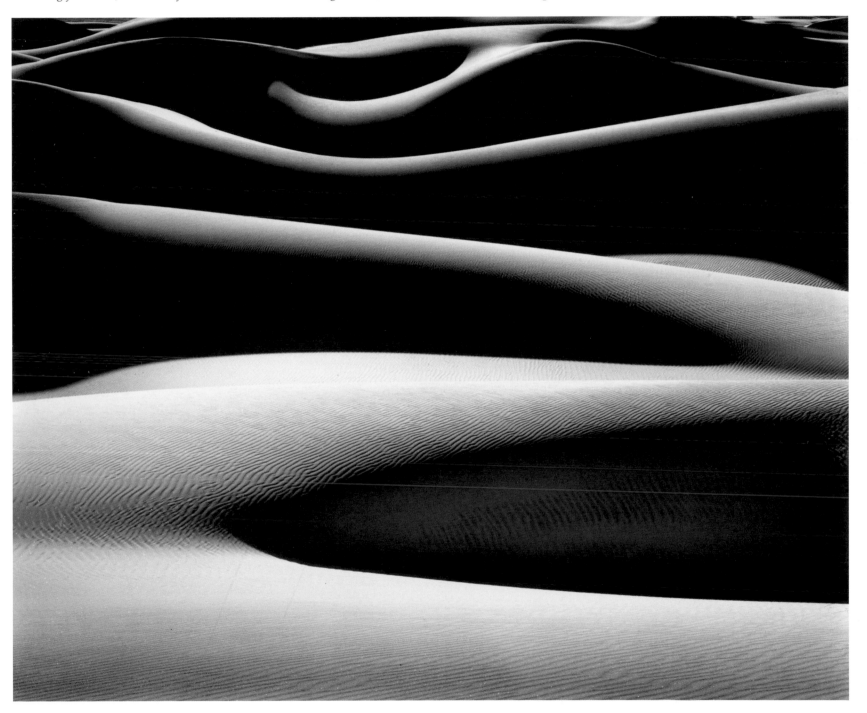

► *Figure 1–6: Circular Chimney, Antelope Canyon*
The first negative I exposed in Antelope Canyon, just five months after seeing
Brett Weston's work. It is entirely abstract, having no sense of scale or direction,
and even the subject matter is unclear without an explanation.

with a single interest and remain focused on it throughout their career. Some skip from interest to interest, dropping the previous one as they latch onto a new one. Some start with a variety of interests, and gradually narrow them down to one or two interests that remain with them for a lifetime.

Which is the correct approach? Which is wrong? It turns out they are all correct. None of them is more correct than another. The approach you use has to work for *your* interests. What has worked well for me may not be good for you, or for another photographer, and vice versa. This is all part of finding your interests and your groove, and it has nothing to do with anyone else's groove. It's recognizing that your interests can change, expand, or become more specific. It's understanding that you are the only one who can determine what you want to do photographically. Only you can determine how you want your photograph to look, what you want to show, what you want to avoid, what you want to emphasize, and what you want to de-emphasize—in other words, what you want your photograph to *say*. It's yours, and you'll find your proper voice and groove in time.

Some photography instructors try to push a student toward a single area of interest. I don't agree with this approach. We're multifaceted people. We have more than one interest in life; why can't we have more than one interest in our photography? As a longtime workshop instructor, I have never tried to push a student into a single area of interest. I may point out the realm in which I feel a student is doing his strongest work, and encourage him to continue to pursue that realm, but I feel that photographers should always look toward other realms as possible wellsprings of inspiration. I see no problem with your pursuit of multiple areas of interest if they turn out to be areas of real passion for you. Why walk away from any of them? Only you can determine your interests, and sometimes one may come as a complete surprise, just as the cathedrals of England did for me. Of course, my discovery of Antelope Canyon and other slit canyons were even more surprising, but

that was simply because I never could have imagined places like those existed.

Photographic Rhythm

This leads to a key point I wish to discuss in this chapter: your rhythm. Some photographers have to go to an area, explore it, get to know it, and learn how to depict it over time before they can produce their best images. It's a process of growing and learning. I've seen several photographers go through this evolution, where their first images were not terribly interesting, even though they were falling all over themselves with enthusiasm for the subject matter. But as time went on, they tuned in and their images became progressively more interesting, more refined, and more insightful. They found their groove, and then they moved through it with immense power, grace, and finesse.

Harrison Branch, the long-time chair of the photography department at Oregon State University, will explore a location that is new to him without any camera in hand. If he finds an area to be of interest, he will go back, again without a camera, to gain deeper insights into the location and its nuances. Finally, after several visits, he'll take his camera with him to photograph the area.

Harrison's approach is very different from mine. In fact, I could not work the way Harrison works. At workshops we've taught together, we have discussed our differences with our students. I generally see things and respond quickly and strongly, or I really don't respond at all. When visiting a new area, I tend to make my most powerful images right from the start (figure 1–6, my first exposure in Antelope Canyon, 1980—utterly abstract and very bold.). As I continue to explore the possibilities within the region, I work my way toward finding more subtle imagery (figure 1–7, my final exposure in Antelope Canyon, 1998). In fact, if I had to study an area at

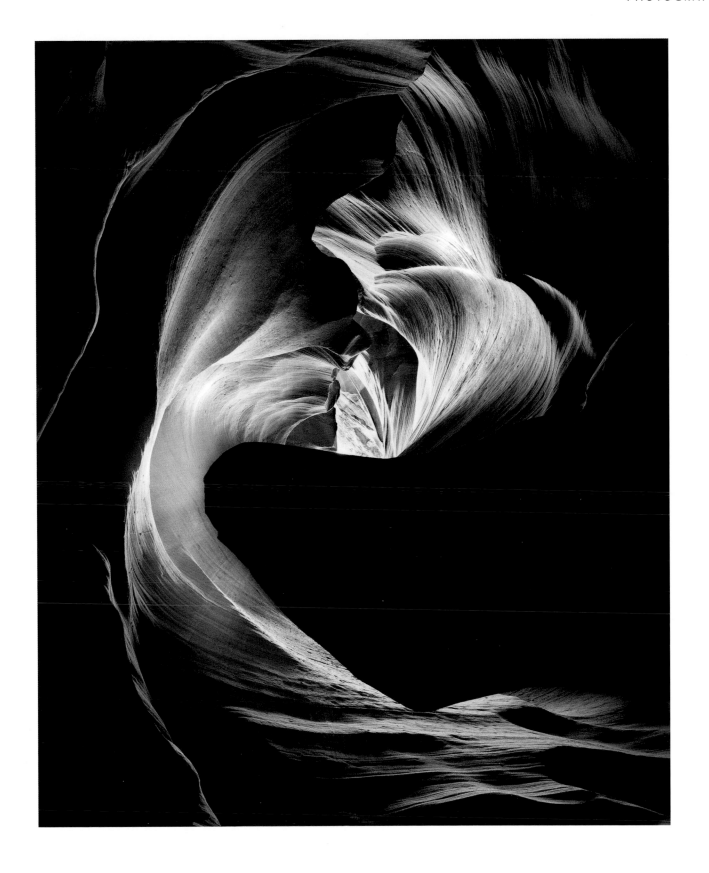

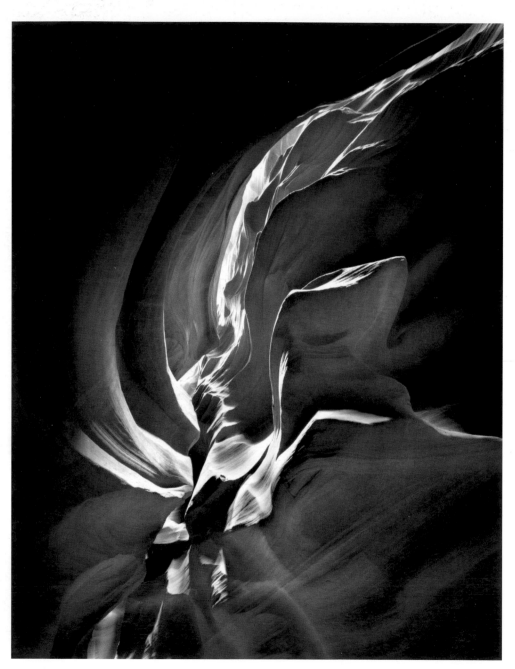

▲ *Figure 1–7: Layers, Antelope Canyon*
The final negative I exposed in Antelope Canyon in 1998. It's still abstract, because the place itself is abstract, but perhaps not as abstract as my initial image. I have not visited Antelope Canyon since then, due to the overcommercialization of it; it is too sacred to me to see it treated as it is today.

length before bringing a camera in for photography, I think I'd lose a great deal of my spontaneity and enthusiasm for the place. I don't think my imagery would be as strong. I have to work quickly, responding to my gut feelings. I can't put them off until some time in the future.

Let me expand on this further. It's a certainty that my lifelong interest and academic background in the forces of nature—from those of the subatomic world to those of the cosmic—informed my instantaneous reaction to Antelope Canyon. I immediately saw its swirling lines of interbedded sandstone as a representation of a force field, similar to the lines of magnetic force created when iron filings are scattered on paper and a magnet is held below the paper. To me, Antelope Canyon wasn't a narrow, eroded sandstone canyon; it was a force field. I didn't have to think about it; it was an immediate reaction to the place I had walked into. I didn't have to go into the canyon several times to fully grasp my reaction to it.

Beyond that, I immediately recognized that the extremely high contrast within the canyon necessitated a completely different technical approach than the one I had employed and taught in my workshops up to that point. Rather than exposing film to the darkest area where I wanted to maintain detail, I exposed for the brightest highlight within the image, which was well over ten zones (stops) brighter than the darkest regions. So, not only was my visceral reaction to Antelope Canyon immediate, but it was accompanied by an entirely new technical approach to deal with the unprecedented lighting situation within the canyon.

I had virtually the same reaction to the cathedrals of England, which I encountered just six months later. It wasn't as instantaneous as my reaction to Antelope Canyon, but I quickly saw the cathedrals as allegories on infinity (my math and science background reared its head again), with column after column, vault after vault, and archway after archway, going on forever (figure 1–8). The lovely small town churches

▲ *Figure 1–8: Retrochoir, Wells Cathedral*
A seemingly infinite number of columns, arches, and vaults created the musical and mathematical settings that, for me, defined the English cathedrals. Unmarred by colorful paintings, the integrity of the structures themselves showed through clearly. I would have never guessed that I could have been attracted to these structures photographically, but they proved too irresistible to me to avoid.

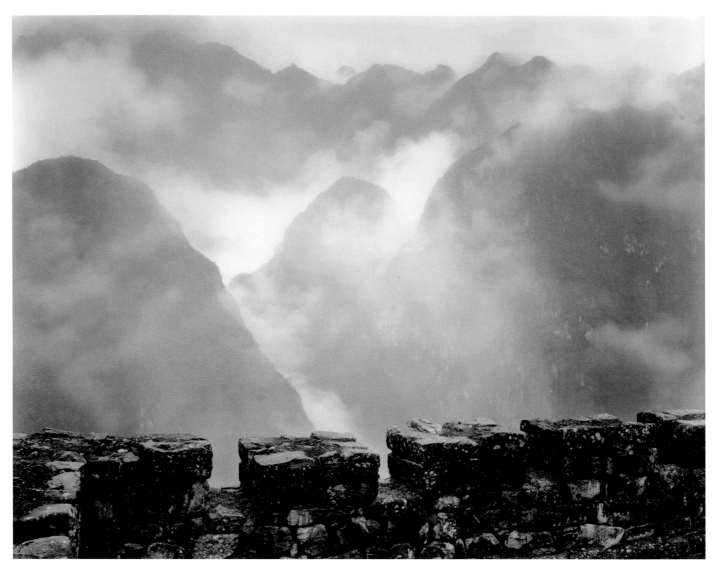

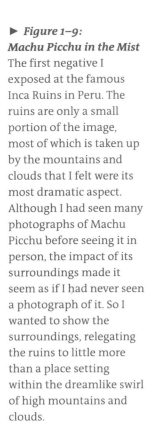

▶ *Figure 1–9:*
Machu Picchu in the Mist
The first negative I exposed at the famous Inca Ruins in Peru. The ruins are only a small portion of the image, most of which is taken up by the mountains and clouds that I felt were its most dramatic aspect. Although I had seen many photographs of Machu Picchu before seeing it in person, the impact of its surroundings made it seem as if I had never seen a photograph of it. So I wanted to show the surroundings, relegating the ruins to little more than a place setting within the dreamlike swirl of high mountains and clouds.

had no such lure for me. I needed the size and complexity of the cathedrals to fully elucidate these concepts.

Throughout my career I have found that my initial reaction to a new area almost invariably yields my strongest images. Others seem to agree, for they generally gravitate to my first exposures. In 2009 I was invited to teach a workshop in Peru, which included field sessions in the Peruvian Andes and at the famed Inca site of Machu Picchu. It was exciting and highly successful, and I was invited back each of the next two years. At the end of the first year, the man who invited me, Adam Weintraub, asked if I would be willing to send him a 16×20-inch mounted print of one of my Peruvian photographs that he could display on a wall in his bed and breakfast in Cuzco,

which is the starting location for most of his workshops in Peru. I sent him about 20 black-and-white jpeg images, all of which I photographed with my 4×5 film camera, but later scanned and saved as digital files. Half of the photographs were Peruvian landscape images and the other half were from Machu Picchu. Adam chose one landscape and one Machu Picchu image, saying he would be equally pleased with either one. Interestingly, the landscape image was my first exposed negative in Peru and the Machu Picchu image was my first exposure at that site (figure 1–9).

I don't know why I tend to see strongly from the very start, but I do. I find this tendency time and time again. Which approach is right; my quick response to an area or Harrison's

deliberate analysis of an area? They're both right. Harrison's is perfect for him. He knows his rhythm and he works best in that manner. I know mine, and I work best within my manner of seeing. You have to find your own. It's quite likely that Harrison's approach and my approach are at the extremes, and others' lie somewhere in between. That's fine. You have to work at your own speed and leisure, and with your own rhythm. Doing anything else throws you off your game. You have to find your comfort zone.

Despite the fact that my initial response tends to be my strongest, that's not always the case. It's not a rule for me, and I'm not bound by it. The perfect counterexample is my ongoing photographic study of the sand dunes in Death Valley (figures 4–1 through 4–3, and 7–10 through 7–12). Amazingly, each time I return I find new and fascinating imagery. As long as I keep finding new and exciting things to photograph there,

the project will continue to grow. My recent imagery strikes me as strongly as my initial image, and my best may be sometime in the future. I'm leaving that possibility open.

How Your Equipment Affects Your Photographic Rhythm

I started using a large format camera (4×5) in 1969 when I was still working as a math analyst at The Aerospace Corporation in the Los Angeles area. I still use it today, and I love using it. It forces me to look more carefully. I have to first explore my compositional options—sometimes very quickly, but always quite carefully—before setting up my camera in the right spot.

By contrast, I've seen people using 35mm cameras as if they were using a rapid-fire pistol, shooting off one image af-

◀ *Figure 1–10:*
Llama in Fog, Machu Picchu
Fog that was so heavy it turned to a light mist filled Machu Picchu as I climbed its stairs and looked back toward its entry area, only to see a llama calmly chewing its cud and looking over the enchanted scene. Not knowing how long the fog would remain, or how long the llama would stay there, I grabbed my digital camera rather than my 4×5 in order to record this magical moment before it disappeared.

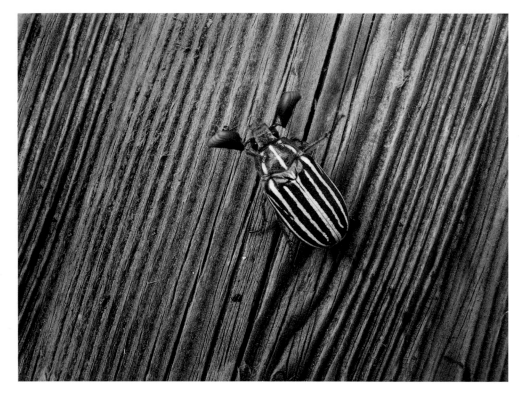

▲ *Figure 1–11: Beetle on Deck*

This large beetle (over an inch long) was slowly walking across our front deck when I first saw it, and I immediately noticed the beetle's stripes and the wood grain stripes of the deck. I quickly ran into the house, grabbed my digital camera, ran back to the deck, and got down on my knees to photograph this remarkable bug before it left the scene. It was moving so slowly that I thought it was injured. I was as fascinated by the beetle as I was by the nearly 90-degree angle between the beetle's striped pattern and that of the wood grain. It was perfect. I made a couple of exposures using the macro mode, before it suddenly—and very unexpectedly—flew away, first flying straight up into my face, scaring the hell out of me!

while I'm certain that there are times when this could yield a wonderful image, I tend to think that photography actually requires some forethought and planning. Many of history's great photographers shot fewer images in a year than some of today's digital shooters pump out in a day.

In many ways, digital photography has turned the usual approach to photography on its head. It used to be that a photographer would look and then shoot, taking time to compose the image and look for important relationships within the scene before tripping the shutter, even if it was as rapid-fire as street photography. Today, most digital photographers shoot and then look. They expose the image first, then look at the display on the camera back to see what they captured. Digital cameras make it easy to proceed in that manner because if you're not pleased with the image you've captured, you can simply delete it. You can't do that with film, where the exposure is permanent and you have to move on to the next frame. Digital photography certainly frees you up to do more shooting, but it's a double-edged sword because it also allows you to do a lot of really bad shooting.

That's not what I would call shooting in a rhythm; it's wishing and hoping, pressing a button and seeing what happened later. There's no personal rhythm there. It's pure quantity, with the hope that some quality may be hidden within. I have to admit to deleting a few digital exposures along the way myself, but almost exclusively because of things such as contrast that I originally felt was within the range of the exposure but turned out to be too high, or other such issues that I didn't expect; not so much because of poor composition or a serious distraction within the image (though there have been a few such obvious mistakes).

I now use digital procedures for all my color photography because I feel that digital technology has surpassed traditional film technology. I do not see the same superiority with black-and-white photography, an area in which I also love the traditional film and darkroom process. One of the

ter another with little forethought as to the optimum camera position or any other variety of concerns. And today's digital shooters often seem to use the camera like a machine gun, reeling off a virtual movie roll of images and searching for the best frame at a later date, assuming that in the midst of all that manure, there's got to be a pony somewhere. This approach makes you much more of an editor than a photographer. And

obvious advantages of shooting digitally is that it allows me to photograph quickly, which is an option that is not available with my 4×5 camera. This has given me a degree of freedom that I don't have with the 4×5, yet my time spent working with a large format camera has given me a sense of discipline that I find too often missing for most of today's digital users. I always look for the compositional elements first, even if it's a very brief look (figures 1–10 and 1–11). While it would have been possible to make the image of the llama at Machu Picchu with my 4×5 camera—the llama and fog both remained in place for quite some time—I was able to move quickly because I had a digital camera with me. I didn't have to worry about the animal disappearing while I was setting up my large format camera. On the other hand, it would have been impossible to use my large format camera to make the image of the beetle because the beetle was in constant, if slow, motion, and it flew away within a minute or so—not nearly enough time to set up my large format camera.

Perhaps I'm still in the process of finding my rhythm with the digital camera. Perhaps I've already arrived at that rhythm. It certainly allows me to work far more quickly than I can with my 4×5 camera, yet I have no desire to move away from large format imagery. I do not believe that art is an instant creation; it takes forethought. Although working with a large camera on a tripod takes time, when I look at the work produced by those who came before me, over a period of more than a century using large format cameras, I feel I'm part of a recognized tradition that still remains valid. After all, nobody would say that Paul Strand or Ansel Adams or either of the Westons or any number of other large-format photographers would have done better with digital technology. And the slow, careful methods used with the large format camera meshes seamlessly with the thoughtful approach that I feel is a necessary element of fine art. Some of these methods spill over into my digital work. I firmly believe that well-conceived digital work is as valid an art form as any other photographic approach.

I'll have more to say throughout this book, especially in chapter 7, about what I feel are the benefits of using a digital camera. It turns out that virtually any camera has its strong points and can be used effectively for creative, expressive purposes. You are not going to jump to using every possible type of camera as a creative outlet for you, just as you're not going to employ every possible rhythm as a valid working method for you, but it's worth trying a few of each to find both the equipment that works for you and the workflow that meshes with your own inner rhythms.

Chapter 2

Your Interests and Your Imagery

IF YOU ARE GOING TO ENJOY PHOTOGRAPHY and produce meaningful images you'll have to find subject matter that interests you, that excites you, that draws you in and involves you. I was particularly lucky in this respect because I already enjoyed hiking in the mountains, which drew me into photography, so my initial area of photographic interest was predetermined.

You may not be that lucky. Perhaps you are interested in the idea of photography because you've seen a number of photographs that you like, and you want to produce some yourself. Perhaps you've been photographing for years with a degree of pleasure, but you want to improve the quality of your work. You may have picked up this book hoping that it could help you along that path, which is actually my goal in writing the book. So let's try to travel down that path together.

First, however, I want to engage you in a short five- to ten-minute exercise. I believe that this can be a very useful, perhaps even pivotal, exercise. Please pull out a sheet of paper and a pencil, or your computer, and list your three favorite photographers, followed by a sentence or short paragraph explaining what it is about each photographer that you like most. If you only have two favorites, just list two. If you have more than three who are all real favorites, make the list a bit longer, but don't let it get too long; confine it to your real favorites. Because I think this is an important enough exercise, I urge you to put this book aside for a while, give the issue a bit of thought, and then write down your choices and your reasoning. I'll return to this at the end of the chapter to explain why this exercise is so important.

◀ *Monte Cristo Grade Road Sunlight*
The road across the river from my home turned to magic
as the fog cleared on an early autumn morning

Finding Your Photographic Interests

Now, with your list completed, we'll start down the path of finding your interests, with the assumption that you don't yet know what really excites you. (If you do, you're already part way down the path.) How do find out what it could be? My suggestion is to try a variety of different things. Try portraits, either in a makeshift studio, perhaps as simple as one side of a room in your home, or on the street; in front of stores at shopping centers or at bus or train stops; or any other place where people are likely to congregate. You'll have to be pleasant and maybe a bit assertive when asking people to pose for you. Most won't, but some will. You'll have to wait patiently to find the few who will say yes. You may even ask if some of them would pose nude for you (a bold leap forward, but some will say yes, though probably not on the spot), or you can hire models to pose nude for you. Nude photography has always been a very popular pursuit, just as painting of nudes prior to the advent of photography had been popular subject matter for centuries.

Ask friends and family members if you can photograph them, and if you can photograph their young kids, not only as portrait subjects but as they play and interact with one another. Action photographs are popular, challenging, and a lot of fun for those on both sides of the camera.

You can try driving to the countryside, the seashore, a nearby forest, the mountains, or to any other natural area to see if you like photographing nature. Try exploring a range of subjects, from the biggest mountains to the tiniest flowers; from the cows grazing out in the farm fields to birds perched on tree branches; from the isolated farmhouse in the small valley between the hills to the waves of the ocean crashing on the beach. There are lots of different things to see out there, and some may truly resonate with you.

You can walk the streets of large cities and see if unplanned events prove exciting to you. Watch what individuals or groups of people do on the streets, and try to photograph those special moments when things come together in fascinating and unexpected ways.

You may find that the architecture of the town or city is of interest to you. For me, this tends to be true of older architecture rather than new, but not always. The third section of my first published book, *Visual Symphony*, dealt largely with with photographs of huge, generally ugly, downtown office buildings. I included several buildings within a single image, thus concentrating on their geometric interactions and the play of light and shadow upon them, rather than the general drabness of each individual building. To my eye, most of the buildings were uninspiring when looked at individually, but the abstract geometric interactions among them fascinated me (figure 2–1). I've continued to photograph such subject matter over the years. Yet it is the old architecture of Europe, or that of the Maya or the Incas (think Machu Picchu) and other places that I've visited—and many more that I haven't visited—that are the most attractive to me.

My general interest in older architecture indicates my leanings, but as noted above, I've delved into modern architecture quite often. Architecture that is old, new, or anything in between can be fascinating. It depends on you, the photographer. Modern architecture can be fantastic subject matter— not just structures like Frank Gehry's wonderful buildings, but

▶ *Figure 2–1: Overlays, Dallas*

Growing up in Chicago, I marveled at the tall buildings clustered in the downtown area. My fascination with skyscrapers continued into adulthood, even as buildings became progressively more box-like and less tapered and organic. My photographic work started in downtown Calgary, Canada, and continued in New York, Chicago, Los Angeles, Dallas, and other North American cities with concentrated downtown skyscrapers. The most compelling images to me are the ones that force a double-take because the combination of structures is so puzzling and confusing.

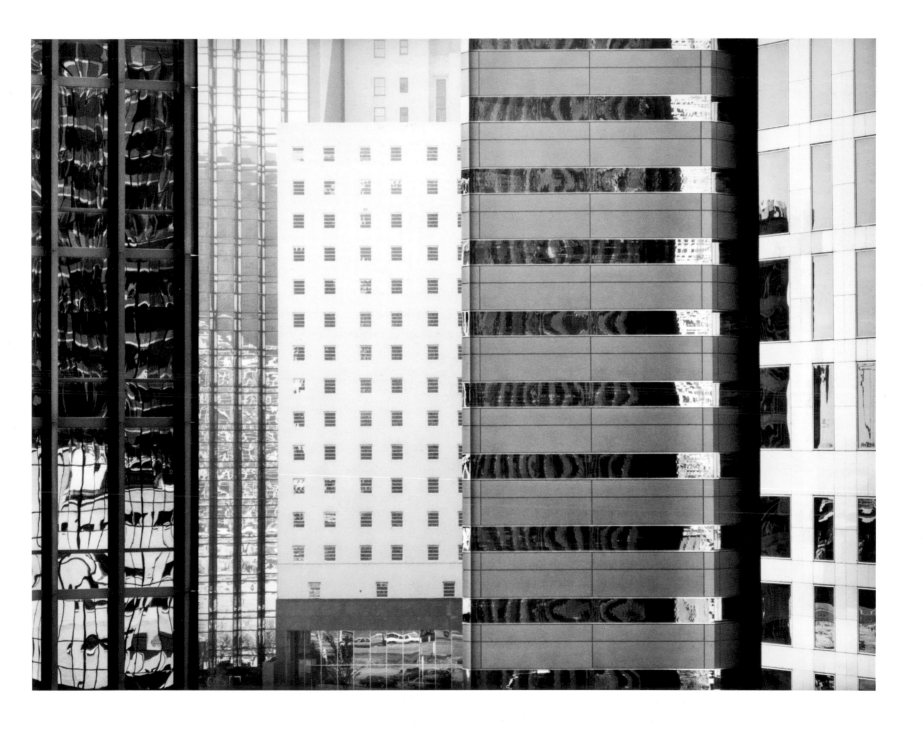

even supermarket structures from the 1960s, or a beat-up industrial warehouse. Old architecture—from Machu Picchu to European towns and cathedrals to Ankor Wat—draws almost everyone to it. But it's you, the photographer, who is drawn to subject matter. As acclaimed photographer Frederick Sommer once noted, "subject matter is subject that matters." It has to matter to you.

Some people have taken to photographing old barns, some abandoned, some still working, some in serious disrepair, and some in the process of collapsing. Barns are fascinating subjects, and you may be able to photograph the landowners as well. These structures are in rural and even some suburban areas all around the country, so unless you live somewhere like downtown Manhattan, there are probably some within striking distance of your home. In fact, from Manhattan, you'll find some in nearby Connecticut, New Jersey, and not too far north of New York City within the state.

Try some sports photography, perhaps at local high school games or even games in your neighborhood playgrounds and ball fields. You may be able to up the ante by getting into some college or professional events as you begin to get better at it.

Street photography is another genre that may interest you. Some people like to wander through the streets of big cities, finding great meaning in the daily activities that others tend to ignore or take for granted: the person walking briskly down the sidewalk, suddenly stopping because he or she remembers something of great importance that needs attention; the person looking intently into a window display that everyone else is passing by with no interest; the two people discussing or arguing about something as others avoid them on the way to their destinations; the person who dropped a package and is frantically trying to gather it all up before others trample it. These are human interest issues that can be photographed with great affect by the right photographer who finds the angst, humor, or joy conveyed by those involved.

These are just a few suggestions. You'll come up with many more. Subject matter is anything that you can see and that you feel has some real, intrinsic importance. Try any or all of them, or anything else a friend may suggest. Some suggestions may be so unappealing to you that you won't even consider them. That's to be expected. Consider others. You'll try a few once or twice and find them boring, but one or two others will prove to be attractive, perhaps even exciting. When you start going back to the same type of subject matter over and over, that's a sure sign of where your interests lie. It's that simple. You've got to try different things to see what draws you in time after time, and what you'll avoid at any cost.

Start looking more carefully and thinking deeply about what you see in a scene and what you want in the final image. Pay attention to how the visual relationships within your picture frame are working with one another (figure 2–2). These are the relationships among lines, forms, colors, textures, etc., that I discussed in chapter 1. You'll work at making them relate even better by noting that moving to the left or right, up or down, forward or back can subtly improve those relationships. In time, you'll start finding that camera position sweet spot almost instinctively. Your compositions will become stronger and more assured.

Along the way, try to analyze *why* you're attracted to the subject matter you've chosen. This may seem like an exercise in psychological silliness at first, but I think that over time you'll find that the answers you come up with—however amorphous or inarticulate they may be—will help you make stronger images as you proceed.

I'll bet that Ansel Adams could have explained why he was drawn to the landscape. Ruth Bernhard could have explained with great clarity why she was so drawn to photographing nudes, women in particular. Mary Ellen Mark can easily articulate why she photographs street people. Diane Arbus could have fully explained why she was drawn to photograph the "losers" in society. These are photographers who have pushed

◀ *Figure 2–2:* ***Cosmic Ice Dog***
Where can you find good subject matter? Everywhere. You just have to look and keep an open mind to all possibilities. This ice formation was in a low point in my gravel driveway (one of many such potholes). Every winter we get enough cold days to turn puddles into sheets of ice, and often the forms within them are amazing. This rather bizarre configuration reminded me of plasma clouds in the universe, while the comical form at the bottom center reminded me of a small dog. If subject matter can be found in a gravel driveway, it can be found anywhere.

the limits of their specialization, and they fully knew (or know) exactly why they were drawn to those things they do so well. I'm sure they would agree that understanding why they were drawn to their chosen subject matter has served to strengthen their imagery.

As I've already stated, I think that fine photography is a product of interest, keen observation, intelligence, and planning. Intuition and creativity spring from these basic foundations. So it's hardly surprising that I'd ask you to articulate why your areas of interest are pulling you in. I am convinced that it will help you produce better images because when you reflect upon your interests, you begin to understand them better and you can determine what it is you want to say about them.

The Starting Point of Photographic Seeing and Creativity

For many people—photographers and viewers, alike—a photograph is simply a record of what was in front of the camera. There is really no thought given to interpretation. But for those of us who see photography as a creative, artistic, and personally expressive endeavor, the scene in front of the camera is always a *starting point for* your journey. The creative photographer has to find the scene that she responds to and recognize its potential for personal interpretation. This is not an easy task.

Few understand the difference between snapshots, with no interpretation, and real photography that entails personal interpretation. This is the reason we so often hear the phrase, "you were in the right place at the right time," a comment based on the false idea that the photograph represents exactly the scene that the photographer encountered. It's a comment

devoid of the concept of personal interpretation. For the photographer striving to be creative, the recognition of the vast difference between *the scene in front of you* and *the photograph you can produce* is the beginning of your transition from recording a scene photographically to expressing how you feel about a scene emotionally.

Think of it this way: the scene is your palette, and the print is your canvas. This is not dissimilar from Ansel Adams's famous statement that the negative is the score, and the print is the performance; however, it starts at an earlier point—when you're at the scene, not in the darkroom with the negative, or at the computer with the RAW file. If you look at the scene as the starting point for your artistic statement, you give yourself the leeway to alter it; to expand upon it; to emphasize some aspects of it and subdue others; to increase or decrease the contrast, both overall and area by area; to increase or decrease the color saturation; or to alter the colors themselves. If you look beyond the scene and consider how you can portray it to express why it moves you or how it affects you, you are thinking creatively right from the start. You can go even further and think about how you may be able to use it as part of a multidisciplinary collage, which could include painting, drawing, magazine cutouts, or anything else that contributes to the final artistic statement.

Photography is inherently different from the other arts. If you're a painter, sculptor, writer, composer, or virtually any other type of artist, you start with a blank slate and create your painting, sculpture, novel or poem, or your musical work. The subject or scene that inspires you can be imagined, remembered, or found. In photography, on the other hand, you *must* start with a "found object"—whether it's a landscape, portrait, sports event, architectural subject, street scene, or virtually anything else you can imagine—and respond to it with a negative, transparency, or RAW file that you can then interpret in your own creative way. You generally have to start with what is in front of you, rather than invent something

new with your imagination. Counterexamples exist, as they always do, such as creating abstract art by shining light directly onto photographic paper, without any use of a camera or scanner. But aside from such arcane pursuits—which can be absolutely wonderful, and are surely very creative—most photography starts with an object or scene. The interpretation begins with the exposure itself, where you *see* what's in front of you, and simultaneously *imagine* what you can do with it. The great exception to this may be studio portraits or still lifes, where the photographer creates or poses the subject to be photographed, in which case the creativity may begin with the set-up itself.

In studio portraiture or still lifes, you can pose the portrait subject or build the still life as you desire; you can set up and alter lighting to suit your desires; and you can set up a backdrop as you please. In outdoor portraiture, you may be able to find the appropriate setting and the lighting situation you desire, or you may be able to alter it with reflectors or fill flash or other such controls, but it's not quite as fully controlled as it can be in a studio. In either case, however, the unexpected may still occur—a seemingly uncomfortable position that the sitter assumes, a lock of hair that springs upward, a wrinkle in the clothing that proves distracting, a strange conflict between the sitter and the carefully chosen background—so you have to see these problems and deal with them on the spot.

With landscape or architectural subjects, sports photography or street photography, you have to work with a changing scene, with the ambient light, and you have to do it with few controls. You have to see how the light works for you, and if you have the time you may have to move your point of view to optimize the composition.

A painter does not have the same restrictions. The painter can ignore the lock of hair springing upward or the conflict between sitter and background. The painter, perhaps basing the painting on a real scene, can put anything into that painting that does not actually exist in the scene, and can remove

any undesirable aspect of the scene from the painting. Photoshop and other digital apps may allow you to do the same thing, but let's not debate whether that's still to be considered photography, for a debate like that solves nothing. It's still part of the creative, expressive process, so I'll defend it as perfectly acceptable.

In general, the photographer has to see the distractions and figure out how to eliminate or subdue them to the point of insignificance. Sometimes it's as simple as moving the location of the camera so that the relationship between the forms of near and distant objects is better revealed—perhaps moving the camera just a few inches—and sometimes this has to be done quickly before conditions change. This requires skills of quickness in seeing and responding that are quite different from anything required of a painter. Most important, you're thinking about the final image while standing behind the camera, and making sensible decisions based on your vision of the final image. You're not just recording the scene. You're now elevating the seeing of the scene to the same level of creative importance as that of your subsequent processing of the exposure.

convey the message he wants to convey. When used well, these tools may provide the most universal language on earth, far more ubiquitous and understood than any spoken language. People throughout the world are able to respond to imagery in similar ways, even when they have no common spoken language. They will be jolted by visual imagery featuring jagged lines, extreme contrasts, and intense color saturation, and will be soothed by softly curved lines, dominant midtones, and pastel colors. This makes photography a very powerful language, indeed. To employ this language in an articulate manner, you have to fully understand its recognized meaning.

Applying appropriate lighting to your chosen subject matter and composing your image in a thoughtful way allows you to control the emotional impact of your image on the viewer. Photography is a communication between the artist and the viewer, just like the communication between a composer and the listener. Just as you can viscerally connect with certain pieces of music, you can connect with photographs. And of course, if you're the photographer, you want to know how to effectively connect with your viewers.

Compositional and Lighting Considerations

Let's assume you've found the subject matter that really interests you, and you're looking at the scene with an eye toward finding interesting visual relationships within it and interpreting what you see, rather than simply recording it. What does that really mean in practice? Photography, as with all of the visual arts, is a non-verbal language. In order to express yourself adequately, you have to learn how to communicate your thoughts to the viewer, for communication is truly the essence of fine photography.

Light and compositional relationships are the tools used by the creative, imaginative, and thoughtful photographer to

Composition

To translate your passion for the subject matter that means so much to you into an image that captures the viewer's attention and makes him sit up and take note of what you're saying, you have to concern yourself with the nuts and bolts of composition. You have to figure out how to arrange the elements within the scene, and of course, make use of appropriate lighting, so that all of your emotions are translated into visual language.

That's not an easy transition or translation. How do you channel a multitude of feelings into a visual experience? This is especially difficult if some of those feelings are thought-based

(such as my deeply held feelings about how global warming is affecting all life on our planet) rather than sensory-based (what you see, feel, smell, etc.).

Consider the following compositional basics, some of which I've already mentioned, and then consider how they can affect your initial seeing and your approach to translating the scene in front of your camera lens into your photograph in front of the viewer's eye.

1. A photograph composed with a number of vertical lines tends to impart a feeling of strength and stability, like that of tall conifer trees or buildings. Horizontal lines tend to impart restfulness and quiet. Diagonal lines have an inherent kinetic energy, as if a vertical line is in the process of rising or falling, and they imbue an image with a strong sense of dynamism and activity.

2. A photograph that features sharp, broken or jagged lines, or lines with tight curves, will have far greater impact than one that features gently curved lines. This is true for both color and black-and-white images. So if you're looking for immediate high impact, it will serve you well to look for those broken, jagged, or tightly curved lines. If you're seeking a quieter mood, it's best to compose the image with lines and forms that are gently curved, sort of soft and squishy.

3. Highly saturated, deep colors will have far greater impact than soft pastels. If the colors are on opposite sides of the color wheel, such as deep blues and flaming oranges, the image will jump out at you aggressively. On the other hand, if your imagery is dominated by light beige and soft blues, it will have a very pastoral or gentle feel.

4. In black-and-white images, high-contrast juxtapositions of bright whites against deep blacks have a high impact, whereas mid-gray tonalities bordering on one another tend to impart a much softer, quieter, and perhaps reassuring feeling. You have to be careful not to cross the line from

quiet to boring. Your choice of tonalities in a black-and-white image parallels the choice you may make between deeply saturated and pastel colors in a color image. This basic choice goes a long way toward setting the mood of the image for the viewer.

5. A high key image (i.e., one dominated by light tones or pastel colors) tends to impart a more positive, optimistic, or perhaps dreamlike feeling, whereas a low-key image (i.e., one dominated by deep, dark tonalities and colors) tends to impart a more dramatic or mysterious mood, perhaps a pessimistic or even a frightening feel. This may mirror our basic feelings of fear or trepidation that arise when we think about walking through dark city streets or on a forest trail at night, where it's difficult to know what's hiding in the deepest shadows. This has been a scary prospect for millennia, and it's still very much part of our psyche.

Now let's give some thought to what these basic compositional elements mean when you're standing there at a scene with your camera in hand. You are drawn to a scene that you probably did not create, and now your task is to make that scene into a meaningful photograph. Looking carefully, you may notice that an object in the middle distance with an especially nice line at its edge will be repeated like an echo or a shadow by another form in the far distance if you move a few feet over to your right. So changing your camera position will create a stronger relationship between the elements in your image. Therefore, you move to make that relationship more apparent.

Perhaps there is something in the far distance that is visually irritating in an otherwise wonderful scene, but if you step forward a full step and to your left a few inches, something in the foreground will block it without changing the overall composition. By blocking the irritant, you strengthen the composition.

Depending on the subject matter, you may be able to angle the camera a few degrees off of true vertical, or even turn it

wildly off axis, to make the forms flow more dynamically and create a stronger image. For example, if you're photographing conifer trees, you'd better keep the verticals vertical, but if you're photographing sand dunes or oak trees or the sandstone undulations of Utah, verticality may be meaningless, giving you leeway to move away from formal "plumb line" photography. In a portrait, putting the subject at an angle could bring about a very different dynamic, and is likely to say something about the person's personality.

You may be attracted to a scene, but quickly realize that by zooming in on a smaller portion of it, you really get to the heart of the issue without being distracted by the the pleasant but extraneous material around it. Alternatively, you may be attracted to one specific subject, and then realize that the more you include around it, the better it becomes. So you zoom out or use a shorter lens to include more, which may bring in additional relationships that strengthen the visual experience.

These are just a few of the many decisions you can make in the field to strengthen your imagery, once your mind is focused on the compositional possibilities. I've been involved in every one of these situations in my career, along with so many more, and you will encounter them yourself in your photographic endeavors. These are some of the considerations that separate "seeing" from "photographic seeing." These are the things you have to think about and act upon when you're photographing, no matter what the subject matter is.

Light

Together with the many compositional choices you have to make, you must also consider one overriding issue: light. Whether you're using a digital sensor or film, the only thing it records is the variety of light levels within the image area. Light is your tool, so you must use it wisely. You have to keep in mind that it's not the *objects* that the camera sees, it's the *light levels*. So you have to determine whether the light in your scene leads your eyes to where you want the viewer's eyes to go. Or, thinking through the entire process, you may be able to determine if there are processing options that would help the light work for you.

If you're using black-and-white film, you may be able to use appropriate filters to brighten or darken portions of the scene that have a color dominance, in order to better interpret your feelings. A red filter will darken a blue sky, as will a yellow or orange filter, but to a lesser extent. A green filter will darken lips or a man's ruddy complexion, enhancing either one. Digitally, you can achieve much the same effect in postprocessing by using color sliders to lighten or darken portions of the image.

Perhaps you can burn or dodge portions of the image, alter the contrast, enhance or subdue the colors, or whatever else it may take to direct the viewer's gaze where you want it to go. Actively thinking about these things when you're out there with your camera pushes you far along the path toward a meaningful, expressive image.

In a studio, you may have complete control of the light, but if you are doing landscape work, you have to work with the light that exists. Is the light strongly directional—perhaps sunlight coming in from the left or right—or is it soft and directionless, which you may encounter on a foggy day? Is it drawing your eyes toward the portion of the scene to which you want to draw the viewer's attention, or is it pulling you off to the side or to something of relatively limited importance? You may be able to exert some control with reflectors or fill flash if the subject matter is close enough, but those controls won't work for a distant mountain range or seascape. In all cases, you have to recognize if the light is working with the compositional elements, and if you can work with it further in the darkroom or with photo-editing software to bring out the effect you want.

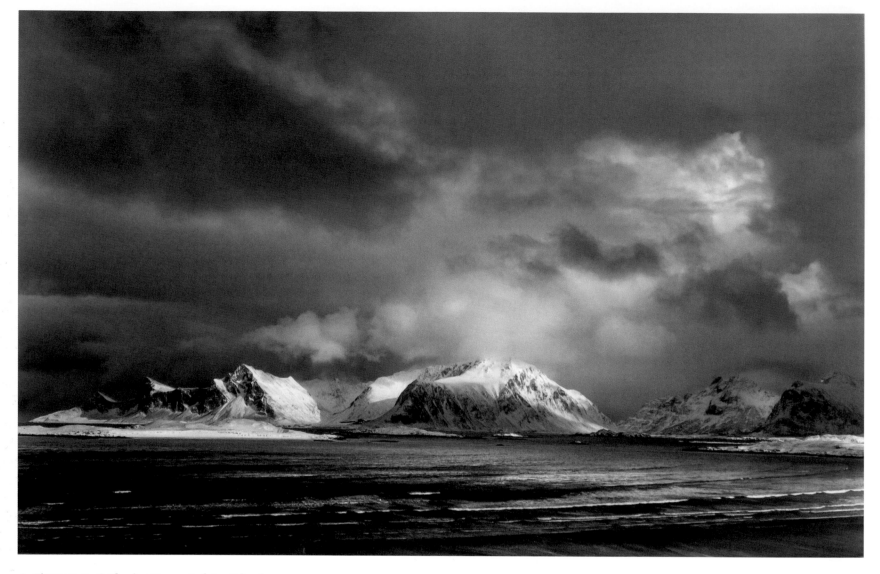

▲ *Figure 2–3: Gathering Storm, Lofoten Islands*

It was really the latest in a series of violent winter squalls screaming through the archipelago of islands just north of the Arctic Circle in Norway. The clouds were brilliantly white, with sunlight hitting them directly. They were also deeply black, or so it seemed to me. They certainly felt black on that day in March 2013, perhaps because I knew that within minutes we would again be assaulted by screaming cold winds and pelting snow. (Following that was another period of calm and sun before the next squall came roaring in.)

Suppose you make a portrait or a landscape exposure under bright sun. Do you have to print it as if it were a bright, sunny day? Not necessarily. You can "turn down the lights," in essence, to create a lighting situation that more closely fits a darker emotional mood. You can't change the direction of light, and you probably can't make it look like a foggy day (although with the proper exposure and development you can come surprisingly close), but you have a remarkably high degree of latitude in your presentation of the image, giving you a high degree of control (figure 2–3). It's yours. Use it.

In the studio you can control the intensity of light, the directionality of light, and the sharpness or softness of light. For portraiture, the interpretive possibilities are endless. You can use different types of lighting to bring out the cragginess or smoothness of skin. You can work with the subject to bring out the wry smile or the irritated scowl. All of this goes a long way toward conveying the personality of your subject. This

can be used to altruistic or devastating ends; the choice is up to you. This is where your creativity springs into being.

Without considering composition and lighting, you're simply snapping pictures. You have to engage your mind from the start, and ultimately you have to think the process through to the very end, to your final photograph. You have to think about the steps needed to get from the scene that you didn't create to the photograph you want to create while you're standing there with your camera. In other words, the whole process must be part of your thinking from the start.

Example Images: Applying Compositional and Lighting Considerations

Now let's look at a few images to see how these ideas work in practice.

Deception Pass Bridge (figure 2–4) features three key elements: the upper right black square, the lower left triangle, and the strong line of the girder dividing the two. There is a feeling of stability laced with some kinetic energy from the many diagonal lines. Beyond that, everything slowly fades away into the fog in a series of geometric lines going in every direction. It was necessary to carefully place my camera to bring out those key relationships in the strongest way.

Radiator Rocks, Alabama Hills (figure 2–5) is related in many ways to the studies I did of the English cathedrals. The columns, vaults, and arches of the cathedrals are replaced here by a parallel series of vertical-to-rounded boulders that creates a feeling of quiet stability and strength, yet also alludes to infinity, since the viewer's eye-mind combination projects this series of forms to go on forever. I used my longest lens (500mm) on my 4×5 camera to focus on this set of giant granite fins, eliminating everything else around it, but still maintaining an interesting relationship between the foreground fins and the distant background in the upper right. The pho-

▲ *Figure 2–4: Deception Pass Bridge*
The bridge, which links Whidbey Island with Fidalgo Island in the Puget Sound, was surrounded by dense fog at sunrise. Standing immediately beneath the roadway, I set up my camera to photograph the supporting structure—seemingly random in many ways—disappearing into the fog. Within 45 seconds of exposing the negative, the fog abruptly disappeared, and the feeling it imparted disappeared along with it.

▶ *Figure 2–5:*
Radiator Rocks,
Alabama Hills
This remarkable series of
round rock fins in the
Alabama Hills, immedi-
ately east of the Sierra
Nevada, reminds me of
old radiators from my
childhood apartment in
Chicago. At the same time,
it reminds me of the
series of columns, vaults,
and arches I photo-
graphed in the English
cathedrals in 1980 and
1981—almost a mathe-
matical metaphor on
infinity.

tograph was exposed just prior to sunrise, when the light was directional but soft. Minutes later, when the sun rose, the harshness of the bright sunlight and deep shadows turned the scene into an uncontrollable cacophony of intense blacks and whites.

Ghosts and Masks (figure 2–6), part of my "Darkness and Despair" series, is dominated by dark tones with tightly curved highlights that look like grotesque faces, imparting a brooding, scary feel to the image. Many have likened the image to Norwegian painter Edvard Munch's *The Scream,* which I have always taken as a great compliment. I made this image with my 6×4.5 cm camera with extension tubes, which allowed me to do macro work on a portion of a log that was no more than five inches on a side. The scene was photographed under soft, evenly lit, cloudy conditions. I increased the contrast both in negative development and during printing.

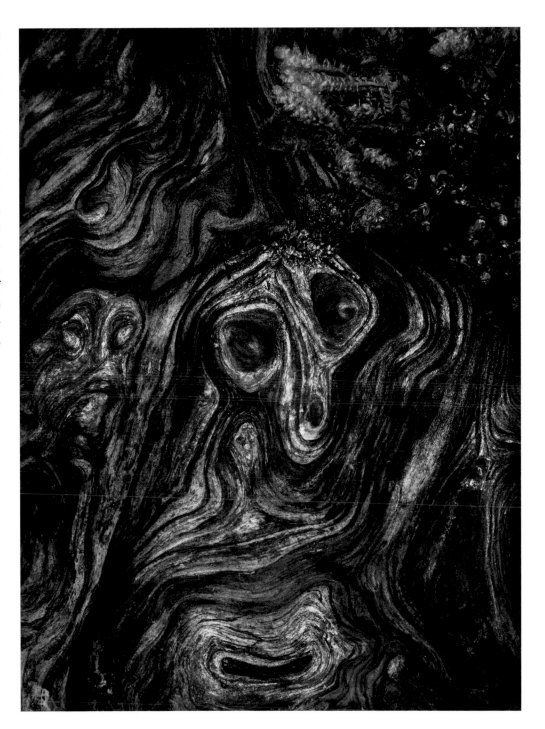

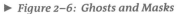
► Figure 2–6: Ghosts and Masks
This image is part of my "Darkness and Despair" series, which was triggered by the devastating loss of an environmental battle in which politicians illegally gave a permit for an aggregate mine after its permit was denied in court. I funneled my anger and frustration into photographs of burls on a small log I found in the forest on my property. Its grotesque figures peer out from the blackness within the image and that within me.

Into the Center of the Earth, Buckskin Gulch (figure 2–7) jumps out at you powerfully, with it's brilliant reds and oranges glowing against the deep purples and blacks of the enclosing walls in the deepest portion of the slit canyon. The light was coming from above and around the next bend, causing me to audibly gasp when I emerged from an even darker segment of the canyon into this paradise of brilliance.

Font's Point, Anza Borrego Desert (figure 2–8) is a dramatic landscape image that I took under rather striking lighting and weather conditions. Yet it is softened greatly by the pastel beiges and browns of the badlands, and by the light, unsaturated blues of the sky.

◄ *Figure 2–7: Into the Center of the Earth, Buckskin Gulch*
In the deepest portion of Buckskin Gulch, 400 feet below its top and only 10 feet wide, the dark, foreboding walls suddenly give way to brilliant sunlight reflected off of walls ahead and around the next bend. It was a knee-weakening sight to unexpectedly come upon such brilliance down in the depths of this 11-mile long crevice in the land.

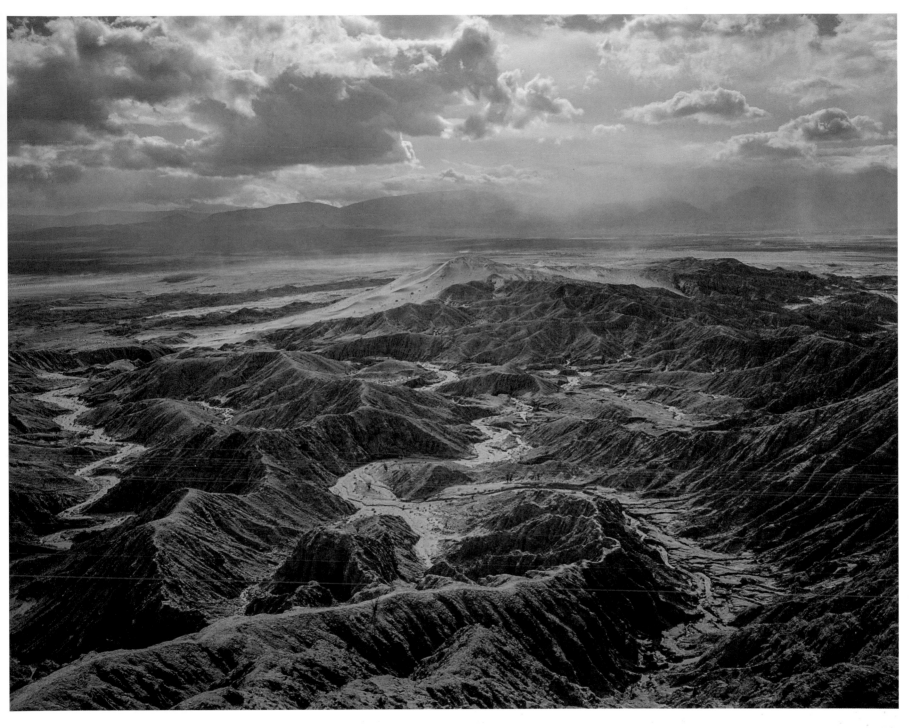

▲ *Figure 2–8: Font's Point, Anza-Borrego Desert*
The badlands of the Anza-Borrego Desert east of San Diego shimmered below storm clouds that
were blowing in and blowing out simultaneously. It was a striking landscape and cloudscape, yet
it was strangely softened by the pastel colors that dominated the scene.

Eliminating Problems in Advance with Careful Looking and Seeing

When exposing any negative or digital capture you have to concentrate on the main subject matter and the relationships in your composition, which is entirely obvious. What seems so counterintuitive to beginning photographers, and to many intermediate and advanced photographers as well, is that the "unimportant" areas of the image are just as critical. I've found that so often when I try to photograph the landscape—particularly when I'm not out in an undisturbed wilderness area—there are inevitable distractions or undesirable objects lurking somewhere within the frame I've chosen. Somehow, I must eliminate those distractions.

Consider how you would feel about Ansel Adams's famous photograph *Moonrise, Hernandez, New Mexico* (figure 2–9) if there were a bulldozer in the lower left corner. That would probably be enough to kill the photograph for you. The rest of it is great, but that distraction, taking up no more than one percent of the entire image, is deadly. If something that small can ruin a photograph as wonderful as Ansel's iconic image, it's a certainty that equally undesirable intrusions into your images will ruin them as well. Therefore, you have no choice but to eliminate that distraction.

Sometimes you can literally remove that distraction yourself. Maybe it's the small branch of a nearby tree intruding into the edge of your image, or a blade of grass at the base of that tree that can be bent out of the way or pulled out. Maybe it's a strange wrinkle on a portrait subject's sleeve that can be cleared away. As previously stated, sometimes moving the camera to a slightly different position—maybe a bit to the left or right—is enough to put the distraction behind something in the foreground or middle ground without compromising the composition. But what happens if you can't remove the distraction from the scene and still maintain the good compositional relationships?

The next option to consider is whether or not the object can be removed during the printing or finishing. Using traditional methodology, I've sometimes been able to remove an unwanted object by carefully drawing on the negative with pencil to effectively remove that object from the negative, or by spotting directly on the print to remove the unwanted object at that stage. Sometimes I've worked partly on the negative and partly on the print to eradicate an unwanted distraction.

This is where digital technology offers the best solution: the clone stamp tool from Photoshop or its equivalents in other applications. Oh, how I wish that that tool were available in traditional photography. At times it would be invaluable just to remove dust specks or spots on the negative that appear as black spots on the print, and that can only be removed by etching the surface of the print. With the clone stamp tool,

▶ *Figure 2–9: Moonrise, Hernandez, New Mexico, 1941 Photograph by Ansel Adams.*
Photographed seconds before the sun set, this iconic image has captivated viewers for over 60 years. It draws us in and holds us there. Yet it is a dramatic departure from reality, and a dramatic departure from the early printing of the same negative.
Years after making the exposure, Ansel intensified the lower portion of the negative, giving the foreground, church, and cemetery more life and brilliance. He burned (darkened) the sky to total blackness, obscuring the clouds above the moon that were visible in earlier printings. He lightened the ground, which in earlier printings was darker than the sky and clouds. In essence, the photograph that has become an icon bears little resemblance to the scene Ansel photographed. It is, to be sure, a dramatic abstraction and personal expression of how he felt, at least in retrospect, but it's not meant to be reality. Yet most viewers worldwide view it as reality, as if he was simply "in the right place at the right time." It turns out that "the right time" never occurred; it was created.

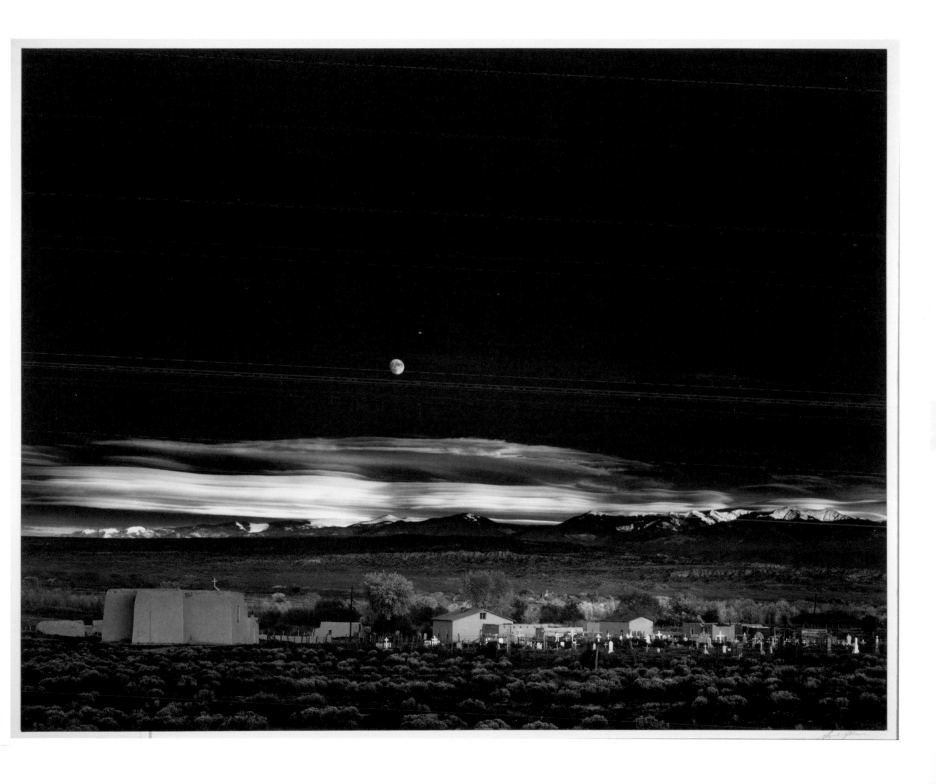

you can replace a lot of distractions with a similar color or tone drawn from a nearby area. In some cases you can even use the tool to fill in empty areas, such as an absence of foliage in a portion of a tree where a bright sky peeks through. Here you may be able to copy a section of foliage from another part of the tree and plunk it into that empty space without it being noticed, even upon close inspection.

The clone stamp tool is a fabulous tool. But it can also be a double-edged sword. I have noticed that digital photographers are relying on that tool more and more, and are not taking the time to look for distractions within the frame before exposure. This promotes sloppy seeing from the start. Yes, you may be able to remove distractions later in the process, but it helps to be aware of them from the beginning so that you can factor that requirement into your complete strategy for producing the final image. The availability of digital tools like the clone stamp tool often make people think that virtually anything can be fixed later in Photoshop or another application. Some people feel they can even change the lighting later in the process, which you really can't do.

While I wish the equivalent of a clone stamp tool or some other "fixit" tool that could be applied to an image at a later stage were available in traditional photography, the fact that such tools don't exist forces me to look more carefully at the scene. I am convinced that this extra-careful looking—even if done quickly—has improved my ability to see and understand a scene more deeply.

The reason I stress the need to carefully look from the start (aside from Yogi Berra's wonderful statement that "you can see a lot just by looking") is that it strengthens your composition. I see photography students who have become oblivious to bothersome elements in a scene because they feel they can rely on fixit tools or apps to rectify the problem. But this thinking produces a second problem: they fail to see the distractions in the final image. I have learned over time that it's usually the insignificant things within the rectangle of your image that destroy the photograph, not the main points of interest. Most photographers are so involved with the main points of interest that they ignore the backgrounds, the image edges or corners, or anything of non-importance that can pull the viewer's eye away from those primary points of interest. You have to see the distractions right from the beginning, and do whatever you can as early in the process as possible to avoid them, including devising a method for removing them at the appropriate point in the process.

Improving Your Seeing with Film

The discipline of using film, and particularly large format film, is one that every serious photographer should avail themselves of. It sharpens your observation and seeing. With film you have to look carefully—even if conditions warrant speed—to see if the prime subject matter works compositionally with the other elements in the image. You have to see if the light is working to your benefit. You have to look for distractions more carefully. You have to do this because you can't quickly review the image and delete it. Once exposed on film, it's permanent (figure 2–10).

Too often it seems that when shooting digitally, the photographer is thinking something like, "beautiful tree...click," or "pretty face...click," or "crashing surf...click," without seeing the light, the other elements within the frame, or the moment when the action is at it's height. There is clearly a higher skill level that is required to capture the "decisive moment" (think Henri Cartier-Bresson) in a single exposure than there is to go through a virtual moving-picture set of frames to single out the best image among many. I believe that film forces a type of discipline and keen observational skills on a photographer that digital does not. I consider that level of discipline to be invaluable. I'm convinced that whether your specialty is street photography, landscape, sports, architectural, portraits, or

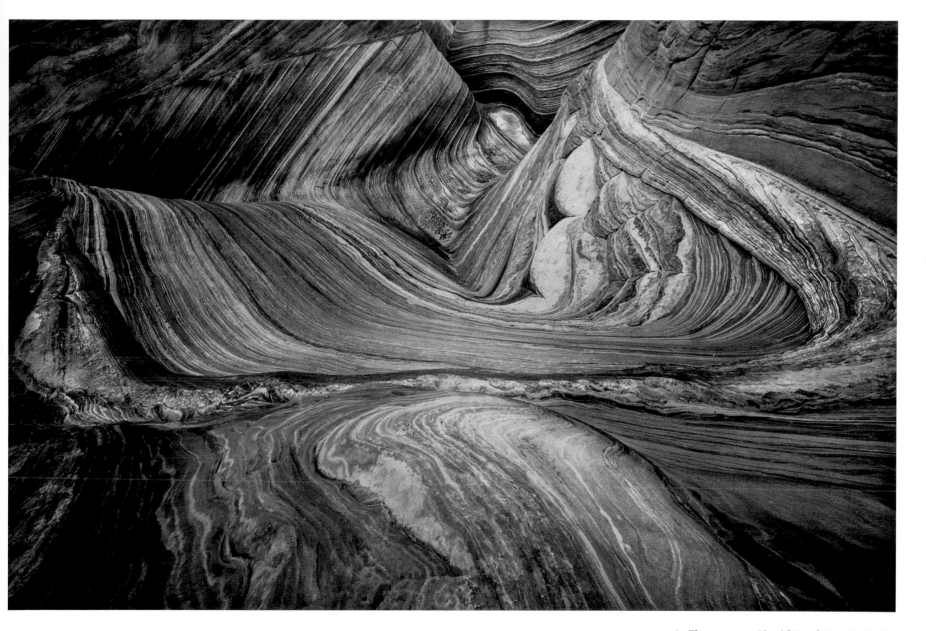

▲ *Figure 2–10: Liquid Land, Coyote Buttes*
In an area at the Arizona/Utah border often referred to as "The Wave" I photographed the undulating, flowing sandstone, which almost seemed to be moving rhythmically beneath my feet. It was a cloudy day, so I had none of the problems associated with bright sunlight and deep shadows, which could have interrupted the flowing forms. Soft light was perfect for my intent, which was to bring out the remarkable fluidity of a landscape that seems unearthly even as you stand within it.

anything else you can think of, it's better to start with a strong sense of discipline, rather than develop a habit of making an exposure too rapidly and then deleting it immediately upon a second glance.

Some readers may think that I'm overemphasizing this issue, beating a dead horse, if you will. I'm not. It really can't be overemphasized. If you want to improve your seeing you have to do it right from the beginning. If you can proceed with the knowledge that you're already aware of the pitfalls and distractions within the scene—and even better, if you've already avoided or mitigated them—your images will improve markedly. By incorporating that level of discipline into your thinking, your images become stronger because you instinctively see things at the start that you wouldn't otherwise see. You may have read research that shows that people working on fast-moving computer games become better at quick reactions to unexpected situations while driving. This is much the same thing; the more it becomes part of you, the more your imagery improves from the very start.

I credit a great deal of my own seeing to working with a view camera. Even when I use my digital camera, I seem unable to just snap away with the thought that I'll look for the good frames later. View camera work has instilled a sense of discipline in me that pervades all of my photographic work. I have heard the same thing from others who have worked with view cameras, even those who now shoot only digitally. They all say that the view camera work helped their seeing, their sense of discipline, and their entire approach to digital work. Interestingly, I have heard from those who have made the switch from digital to traditional work that the change forced them to see more carefully, and therefore their seeing has improved. It leads me to believe that some grounding in traditional photographic processes—and especially some use of a large format camera—has lasting beneficial effects in honing one's seeing.

This corresponds to the type of careful seeing and discipline that Pablo Picasso's father forced on him as a youth when he showed that he wanted to be a painter. The elder Picasso had him paint pigeon feet to look realistic. Pablo did it over and over and over, more than 100 times, until his father felt satisfied that he was seeing and translating the imagery correctly. At that point, Pablo's father allowed him to proceed. You wouldn't think that a guy who did cubist paintings and so much more would need that type of discipline, but he went through it. He could have painted anything in a realistic manner, but he went on to create new paths, producing a lifetime of art that ranks with the very best. It's that discipline that I feel many photographers lack today.

For digital shooters, it could be helpful to spend a couple of hours every month or two shooting with film, as a sort of training regimen for careful planning and seeing. If you don't already have a film camera, you can often find inexpensive, used ones at local camera shops or online. A 35mm camera would be sufficient; 35mm film can be purchased at virtually any camera outlet. You can have the film processed at a lab or process it yourself. The objective here is not to learn film processing, but to learn the discipline needed to more carefully and objectively look at a scene—without the instant feedback you're used to getting with a digital camera, and have become dependent upon—so that you understand the concept of looking, seeing, and analyzing more clearly.

Let's go back to Ansel Adams's *Moonrise, Hernandez, New Mexico* for a moment. Would he have made that photograph if a bulldozer had been there in the lower left corner? Perhaps. Maybe he could have aimed the camera slightly to the right to eliminate the bulldozer, and still produced an equally powerful image. Maybe he could have simply cropped it out. Maybe he could have tried spotting it out later. If digital processes had been available to him, there would have been no hesitation. He could have made exactly the same composition and cloned it out. That would have been the simplest solution.

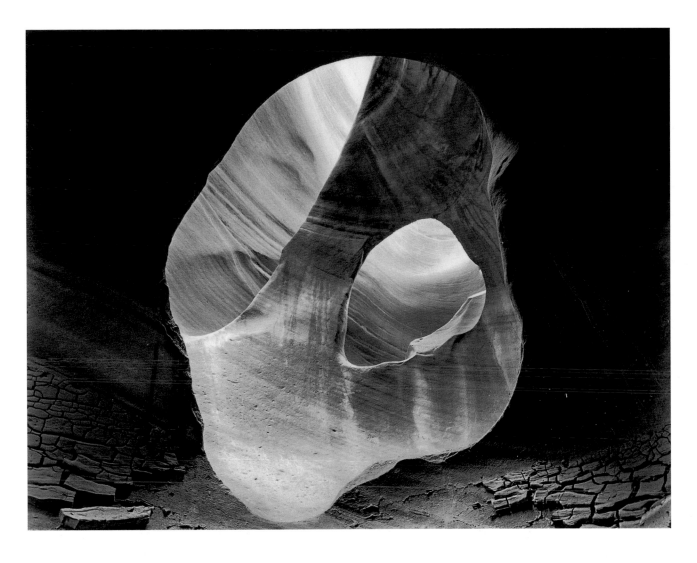

◄ *Figure 2–11:*
In Peekaboo Canyon
Although this image was made with a 4×5 camera, it was placed on the ground rather than a tripod, making it difficult to focus and tricky to prevent the camera from swiveling as I put the film holder into it.

I print the image small—about 6×8 inches—even though it is quite sharp. For me, the upper corners work well in the small size, but would turn into large, dark, boring areas in a large image.

I'll guarantee this much: if I had been Ansel Adams and had digital tools at my command, I wouldn't have hesitated to make that photograph.

Print Size

I also feel that print size is closely related to compositional elements in creating the final feel of an image. I generally produce 16×20-inch prints for display. Sometimes, assuming all the technical issues fall into place (e.g., sufficient sharpness and smoothness of grain), I can print some of those images even larger, up to 20×24, 24×30, or even 30×40. But sometimes

▲ *Figure 2–12: Road to Monument Valley*
Despite being a vast landscape, the image is printed in a small size because I feel that the dark sagebrush expanses on either side of the road would be oppressively ponderous in a large image. My decision to make a print large or small is independent of the size of the scene in front of the camera. Instead, it's purely a function of visual considerations of the final image.

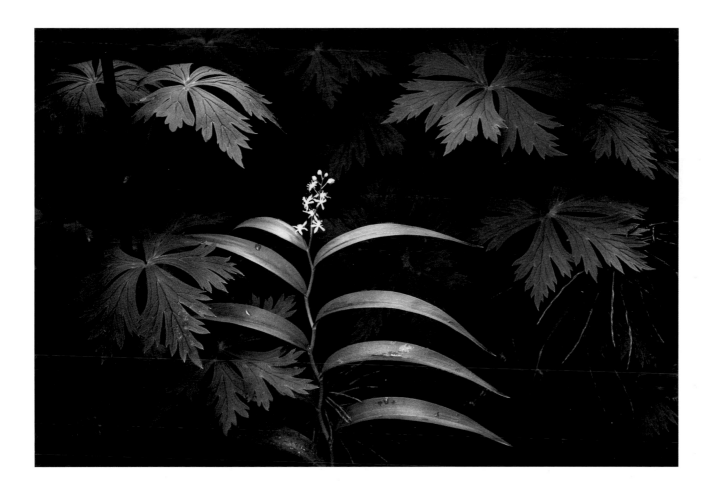

Figure 2–13:
False Solomon's Seal
The delicacy of the False Solomon's Seal, its stem, its narrow leaves, and the surrounding leaves from a different plant pushed me toward making this a small print—little more than 5×7 inches. In a larger size, everything seems overbearing to me, and the dark, out-of-focus leaves in the background, which seem immaterial in the small size, become bothersome distractions in a larger image.

I print images at smaller sizes, no larger than 11×14, 8×10, or 5×7. Why? What are the considerations for making a print 16×20 or larger, or as small as 5×7?

Of course, an overriding consideration would be technical issues. For example, an image that I feel requires extreme sharpness may appear sufficiently sharp at one of the smaller sizes, but is unsharp at 16×20 or larger. Another consideration would be the size of an area with low tonal variation. It may be quite acceptable in a 5×7 image, but it becomes boring or oppressive in a larger size (figures 2–11 and 2–12). Sometimes, the image may hold up technically in every way, but I simply

don't want a large image because it negates the delicacy of the feeling I want to convey (figures 2–13 and 2–14).

The major considerations in my decision to make figures 2–13 and 2–14 in smaller sizes can be better explained by allegory to music, particularly the classical music I'm drawn to. I feel that some pieces of music are specifically composed for a full symphony orchestra, while others are composed for a string quartet. I want to hear Beethoven's *Symphony No. 5* played by a full orchestra, but not by a string quartet. It simply wouldn't work for a string quartet; it would sound thin. On the other hand, I wouldn't want to hear a piece written for a string

quartet played by a symphony orchestra. It's delicacy and intimacy would be smothered by 100 musicians. Similarly, I feel that some images work best as a large, 16×20-inch image or larger, and some work best as an 11×14-inch image or smaller.

Getting Feedback and Responding to It

As I've already stated, photography is a non-verbal form of communication between the photographer and the viewer. If you have nothing to say, nobody is interested in listening. Making meaningless photographs is right on par with producing meaningless sounds. Sure, you can take pictures of a family gathering or club party and pass them around to family or club members who will enjoy them, but those photographs will probably have little meaning to anyone outside of the family or your group of friends.

So if you want to say something that will appeal to a wider audience, it's good to know what you're trying to say. Just as great speakers must know what they're trying to communicate verbally, great photographers must understand what they're trying to communicate visually. This isn't exactly rocket science, but in many ways it may be just as difficult. Trying to understand and articulate what you want to communicate visually is not an easy task. But if you can come close to doing so, your images will undoubtedly improve.

When determining whether you are successful in communicating your message, it helps a lot to get periodic feedback from someone who knows something about visual imagery. Friends and family members can and will comment on your photographs, but they'll be especially kind, largely because you're part of the group or family, and also because they may understand little about the elements of photography. You need feedback that's truthful and insightful. A good college-level class or a good workshop can be very valuable in this respect. That last recommendation may sound utterly self-

serving, since I conduct photography workshops, but I have also attended one as a student—the two-week Ansel Adams workshop in 1970—so I know from both sides of the fence just how valuable some knowledgeable, intelligent feedback can be.

This raises a very interesting philosophical question: Should you always go along with the recommendations and critiques of the "experts" reviewing your work? Let's face it, if van Gogh had listened to his critics, his marvelous paintings would never have been produced. Monet, too, was criticized mercilessly throughout the first several decades of his career. In response to my first major photography exhibit, a critic from the Los Angeles Times referred to my images as third-rate Ansel Adams attempts, and specifically pointed to my most popular image, *Basin Mountain, Approaching Storm,* as the quintessential example of the shallowness of my work. Six years later, in a critique of another exhibit of mine, the same critic wrote about the power of my work, and pointed to the very same image as an example of that power (figure 2–15).

The initial negative criticism hit me like a ton of bricks. I was devastated and I didn't even want to look at the photograph. However, it sold multiple times during the exhibit, forcing me to to print it over and over and over to fulfill the many orders. Somewhere along the way, while inspecting one of the prints in the darkroom, I suddenly came to grips with the issue, realizing that I really loved the image and I didn't give a damn what the guy said about it. I've continued to love it and show it ever since. I'll stop showing it only when I get tired of it.

The answer to the question of whether you should go along with what a reviewer recommends is "sometimes yes, sometimes no." You know what your goals are. A reviewer may or may not understand your goals or recognize your message as you want them to. It's up to you to determine whether that reviewer is pointing out salient defects in the work that you can strengthen, or if the reviewer is just plain wrong.

That's exactly what I tell students in the image review sessions at my workshops: we're giving you ideas and suggestions about the imagery ("we" being the other students and the instructors). You'll remember every one of them because you're on high alert when your work is being reviewed. I've never seen a student fall asleep while his work was being reviewed. So, now you have a set of ideas that you can evaluate when the real critique takes place, which is when you take your images back home and review them yourself. It is up to you to decide if one of your images needs to be altered in some way, is quite effective just as presented, or really belongs on the scrap heap. Since you know your goals, you'll decide which suggestions to discard, which to accept, and which to accept in part.

Of course, if you are going to convey emotion, you have to be in tune with your own emotions and those you want to express. It's generally useless to make a photograph with the hope that someday it will say something, but it's not impossible. I have found many years after creating an exposure that the photograph suddenly means something to me, something that I had overlooked over the years. Maybe I was ahead of myself when making the exposure, perhaps feeling something

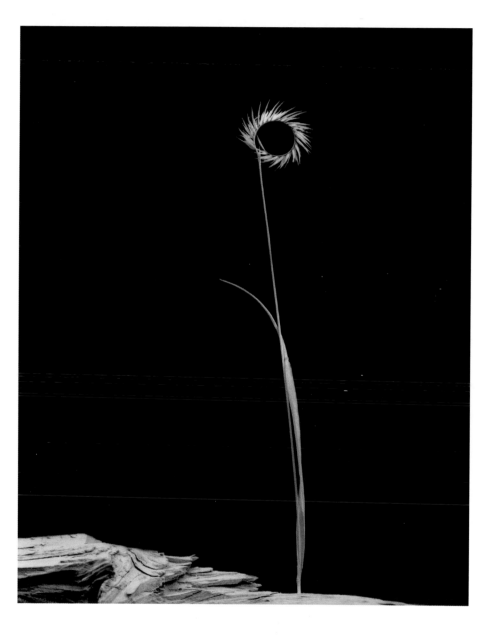

▶ *Figure 2–14: Grass and Juniper Wood*
The graceful delicacy of the strange Blue Gramma Grass with its full circle of seeds at the top captivated me. Usually the top forms a crescent, but the complete circle of this blade made it unusual and irresistible. I found it in Northern Arizona, and then found the piece of juniper wood with a narrow cleft in it a few steps away, providing a lovely stand for the blade of grass. I photographed it against a black background, which was my focusing cloth (the cloth large-format photographers use to cover their head and camera to block out ambient light so that they can see the image in the ground glass clearly).

Although I have printed the image successfully at 11×14 inches, I prefer printing it about it at about 6×8 inches to better preserve the delicacy of the grass.

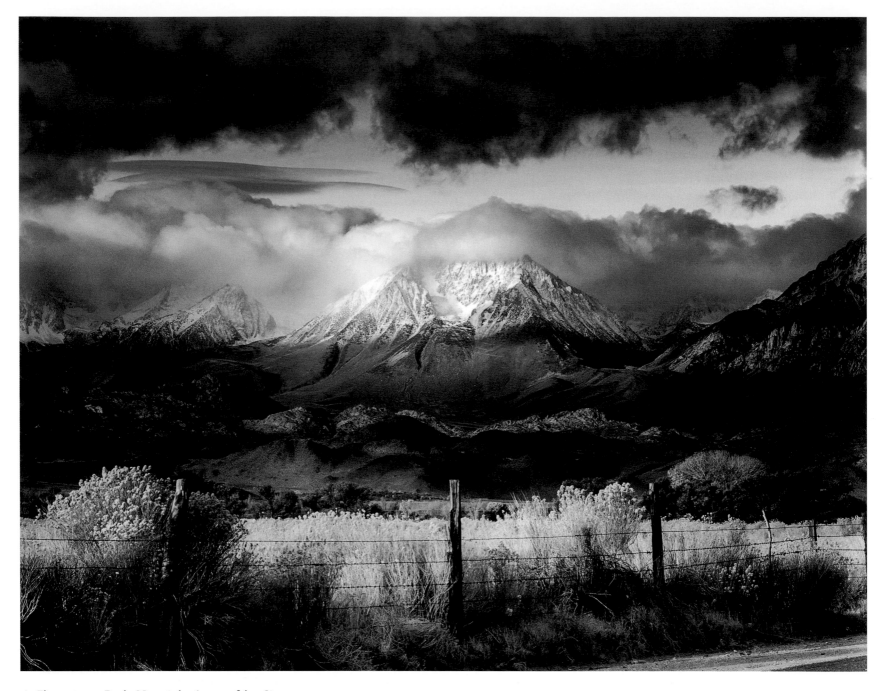

▲ *Figure 2–15: Basin Mountain, Approaching Storm*
Photographed in November 1973, as storm clouds gathered and built over the high peaks of the
eastern Sierra crest. The ranch and fence just north of Bishop, California, provided the perfect
foreground. A dramatic photograph, and a popular one—always my best-selling image—but
critically derided...until things changed and it was critically applauded. Throughout the criticism
and acclaim, I showed it, and I still do, because the image means a lot to me.

deep inside that I didn't know how to express, and now I've finally caught up with those feelings. So I never dismiss those possibilities. As a result, I've never thrown out a negative that seemed useless (except for a few that were physically damaged and impossible to print), knowing that someday in the future, all of it or a cropped portion of it may suddenly strike me as quite worthy of printing.

The Importance of Feedback in Shaping My Work and Yours

After I attended the Ansel Adams workshop, I was welcomed to contact Ansel at any time and schedule an appointment with him to review my work. I was so impressed that he offered this option to all students that I have always offered the same option to all of my workshop students. I visited him twice after the workshop. The second time I showed him not only a set of black-and-white mounted prints, but also a set of 35mm color slides. He reviewed both thoroughly and thoughtfully, and said to me, "If I were you, I'd stop shooting black-and-white."

I immediately knew that I had to stop shooting color. This may seem like an odd reaction since Ansel had just recommended exactly the opposite. My thinking went like this: He was telling me that my color work was stronger than my black-and-white work. But I knew that I wanted to produce really good black-and-white images. So, in order to learn to see black and white more clearly, I had to put color aside. I had to concentrate on learning to see in black and white.

Up until that time, I was often shooting scenes in both color and black and white. I was making no distinction. Furthermore, I was doing professional architectural photography for several prominent architectural firms in the Los Angeles area, and they always wanted both color and black-and-white images of everything. That reinforced my basic procedure of photographing virtually everything both ways. Ansel effec-

tively threw cold water in my face, saying that I was seeing color better than black and white. But my goal was to produce excellent black-and-white photographs. Hence, I had to remove the distraction of color from my shooting.

Ansel Adams made a recommendation; I feel that I took the appropriate action. I didn't get upset by his words. I didn't go into a depression. I acted. I heard what he said, and I did what I felt was needed to achieve my goals. I stopped shooting color for a year or so before starting again. Looking back, I think I did exactly the right thing. In the year or two following my decision, I greatly strengthened my ability to see in black and white. I created *Basin Mountain, Approaching Storm* six months after I stopped shooting color, and I believe my black-and-white seeing was already improving, and continued to improve beyond that.

I've never been upset with Ansel's recommendation. I have to admit that the other thought that went through my mind when he made his suggestion was, "I'll show you, you senile old bastard!" Yes, those exact words went through my mind. Of course, I always held him in the very highest esteem, and harbored no ill feelings whatsoever for his recommendation. It told me precisely what I needed to do, and I recognized that. In fact, I've always thanked Ansel for his words. Even then.

The thing that Ansel Adams didn't do during that review was ask me my photographic goals. I probably would have said that I wanted to make outstanding black-and-white photographs, on the level of his or the Westons'. Perhaps if he had known about my desire to succeed and excel in black-and-white photography, he may have made a somewhat different recommendation. But either way, I think the end result would have been the same for me. This is the reason that I ask each student in my workshops what their goals are, and what they're trying to say, before discussing their work. I don't just look at the photographs they've produced, but I put those photographs in context with their goals. Only then do I feel I can make the most constructive suggestions.

So it's important to get feedback about your work. You have to take the bad with the good, and combine this with your knowledge of your goals. Then you have to make sensible, adult decisions based on the comments you hear from others. Only you know your goals, so only you can take—or leave— the recommendations of others. If someone gives you a harsh assessment, don't get upset; instead, take appropriate action. It turns out that both van Gogh and Monet ignored their critics, stubbornly proceeding with their vision, and today the art world is far richer for their stubbornness.

I was probably fortunate in that I understood my goals at that time, even if I was unable to articulate them. Most likely I couldn't truly articulate them, or if I could, I probably would have been too hesitant or timid to say to the great Ansel Adams, "I want to produce black-and-white prints as good as—or better—than yours." Yet, deep down, that was my goal.

If you're struggling with finding your subject matter, you are probably far from articulating your goals. Latching onto your subject matter is obviously the most important first step. But if you have already found the subjects that really excite you, your next step is to try to articulate why those things turn you on.

Once you've reached that point, you can then go into the third step, which is how to improve on your imagery. How can you make your statement stronger? Can photography be part of a wider artistic vision that includes collages with other materials? Can it be meshed with other art forms—music, poetry, dance, etc.—as part of a wider creative effort? Can you create new and different forms of imagery that have never been seen before? And of course, can you get some sensible, constructive feedback that can help you achieve your desired goals, and perhaps even add some new wrinkles to your ideas that you hadn't thought of yourself?

I strongly recommend seeking opinions from others. The more competent the opinion-giver, the better. But you still have to fall back on your goals, once you understand them.

You have to get the feedback, but process it for your purposes. You can't just blindly follow the advice of the critic. I didn't when Ansel recommended that I quit taking black-and-white images. I reacted to his advice based on my goals. You have to be true to yourself and your goals.

Exercise Completed

Now, let's turn back to the exercise that I recommended at the beginning of this chapter, in which I had you list your favorite photographers. If you haven't written them down yet, along with a sentence or two about why each is on your list, please do so now before reading further. Okay, you now have your list written down. Save it. *Your list of favorite photographers and the reasons for your choices will likely point toward your own photographic interests.*

Why did you choose these photographers? Obviously you like their work, which usually means you also enjoy their chosen subject matter. You probably like how they deal with that subject matter from a technical point of view, whether it's the brilliant colors or the soft subdued colors; the high or low contrasts; the dark, mysterious tones or the light, optimistic tonalities; the heart-wrenching scenes or the scenes of ecstasy. Those photographers' images have special appeal to you for a reason, and I'll bet those reasons closely align with your own interests.

My two favorite photographers are Ansel Adams and Brett Weston. My reasons for both have already been laid out: Adams for the way he saw the landscape in such powerful terms, and Weston for his fantastic abstract images. Both are part of my own output. Beyond these two giants, there is a large group of photographers whose work I am attracted to for a variety of reasons, but none of them rank up there on the same level as Adams and Weston.

Adams's work drew me in and helped peak my interest in landscape photography, but I must admit I wasn't connecting the dots very well. I wasn't analyzing *why* his work struck me as being stronger than that of other photographers. I wasn't focussing on his use of light or weather conditions or anything else. I simply liked it. Only later, starting with his two-week workshop that I attended in 1970, and later that year when I quit my job and turned to photography professionally, did I begin to understand *why* his work struck me as being so wonderful.

With Brett Weston, it was quite different. I was already pushing at the door of abstraction when I saw a number of his photographs in his home. Brett's work opened that door wide for me. In essence, he made abstraction legal for me. So he's on my list with Ansel because I love the work of both photographers, and they both influenced my work in a very direct way.

Look at your list once more too see if the work of the photographers you've chosen provides the inspiration and ideas for your own.

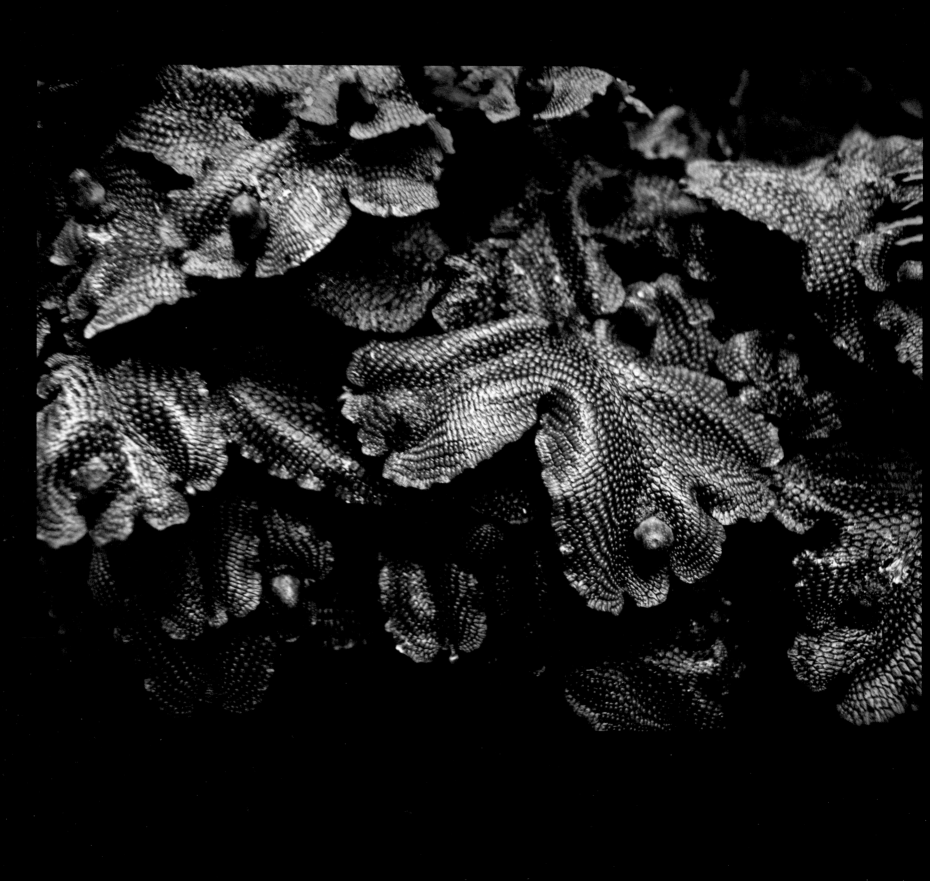

Chapter 3

Who Are You Trying to Please?

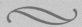

PHOTOGRAPHY HAS TO BE ENJOYABLE FOR YOU or there's no point in doing it. It has always been enjoyable for me, from when I first started up until today. I still consider it to be a hobby. I turned away from an educational background in mathematics and physics and turned to photography because I found that I loved doing it. But I also had to support myself; I was no longer an employee getting a regular paycheck. I was now self-employed, and although my passion was getting up into the mountains and photographing the wonders within them, I realized that nobody in the world needed a photograph made by me of rocks, or trees, or waterfalls, or big billowing clouds above massive granite cliffs, or anything else I really wanted to photograph. I needed a means of sustaining myself financially. I found the necessary path, and I feel that the story of how I did so, while still maintaining my personal interests, has wider lessons that can be of real value.

In this chapter I share several personal stories and observations that have shaped my photographic life. I present these stories because I've been a professional photographer since November 1970, and have earned my money exclusively from photography since then, yet I consider myself to be a pure hobbyist. Photography is so pleasurable and rewarding to me that if I had to turn to something else to stay afloat financially, I would still do my own photography for the pure joy of producing images that are meaningful to me, and maybe even to others. The latter is the true definition of an amateur, one who does something for the joy of doing it. Look it up in the dictionary to see for yourself.

◄ *Home Liverwort*
Plants growing in the forest behind my home.
I discovered them after living there for 22 years.

Personal Work versus Professional Work

From the time I was a young child growing up in Chicago, I was fascinated by the tall downtown skyscrapers. To me they were monumentally impressive and exciting. In those days, the late 1940s and early 1950s, they actually had some real design to them as they stair-stepped their way higher and higher into the sky. But that was how I saw the Chicago downtown skyscrapers when I was eight or nine years old.

Twenty years later, I was a young adult living in Los Angeles, and I had jumped from computer programming to photography. In need of income and looking for ways to make money photographing, I surmised that architects needed photographs of their buildings to show to potential clients, so I started photographing commercial buildings around the sprawling Los Angeles area. I put together an album of 11×14-inch black-and-white prints, and began telephoning architectural firms I found in the yellow pages to show them my work. Amazingly, every firm I contacted made an appointment to view my work. I didn't even get past the letter B in the yellow pages before several firms had hired me to photograph their buildings.

I was happy to have found work, but commercial architectural photography was not what I really wanted to do. It was simply a means of earning income to stay alive. Yet, critically, it involved subject matter that had been of interest to me since my early childhood, so it wasn't something that alienated me in any way. I still wanted to get out to the mountains and other natural areas to photograph my real passion. Architectural photography put bread on the table, but I never had any desire to make it my life's work.

The downside of the architectural work as my financial salvation was that it was sporadic. I couldn't count on any regular income from it, though when I did get jobs, the pay was good enough to keep me going for some time. In February 1972, I was experiencing one of those dry periods between architectural assignments, so I decided that I would pack up and drive to the east side of the Sierra Nevada early Friday morning, stay there over the weekend, and return home Monday night. With no jobs in sight, I thought it would be a perfect time to head out for some of my own photography.

By Thursday afternoon, I had everything packed up and ready to throw into the car the next morning so that I could leave at three thirty and get to the mountains by sunrise. It was then that I received a phone call from my best architectural client saying that he needed me early the next morning for a rush job. This plunged me into an unexpected conflict. I needed the job because I needed the money, but I was already prepared to go to the mountains, and now I was on the phone with my most important client. What was I to do? Whatever I chose to do, I had to make the decision immediately.

I think most people would have said that the job was necessary because the money was needed, which it was. I didn't. But I also knew that if I told the client I was going up to the mountains for my own photography, it would probably be the last time I ever did any work for them. So I cleverly said I was in the midst of a rush job for another firm, and would be completely tied up through Monday. I would be available to

▶ **Figure 3–1: Mt. Williamson, Sunrise**
This photograph was made on my extended weekend trip to the Sierra Nevada in 1972, when I chose to travel to the mountains rather than accept a commercial rush job. Having been on the east side of the Sierra many times before, I was beginning to worry that I would never encounter weather conditions that would put clouds below the great summits. But the first morning I was there, the mountains and clouds cooperated. There was Mt. Williamson, the second highest summit in the Sierra at 14,375 feet, jutting up above the clouds. It was magical. Yet my desire was not to bring out the great height of the summit, but to show the interplay between the granite slabs leading to the summit and the clouds draped over them like soft necklaces.

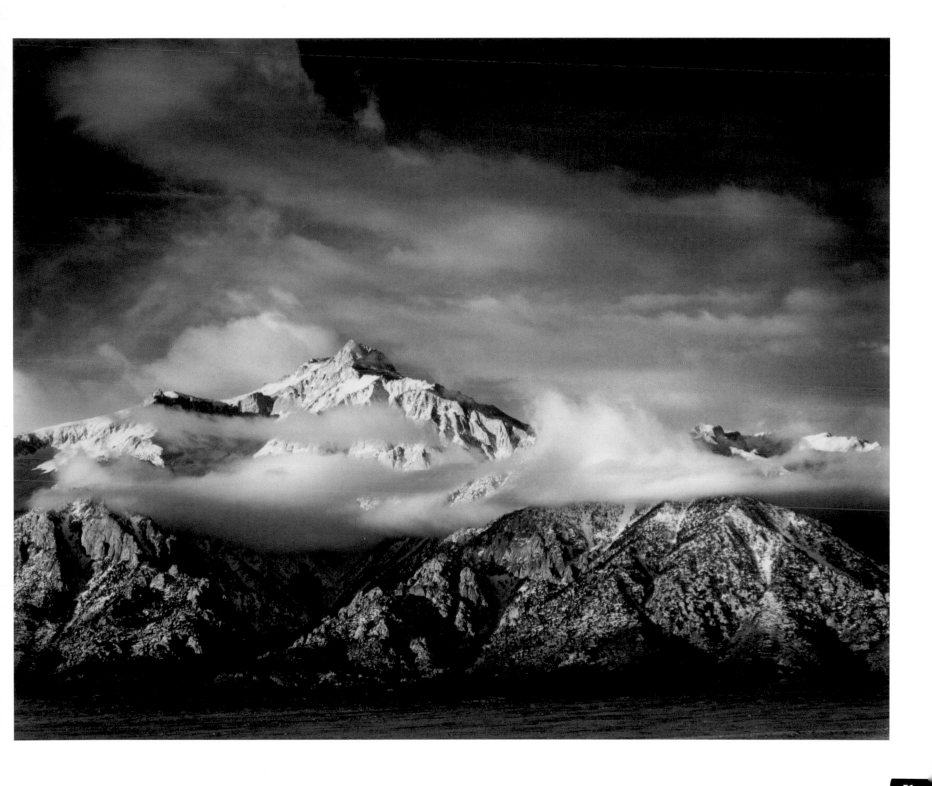

do the job on Tuesday if they could wait that long, but I was unavailable until then. My thought was that by blatantly lying like that, without really hurting anyone in the process, I could probably retain the client, although I knew that I was losing a needed job. I also thought that the lie may make me sound a whole lot more important than I really was.

So right there on the spot, I decided that my personal work was more important to me than the client-oriented professional work. My hobby won out over my profession (figure 3–1). I made that quick decision knowing that I needed the money and recognizing the potential of losing the client by turning him aside. To my surprise, the client phoned again early Tuesday morning, told me where to meet him for the job, and I did it that day. So in the long run, I not only retained the client, but I also did the job. In fact, if I recall correctly, I charged extra money because it was a rush job.

The moment I made the decision that my personal work, my hobby, was more important to me than my professional work was a pivotal moment in my photographic career. Throughout the 14 or 15 years that I did commercial architectural photography, I always did my own work, and it was always the most important aspect of my photography. In doing so I was able to pursue my own personal vision even while I had to satisfy clients (i.e., see a subject the way *they* wanted it to be seen). This gave me a personal vision throughout my career. I always found time—or *made* time—to get up into the mountains, into the forests, out to the seashore, or to any of the natural areas that so strongly lured me toward them.

Along the way I learned that the only critique of commercial architectural photography was whether or not the client was willing to pay for the work. Generally, I was told to photograph a building at a specific location, and was sometimes asked to take a photograph from a specific viewpoint, but beyond that I could produce any images that I felt would best showcase the the building's exterior or interior. In other words, I was given tremendous artistic leeway in terms of how to photograph the

subject. For that I was always grateful. I never had anyone from the firm standing over me and telling me how to photograph the building or where to place my camera. I always got paid, so I assume the photographs satisfied the client.

I also learned a lot of valuable photographic lessons along the way. For example, one client designed a series of massive shopping malls when malls were first becoming popular, and I photographed a number of them around the country. Within the malls, I learned that if I made a long exposure looking down a corridor and a shopper was walking down the corridor within my picture frame, she would generally show up as a bothersome dark blur. But if I aimed across the corridor, toward one or more storefronts, and a shopper walked through the image, she disappeared entirely. The reason quickly became obvious: The shopper walking down the corridor was in the same line of sight throughout much of the exposure, therefore showing up as a blur. But in an equally long exposure made looking across the corridor, the shopper was only in any one spot for a mere fraction of a second, so her brief presence in any single location made no impression on the total exposure.

When I began photographing the cathedrals of England I was able to directly apply this lesson. If I were photographing down the nave aisle and someone started walking down the

▶ *Figure 3–2: Nave from North Choir Aisle, Ely Cathedral*
Photographed on a Sunday afternoon following services. Dozens of parishioners plus tourists were wandering through the cathedral. A minimum of 15 people walked through the gate during the 12-minute exposure, yet none of them appeared in the photograph.

With permission of the cathedral vergers, I removed an enormous table strewn with cans of paint from the right side of the gate, along with many additional dried flowers from the left side. I placed the old chairs from the side of the aisle behind me before exposing the negative. Afterward, at the request of the vergers, I replaced it all as it had been before I set up for the photograph.

▲ *Figure 3–3: Choir and Apse, Canterbury Cathedral*
Photographed on the day of the Queen of England's birthday celebration. The cathedral was filled with over 1,000 people awaiting a concert by the London Philharmonic Orchestra, which was tuning up at the head of the nave, directly behind me. Dozens of people walked through the image during the 11-minute exposure, which I cut back by a minute because one person stopped to view the beautifully illuminated bible set on the bronze lectern. In the image, it appears as though the cathedral was empty. The 11-minute exposure proved adequate, as I had guessed at the time. I did not stay for the concert.

aisle, the image could be ruined by the blur of the person. If I were photographing across an aisle, a person walking by would never be seen. I also realized that I could overcome the problem of the person walking down the aisle by simply covering the lens with my dark slide during that period of time, and then continuing the exposure after the person left the line of sight, simply adding more time at the end of the exposure to compensate for the time I was shielding the lens (figures 3–2 and 3–3).

So the architectural photography not only kept me alive financially, but it also taught me some valuable photographic lessons that I applied to my own work. It was doubly beneficial. If you are involved in commercial photography, always keep an eye on the lessons you learn doing client-oriented work and how you can apply them to your personal work. Make your commercial work part of the learning experience for exploring and defining your own vision. Some of the great fashion photographers—Irving Penn, Helmut Newton, and Richard Avedon, among others—did exactly that, and you should, too.

Pleasing Yourself versus Pleasing Others

There is a radically different thought process that goes into doing work that is truly pleasing to yourself versus doing work that is meant to please others. I came to this conclusion early in my career of presenting photography workshops. Much to my surprise, some of the students at our workshops were professional photographers who had owned a studio for 10, 15, or 20 years, maybe more. I was basically a beginner and these were long-time professionals, so why were they attending one of my workshops?

That question was tantalizing enough, but what really blew my mind was that when these professionals showed their personal work during the print review sessions, they had the worst images among all the students. Always! I was utterly

baffled, and increasingly curious. I wanted to figure out this anomaly.

This all came to a head in 1980 when I taught a workshop to a selected group of professional Norwegian photographers. Among them was a photographer who had previously done some utterly abstract light-on-paper designs that he made without a camera. The images totally captivated me. It was outstandingly creative work, quite different from anything I had ever seen. I was excited to meet him and see his most recent work.

In speaking with him, I found out that he had done this remarkably innovative work decades earlier while in college. After graduation he moved to a small town in the north of Norway and became the town's professional photographer. He photographed newborns, weddings, graduating schoolchildren, sports events, and all the other things you'd expect in a small town (who knows? ... maybe even divorces). He engaged in such work exclusively for over 30 years, never having time to pursue his own interests, or so he said. When he put up his personal work for review at the workshop, it was by far the worst of the entire group—utterly bland and devoid of any innovation, creativity, life, or interest. It shocked and disappointed me deeply. But it made me even more determined to unlock the mystery of professionals turning out poor personal work.

It took a good deal of serious thought, but his example was the key to helping me solve the mystery. Although I can offer no proof whatsoever for my conclusion, I know it's correct. After many years of doing nothing but client-oriented work, each of the professionals finally said, "I got fed up with this work and decided to start doing my own work." I heard almost those exact words from so many of them, including the Norwegian photographer, that I could have provided the script. I became convinced that after so many years of doing nothing but client-based photography, they invented the client for their personal work, and the invented client was the

potential buyer. Before making any photograph—allegedly for themselves—they would ask themselves, "who will buy this?"

Once I surmised that this was their thinking process, I took a number of professional students aside in subsequent workshops to discuss their approach to personal photography. Those private discussions confirmed my conjecture. They would invariably tell me, "of course I try to think about whether or not anyone would be interested in the image." This thought was their downfall. It was the "of course" part of their answer that told me that it was central to their thinking. They were still trying to please others, the potential buyer, not themselves. But as I've learned, it's impossible to know who will buy or even be interested in any given photograph.

I was fortunate. I pursued my personal photography throughout the 14 or 15 years that I did commercial architectural photography. I knew how to please myself. I knew how to please a client. I knew that the two entailed remarkably different thought processes. And it slowly became apparent to me that my decision in February of 1972 to drive to the Sierra instead of driving to a rush job the next morning was a pivotal decision for any future success I may have had.

But my circumstances were favorable. I was unmarried at the time and I had no children. Those with such obligations face very different choices. Life is not the same for everyone. I was particularly lucky with my situation, in which I only had to answer to myself. Yet it's also apparent to me that some people are reticent to make even the slightest change in their life habits to pursue a different course that they claim they want to pursue. They're simply too afraid to make any changes, afraid to make bold decisions, afraid to do anything. They're stuck.

Or so they think. They need to get out of the rut they've dug for themselves, and get into a groove. In my case, perhaps I could have chosen to do the rush job and then head up to the mountains a few days later. Perhaps I would have lived the same life experience. I can't say with any certainty. But I made a bold decision, and it ended up serving me well.

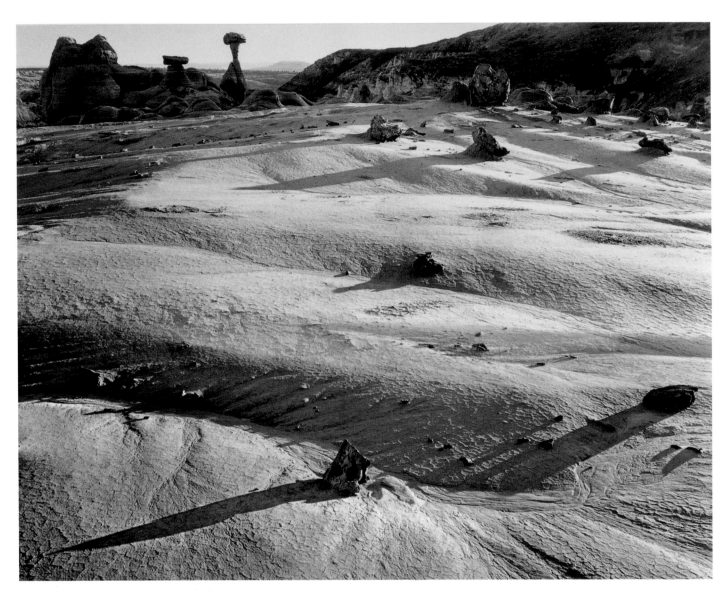

▲ *Figure 3–4: Behind the Paria Cliffs*

On the north side of Highway 89, between Page, Arizona, and Kanab, Utah, where the Paria River crosses the road, stands a set of striped, steeply eroded hills. A long walk around those clifflike structures brings you to an entirely different landscape, more like a moonscape of bare, grayish-white bentonite devoid of foliage, with standing rocks and hoodoos scattered about. In the low, late-afternoon light I exposed several negatives, each with long shadows from the rocks cast atop the rolling land, and with hoodoos at the skyline in the background. I failed to notice that in the one with the most interesting landforms and shadows in the foreground, distant power lines marred the sky beyond the standing rocks. To solve this problem, I meshed the top of one negative that had no power lines in it with the bottom of the negative that featured the most interesting foreground, creating an "ideal" landscape.

My advice to virtually any photographer, new or seasoned, who wishes to express himself, is to first follow your desires, even if it forces a seemingly difficult alteration in your life. And second, jettison any idea that you can predict what will please other people and what will not, or what will sell and what will not. Instead, you have to please yourself.

Yes, perhaps you can determine what will sell and what will not sell in regard to the home décor image that sits above the living room couch because it fits in with the color scheme of the room. You may be able to sell dozens or hundreds of those types of images, pulling in vast sums of money. You may even be able to predict that in advance. But that's décor; it's not expressive photography. It's not art. It's not the way to express yourself and how you feel about the world that means something to you. It's far from any of the central issues of this book.

If you want to produce photographic art, you have to please yourself. You have to go with your vision, even if it rubs some people the wrong way. Monet, van Gogh, and other recognized artists each had their own vision, and they followed it. I learned that lesson myself when I recognized that I could present abstract images as puzzles, rather than irritants. Once I had walked through that door, I was able to present other innovative imagery that was sometimes greeted with skepticism and even anger. For example, figure 3–4, *Behind the Paria Cliffs,* was made from two negatives. When I first presented two-negative, "ideal landscape" imagery at a workshop in 1993, a near-riot broke out. But it was my work, and I believed in it. It became part of my passion. I presented it with pleasure, and I was both fascinated and amused by the reaction it received.

Professional Necessities versus Personal Expression

The difference between a professional photographer and a true hobbyist is that the professional gets paid for what he does, while the hobbyist does it for himself. In client-based photography—whether you're doing studio portraits; architectural studies; photojournalism; sports, fashion, or food photography; or any other type of photography you are paid to do—your prime goal is to please your client. However, everything I have said in the previous chapters about finding your area of interest still applies fully to commercial photography because you must be drawn to your subject matter in order to produce good photographs. A good fashion photographer, for example, must be interested in fashion, and probably wouldn't do nearly as well in architectural, food, or sports photography.

But if you're doing commissioned work in any of these fields it doesn't preclude the possibility that the work produced is of such high quality, and is so creative in conception, that it qualifies as truly artistic work. It's possible to please the client, yourself, the critics, and the public. There are innumerable examples of commissioned work in all of the arts—painting, music, sculpture, writing, photography, you name it—that vividly prove commissioned work can achieve the highest artistic caliber. Surely the great commissioned portraits by Rembrandt, Gainsborough, and so many other painters show this. The same is true for the great journalistic war photographs by Capa, Duncan, and others. But to achieve a high artistic caliber, the work must go well beyond pleasing the client alone. Unfortunately, it seems to me that much of today's client-based photography fails to do this. It is largely pragmatic; it's simply intended to suit a client's needs. So my comments about client-based work are directed toward this level of commercial work, not the higher level that still exists today.

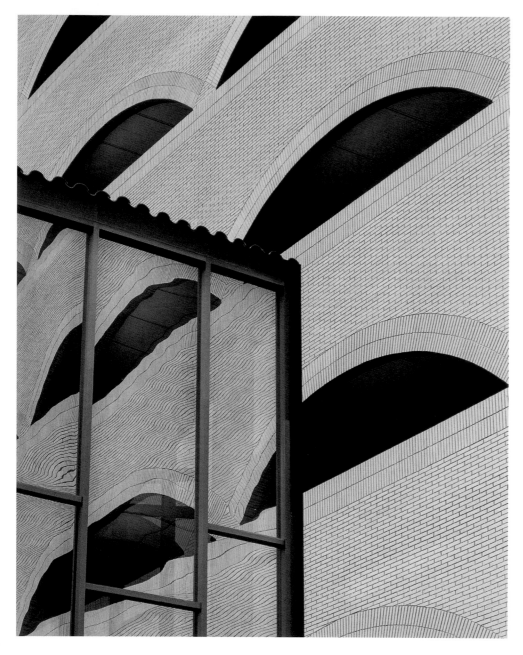

▲ *Figure 3–5: Riverside City Hall*
I found this to be an unremarkable building, but I was fascinated by the rippled reflection on the glass of the public auditorium, which continued the flow of the building's design while altering it. I exposed the negative purely for myself, assuming that the architect would not want to show the "imperfect" glass that I felt provided the interest for the image. My assumption was correct; the architect had no use for the image.

As a hobbyist, you have only yourself to please. Most artists are true hobbyists; they're out to please themselves, and perhaps their peers as well. The great impressionist painter Claude Monet was surely in that category. He struggled against rampant, withering criticism and financial difficulties for decades before he quite suddenly became an icon. Critics began fawning over everything he did and he was able to sell his paintings for extremely high prices to art collectors worldwide, especially those in the United States. Somehow he got by with little, if any, commercial work, a difficult task even in his time.

Because I was doing personal work at the same time I was doing commercial work, I began to recognize the real difference between the two. While on an architectural assignment, I could identify compositions and angles that would be particularly pleasing to the client. Once in a while I would come across a view that I found especially interesting, and I would make the odd image just for myself, not to be shown to the client. I did those while *on the job,* but not *for the job.*

In 1977, I decided to see if my instinct about those personal images was correct. I had been asked to photograph the new Riverside City Hall, about 60 miles east of Los Angeles. It was a six-story rectangular building with rounded corners and a large glass-sided public auditorium that jutted out from one side of the structure. As I worked my way around the structure, photographing it from various angles, I came to a location where the main portion of the structure was reflected in the auditorium's windows. But the window reflections were wavy, making them more visually interesting to me than a perfect reflection would have been. I quickly decided to make a single black-and-white photograph of the main building with its reflection in the wavy glass in the lower left corner of the image (figure 3–5). I felt that the architect wouldn't want that image because it would show a defect in the glass, so I didn't make a color exposure (recall that architects always wanted both color and black-and-white images of everything).

I brought all of my photographs to the client, who was delighted with the set and happily paid me. A couple of months later I phoned him to say that I had made one additional photograph in black and white, but that the lab had destroyed the color image in processing—a lie, to be sure, but once again, not harming anyone. I asked if he'd like to see the black-and-white image anyway. He wanted to see it, so I drove down to his office and showed him an 11×14-inch print of it. Just as I suspected, he was horrified. It showed a terrible defect in the glass. He could never use the photograph.

I was right. I knew what was for me. I knew what was for him. And I most certainly knew what was *not* for him. He didn't even want to look at the photograph. But I liked the image enough to include it in the "Urban Geometrics" section of my first published book, *Visual Symphony*. If you're involved in commercial work, you'll find that there are always opportunities to employ your own vision, perhaps making exposures on the job that you'll never show the client, knowing they are made strictly for you. Even in your portrait studio, you may be able to make the revealing photograph of the sitter that suits your view of him or her, but not the one the client wants to convey. You may not show it for 5 or 10 or 15 years, but you have it for future use.

Personal Satisfaction versus Photographic Sales

Now let's look at another, very different situation in which I learned a lesson about the difference between personal satisfaction and sales. In late 1978 I was photographing on the Kelso Dunes in the Southern California desert, the second highest sand dunes in the United States. Near the top of the highest dune ridge I came across a set of hollows and sand patterns that was striking. When composing the image on the ground glass of my 4×5 view camera, the image looked upright. For those who are not familiar with this type of camera, the image on the ground glass is turned 180°, making the scene appear upside down as you compose your image, like the image on the retina of your eye. The image is not supposed to look upright in the 4×5 ground glass. The fact that the image of the sand patterns did was astounding to me. So, with great excitement, I made the photograph.

I debated for weeks about whether I should mount the image right-side up or upside down. I finally made my decision, and with overwhelming excitement, I took the print to the Stephen White Gallery, which represented my work in Los Angeles. They were so excited that they immediately wanted the one I showed them and asked for about seven more prints to distribute to all of the galleries that represented my work throughout the country. (At that time, all of the galleries that represented my work regionally throughout the United States did so through the Stephen White Gallery, which served as my agent.) I was doubly excited now, for this was going to be a "big bucks" photograph (figure 3-6).

I made the additional prints, got them all into the gallery, and they were distributed to other galleries around the country. Starting about two years later, the prints were gradually returned. The image never sold. Not to this day. But I liked it so much that I put it, too, in my first book, *Visual Symphony,* in the opening section on landscape photography.

This experience turned out to be a great lesson for me. I recognize that I have no clue whether or not an image of mine is going to sell. But the Kelso Dunes episode told me that even the professional sellers—the gallery owner and his staff—had no better insight than I had. I've seen books in which the authors coach photographers on how to make a photograph that sells well, but I seriously doubt that any such formula-images really make the grade. I find that it's best to make a photograph when I'm excited, when something really strikes me as worthy of photographing, when something rings my chimes. I never even think of whether a photograph has

► *Figure 3–6:*
Kelso Dunes
This is the orientation in which I present the image as a 16×20-inch mounted print. Now rotate the book 180 degrees. Which way is correct? It's almost impossible to tell, which is one of the qualities of the photograph that I particularly like.

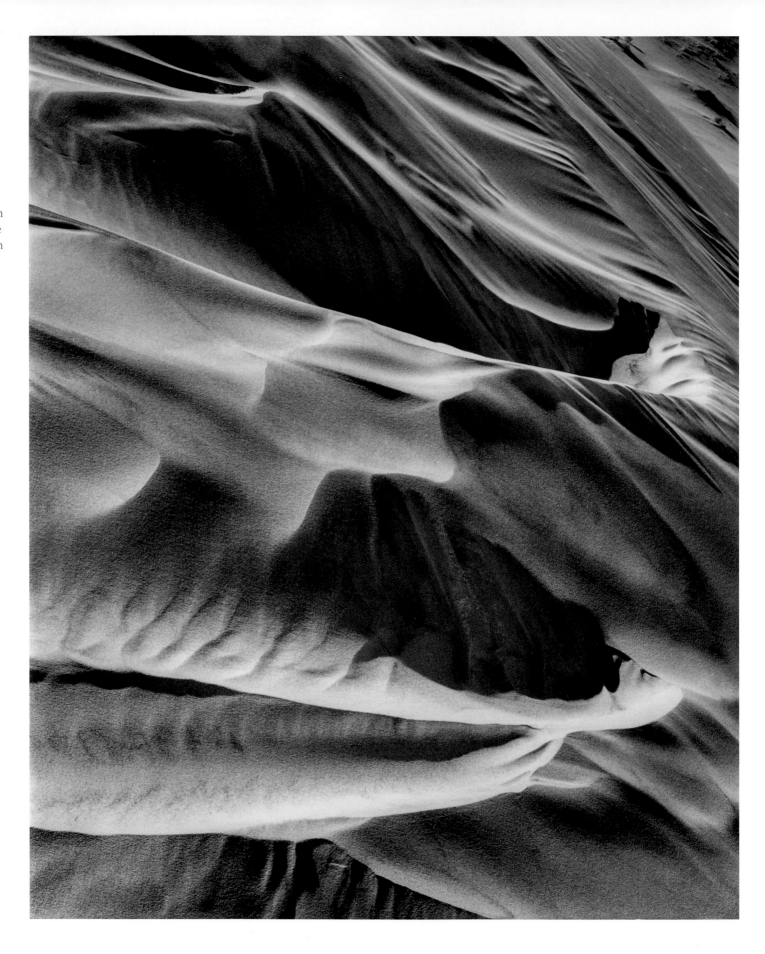

any sales potential because I've learned that neither I nor the professionals have any real insight into sales potential. Some will, some won't.

So I work to please myself, which is how I started photography, and also how I've continued when doing my own work. I now know with certainty that I have no insight into what pleases someone else, so that is never part of my thinking when I expose a negative or a digital image. This is a central theme in all of my teaching: please yourself first.

The Impediments to New and Different Work

While friends and the public have accepted my abstract imagery, I find that there remains a reluctance to easily accept any new concept. The introduction of two-negative images was dramatic proof of that, even though they were accepted in time. But let's speculate a bit. If, for example, I created a new set of images that were largely out of focus and infused with heavy grain, there would likely be a negative reaction. Perhaps I could say there would *certainly* be a negative reaction. But if those same photographs were inserted into the portfolio of another photographer whose work is largely comprised of images that are out of focus and infused with heavy grain, they would be expected and accepted. This, too, is a near certainty.

What this tells us is that people tend to categorize artists. Viewers look for certain characteristics from a specific artist. When presented with expected work, they are inclined to react positively. When presented with unexpected imagery, they are thrown off balance, and their initial reaction is almost always negative. This is in keeping with the fact that we tend to categorize everyone, artist or otherwise, and are generally offended if a person varies significantly from their expected behavior. This proves to be an inhibitory, restraining reality for any artist. We're all affected by our audience's reaction, and it's difficult to hear negative responses and press on without being deflected or distracted in some way.

Some people can continue to move forward even when met with negative reactions. I did when I finally accepted my own desire to produce abstract work, and the audience followed. It happened again with my two-negative imagery. If I suddenly decide to produce out of focus work with heavy grain (not my real desire, so this is purely speculative) I would expect it to surprise and shock the viewers, and I'm sure there would be a negative reaction. But if I truly believed in it, I would have to steel myself and press forward until the time when, hopefully, the audience catches up.

When showing my imagery in exhibits, workshops, or privately, I periodically hear the remark, "Oh, I wouldn't have expected that from you." Sometimes this refers to an individual image, and sometimes to an entire group of images. Long ago, that would have bothered me, but today it excites me. So I often ask, "Why not?" The answers I've gotten have confirmed my observation that I had been categorized by the viewers, and the image failed to land within the expected limits. To me, that's good. It means that I am exploring the unexpected, at least for those viewers, and it tends to encourage me to continue that pursuit.

I don't produce new and different things just to produce new and different things. I produce work that pleases me first. It often worries me that my own limits may be too narrow, that I am inadvertently restricting myself and my creative options to those things that have proven successful in the past. That's a real danger. I may be thinking I'm in a groove when I'm really in a rut, and that's always a possibility.

If you want to be creative, you have to expect external impediments from your viewers as well as self-created, internal impediments, and you have to be prepared to overcome them. You have to believe in yourself. You have to start by producing the type of imagery that is meaningful to you, with the realization that while someone out there may respond

positively, there is a possibility that very few will respond as you would like. But if the imagery resonates with you, keep plugging away at it. In time, others may begin to appreciate your different approach, subject matter, methods, materials, or presentation.

Too often, artists, viewers, or critics equate only new processes with creativity, while ignoring a new or deeper insight into well-known subjects using well-known (some may say "well-worn") methods. They tend to sneer, saying, "It's been done before." But maybe it hasn't; maybe you're digging deeper; maybe you're uncovering new truths. Portraits have been done forever, not only in photography, but also in the older visual arts for millennia, yet they're still being done and accepted. American painter and teacher Robert Henri said, "A tree growing out of the ground is as wonderful as it ever was. It does not have to adopt new and startling methods." Likewise, you don't have to adopt new and startling methods to produce creative work. But you do have to see deeper or more clearly than anyone before you. Robert Henri also said, "We are not here to do what has already been done." The two statements are not mutually exclusive. Using new or newly minted arcane processes may yield some new insights, but ultimately it's the depth of seeing that is the heart of creativity.

Breaking Barriers

Let me expand on the thoughts expressed in the last few paragraphs, for they involve the idea expressed in the book's introduction about using photography as a visual research laboratory. In chapter 14 of *The Art of Photography,* I detail how I made my initial ideal landscape of *Moonrise Over Cliffs and Dunes* from two separate negatives exposed 15 years apart, at locations 300 miles from one another (figure 3–7). While I was quite pleased with the result, I could have let it go at that, satisfied that I had created a pleasing image from two

separate images that each fell short of success on their own merits. But instead, I immediately began to search for more possible combinations, with the thought that I had numerous images that were not entirely satisfying to me, but perhaps if I combined them with an appropriate second negative, I could produce something *that I would have photographed if I had encountered it.* Hence, the term "ideal landscapes."

That last thought in italics was the key. It would have been impossible, or highly improbable, to encounter a scene that looked liked any of the images I created. But I realized that I could create a whole new world completely from my imagination by combining negatives—perhaps a foreground from one location with a compatible background from another, or by placing a more interesting segment of one negative into the upper right quadrant of another negative—as long as they seemed to form a believable image.

The great surrealist photographer Jerry Uelsmann has long been creating images made of multiple negatives, sometimes using up to six or seven negatives in combination, and his work has been praised or damned by many. I think it's terrific imagery—dreamlike, evocative, and even humorous in the extreme. But interestingly, his imagery didn't influence my own in any way. I was simply trying to bail myself out of a dilemma: I had a negative that seemed only halfway successful (the upper part of *Moonrise Over Cliffs and Dunes*), with a lower half that was clearly uninteresting to me. I was aware

▶ *Figure 3–7: Moonrise Over Cliffs and Dunes*
I created this landscape photograph from two separate negatives, and I labeled it an "ideal landscape." This was the first such combination print I made, and its success lead to a search for many more. Each is a fantasy created in my mind and the darkroom, but surely a scene I would photograph if I came across such a landscape. We create fiction and fantasies in every other art form; why not do it via photography as well?

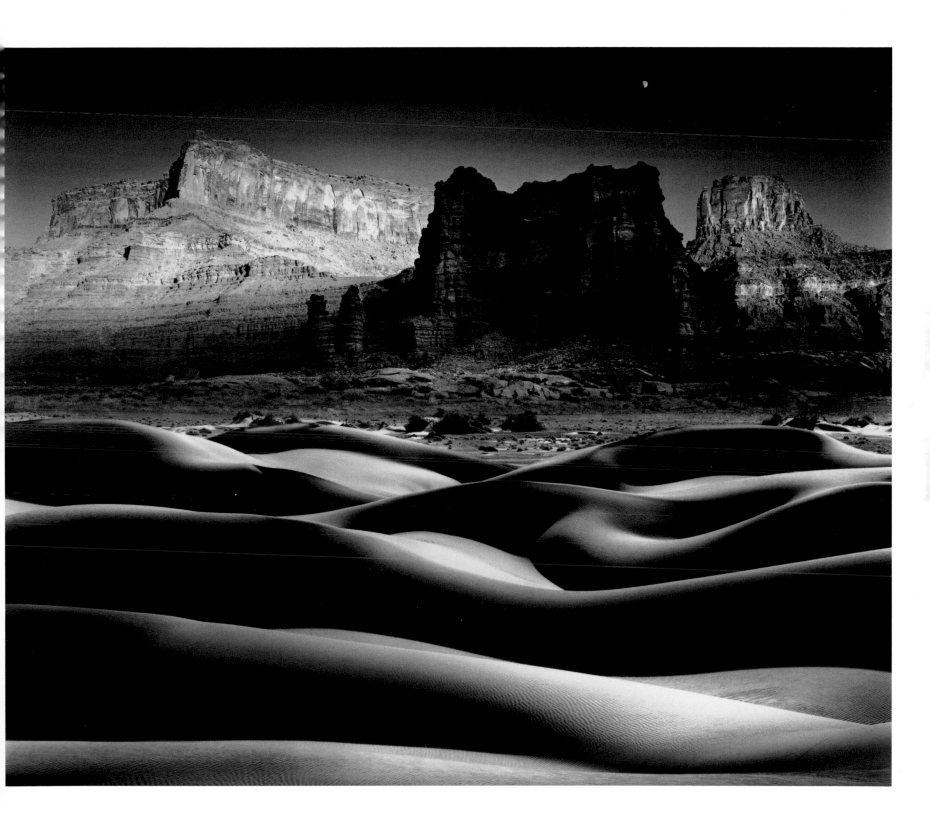

of that failing—or partial failing—from the instant I set up the camera for the exposure. It was the next morning, driving away from our makeshift campsite beside the Lockhart Basin Road in Utah, that I conceived of the idea of combining it with the sand dune image from Death Valley. There was no influence from Uelsmann's marvelous imagery involved.

Once I had succeeded in making that initial two-negative print, I jumped on the idea. I started actively looking for combinations of two negatives—invariably negatives that fell short of being fully satisfying to me on their own—that could form a single compelling image. Although I feel that the abstracts I made in the slit canyons 10 years earlier pushed my limits of seeing, I feel that exploring the possibilities of creating imagery from two negatives (or three, in a few instances) truly fell into the category of using the darkroom as a visual research laboratory. Of course, it started before stepping into the darkroom, because I had to identify the negative combinations that could yield a believable landscape.

The idea of the believable landscape turned out to be the primary reason for the near-riot that occurred when I first displayed a group of these images during a workshop. Uelsmann's imagery was freely accepted by those who enjoyed it as flights of fancy, highly creative fantasies that were thought-provoking and entertaining. But some saw my imagery as basically dishonest, an attempt to pull the wool over people's eyes by making a fabrication seem real. Others fumed at the idea that an environmentalist like me, whose images should be evidentiary in the sense that I should be able to say exactly where I placed my tripod and show exactly what was in front of the camera, could even think of producing such a pack of lies.

I could have been quite disheartened by the reaction of some; instead, I was unperturbed by the flap. In most ways I was quite amused. Eventually the practice of combining negatives expanded into other realms besides landscapes, opening up yet another set of possibilities for me (figure 3–8). My basic contention from the very start of the two-negative imagery was that I was producing artwork, not environmental work, and it did not have to conform to any restrictions. Furthermore, as artwork, I had all the leeway I wanted. Who says that a landscape painting has to be precisely true to the landscape spread out beyond the artist's easel? Nobody would ever demand that, so why would anyone demand that in a work of photographic art? But some people were angrily demanding that.

One of the more amusing fallouts, and in some ways disheartening effects, of that evening was that when I showed other imagery later in the workshop, several students asked of virtually every image, "Is that real?" Obviously I had created a deep credibility gap.

As it turned out, even those who were most stridently opposed to what I was doing when I first exhibited those images changed their minds over time. After thinking about it, they came to accept the idea.

I have to admit that there are some limits to this idea. In my collection of photographs by other photographers, I have an image of the White Rim Trail in the northern portion of Canyonlands National Park, Utah. It is a magnificent landscape, but what lifts it above just being a wonderful landscape is the presence of a lightning bolt in the distance that coincided with the exposure. It is a transcendent moment, putting an exclamation point on a dramatic scene photographed during a thunderstorm. But I wouldn't view that image the same way if I knew that the lightning bolt was added afterwards from a separate exposure. Yes, the image would be the same, but I wouldn't be satisfied with a falsely created moment.

So the question of whether combining multiple negatives to form one complete image is acceptable or unacceptable as art remains open, as it should. Certainly the question of what is art will never be answered conclusively to everyone's satisfaction. There's always some disagreement, always room for individual limitations.

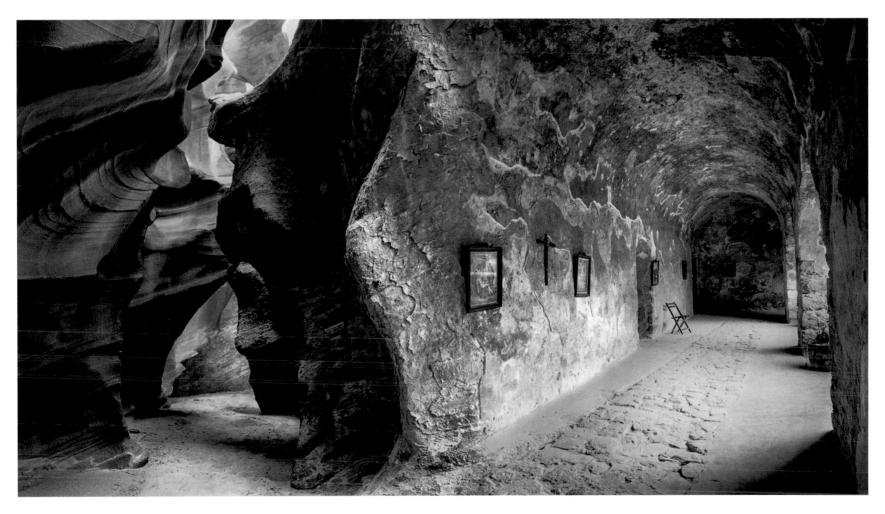

▲ *Figure 3–8: Corridors*

This is another two-negative image, clearly not a landscape. After creating a number of ideal landscapes, the thought occurred to me that I could expand the concept to include any combination of scenes, including manmade structures. I was fascinated by the unexpected combination of a manmade structure and a natural one working so well together. This image is also based on Yogi Berra's comment when giving directions to his home, "When you come to the fork in the road, take it." If I were faced with this fork in the road in real life, I know which way I'd go.

The important issue here—beyond your own definitions of art—is how far you wish to explore visual opportunities. There are an infinite number of ways in which you can create photographic images, sometimes just using a scanner to start the process and taking it from there, no camera required.

Man Ray was one of the great creative innovators in the history of photography. He seemed to have a cascade of ideas pouring out of his very being on a daily basis. I have seen several exhibits of his work, and the creativity is fantastic, so I recommend looking him up or going to see an exhibit of his wonderfully innovative work. But I also must say that I think he produced some of the most innovative ugly work ever created. It is unfortunate that a man so filled with fantastic ideas was so lacking in aesthetic sensibilities. But his work is still worth seeing for the creative ideas within.

Frederick Sommer, a highly acclaimed photographer (mostly by his fellow photographers) who never achieved a great deal of public fame, made a series of black-and-white prints derived from "negatives" that were merely smoke accumulated on sheets of glass with vaseline smeared on the glass to capture the smoke particles. These smoke-on-glass negatives produced some of the most elegant silvery images that I have ever seen. I was lucky enough to ask him about the stunning imagery at an exhibit he had in the 1980s at Long Beach State University in California, and he wryly commented, "soot beats silver any day!"

Just think of the pure creativity behind imagery like that. Sommer used no camera, had no scanner, and used non-photographic tools (glass, vaseline, and smoke) to create the negatives. He had an idea, and he pursued it. If he had suggested this idea to others prior to doing it, it's almost a certainty that everyone would have labeled it a crazy idea. I can just picture them saying, "You're nuts...get on with life!" Whether he had such conversations or not, he went with the idea. Most likely he had no such conversations since he was somewhat reclusive. Only after producing these strange negatives did he turn to more traditional photographic methods—the enlarger and enlarging paper, and the development of the print in photographic chemicals—to complete the process.

It's the imagination and creativity that counts. How imaginative *can* you be? How imaginative will you *allow* yourself to be? And how imaginative will you *continue* to be in the face of skepticism or objections by others?

Photographs versus Fine Art Photographs

Throughout my photographic career, I have been asked, "what is the difference between a fine art photograph and a regular photograph?" This question was asked explicitly at the last workshop I taught before completing the text for this book. It's an excellent question, one that deserves thought and discussion.

My first answer is, "A lot of it is just pretentious bullshit." It is pretentious on the part of artists themselves, and the gallery owners, museum curators, and university professors who have a vested interest in saying that their work, the work they show, or the work they judge can be put in one category or another. Let's face it, if work is shown in a gallery or approved for a thesis, it must be fine art, right? Unstated, of course, is the assumption that work that is not represented in the gallery or shown at the museum or approved for a thesis is not of that caliber, and therefore is just a plain old photograph.

However, to dismiss the question with such a flippant answer would debase the question itself, and would fail to go deeper. So let's go deeper. As I discussed briefly in chapter 2, if you make a photograph at a family gathering, club party, or on your two-week vacation, and you look at it 20 or 30 years later, it may bring back deep feelings of warmth and remembrance. But if you show that photograph to almost anyone who is not part of the family or club, or who wasn't on that vacation with you, it means nothing. It's a group of people smiling or

clowning around for the camera, or some building or mountain or animal that attracted you along the way, but it elicits nothing in the viewer. Such photographs comprise the vast majority of all photographs made.

On the other hand, you can show people a photograph by Paul Strand, Sebastião Salgado, Nick Brandt, or Brett Weston and they can be deeply touched, even though they weren't there when the photograph was made, and they had nothing to do with the event or location or any other aspect of the image. These are photographs that reach a larger audience. They say something, much as a Bach toccata says something and has done so for 300 years. This type of photograph is clearly a different entity from the group snapshot or vacation picture. Both are photographs because both were made via the photographic process, but everyone recognizes that there is a distinct difference between the two.

The problem is that trying to make a sharp-line demarcation between what is a fine art photograph and what is a regular photograph is useless because there is no sharp line. Instead, there's a fuzzy gray area where one slowly merges into another. Within that gray area there can be a lot of controversy over the category in which any image belongs. Those arguments will never be settled.

I think it can be said that if a photograph is well composed (i.e., with interesting internal relationships), well lit (i.e., with appropriate or extraordinary lighting), well executed (i.e., sharp where sharpness is desirable, unsharp where unsharpness is acceptable or necessary, and appropriately exposed and printed), and it has the capacity to reach a wider audience, it can be considered a fine art photograph.

The Power of Photography

Let's continue this chapter with some thoughts about how powerful photography can be as a means of communication to others, and also how powerful it can be to you as a photographer.

I've already referred to Ansel Adams several times, and I will throughout this book because his photographs are both powerful and well known. For those readers who are not familiar with his work, it is readily accessible via a simple search for his name on the Internet. He is known, above all, for his photographs of Yosemite National Park. Millions of people have seen his photographs of Half Dome, of the *Clearing Winter Storm*, of El Capitan, and of so much more in Yosemite. These are icons, and virtually define what can be found in Yosemite and, more specifically, Yosemite Valley.

Many visitors to Yosemite Valley who have seen Ansel's photographs are somewhat disappointed when they see the actual place. This is curious, interesting, and paradoxically understandable.

It is curious because they have become excited about the place after seeing a black-and-white photograph, not the reality in full, living color. The photograph may have been 16 inches high and 20 inches wide, and now in the valley they look at the 3,700-foot cliff called El Capitan, or Half Dome rising more than 5,000 feet above Tenaya Creek, or the 2,425 feet of Yosemite Falls, and they are disappointed! Furthermore, the photograph has literally no depth to it—it is simply a flat sheet of photographic emulsion on a white backing with a picture on it—while the real Yosemite Valley is several miles long with dramatic granite cliffs surrounding it on all sides. So it is not only curious that some are disappointed by the reality, but it's almost astonishing.

Yet it is understandable for several reasons. Ansel didn't photograph these iconic images on ordinary days when the sun was out and there were no clouds in the sky, and when

there may have been a light breeze or none at all. Instead, he chose moments of great drama: when clouds were clustered at the base of the great cliffs that rose above them, when strong winds pushed the falling water way off to the side, or as clouds blew out of the valley after a storm. Many visitors experience the reality of Yosemite without the drama of the conditions that Ansel incorporated into his images, while others come in times of high drama, wishing that the clouds weren't obscuring their view of the great cliffs and waterfalls. So many people fail to connect the dots. They fail to see how Ansel took advantage of unusual conditions to convey not only the sculptural aspects of the place, but also the mystery, magic, and drama of it. So they are disappointed.

This says volumes about what people's expectations may be when they visit a place for the first time. But it also speaks volumes about the power of photography. It shows that photography possesses a power of illusion and communication that is profound.

Photography has often been equated with reality—what you see is what was there. It becomes reality. This is the reason people feel that Ansel's famous *Moonrise, Hernandez, New Mexico* was a special moment in time, when in fact, it's an image so greatly manipulated that it can be truthfully stated that the moment never occurred. It was largely created. The actual moment was used as a starting point for the image, while the image is a dramatic alteration of the starting point. It is a wonderful interpretation of that moment by Ansel.

The ongoing feeling that photography is reality is true not only of landscapes, but of any subject. Craig Richards, a close friend of mine and an outstanding photographer who has instructed workshops with me, made a magnificent series of portraits in Guatemala. Among them is his photograph of Martín (pronounced Mar-TEEN), which he made at the front door of Martín's home in Santiago Atitlán (figure 3–9). I first saw this portrait when we were instructing a workshop in Montana's Glacier National Park. The power of the image and the apparent presence and strength of the man were overwhelming to me. The next year I accompanied Craig down to Guatemala, and he sought out Martín's home so he could give him an 8×10-inch print of the portrait. When Craig knocked on the door, Martín answered. I expected to see a very impressive man open the door, but Martín was hardly more than 4' 10" tall and was nearly bald, with thinning hair cut into a crew cut. In essence, the portrait and the man were two different things, much like the difference between the reality and the image we know as *Moonrise, Hernandez, New Mexico*.

It remains to be seen if this power of photographic reality will stand up in the future, with digital manipulations making so many alterations and transformations, and so many removals of unwanted items from the scene or introductions of desired items into the scene, that it could drain away the aura of reality from this art form. But today, virtually all excellent photographs are still viewed as reality, and are still viewed by many as the good luck of being in the right place at the right time. This gives photography a power that is unrivaled by any other visual art form.

So when you pick up your camera, it's good to remember that you're holding a very potent tool in your hands. When used well, it can convey a message with great authority and emotion. And because it transcends language, in many ways it is more powerful than words.

▶ *Figure 3–9: Martín (courtesy of Craig Richards)*
Craig photographed Martín at the front door of his home, in the shade of a gable or canopy overhead. Brilliant sunlight was reflected onto his face from the dirt road in front of him, bringing out the strong lines of his noble face.

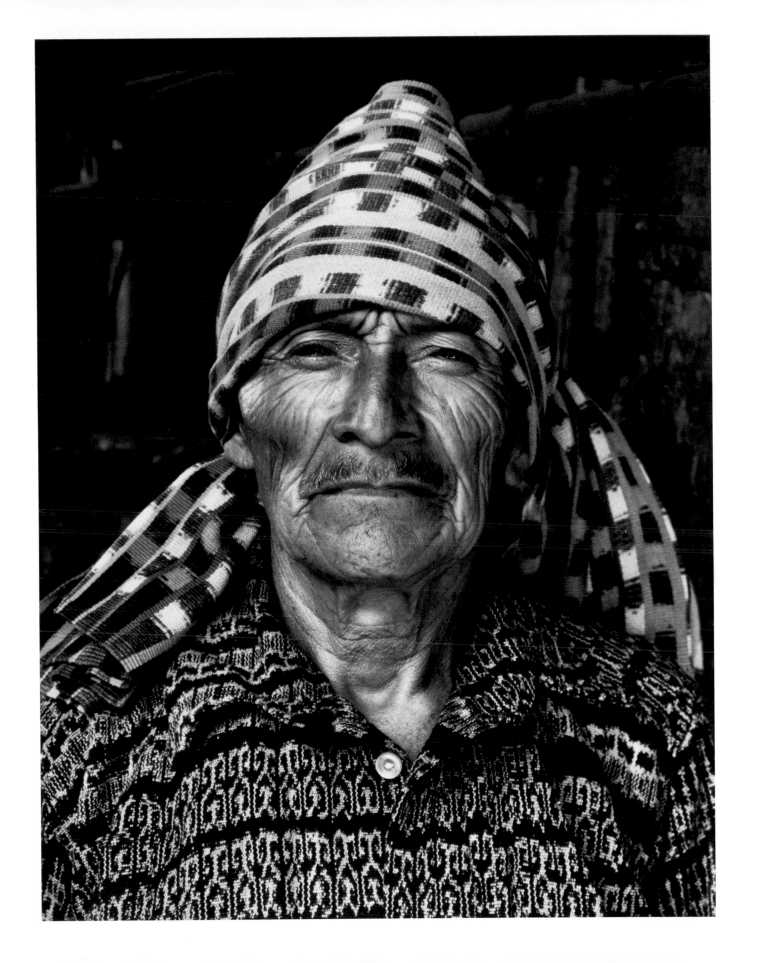

Emotional Effects of Photography

A photograph can be an emotionally moving experience. I have seen photographs that have made me laugh, ones that have made me shudder, ones that have gotten me excited, and ones that have produced all sorts of emotions in me. I've even had the wonderful experience of seeing others respond emotionally to some of my own imagery.

In 1994 Craig Richards and I were conducting a photography workshop in the Yucatán Peninsula of Mexico. During our daily field sessions, I was exposing 4×5 Polaroid images of most of the same exposures I was making for my 4×5 negatives. The Polaroids allowed me to discuss my imagery and compositions with students during the workshop. But, of course, students were scattered about, so few were able to view the images as I exposed them. When each field session ended and we re-boarded the bus that was taking us from place to place, I would pull out the Polaroids I made during the session and send them around the bus so everyone could see them and perhaps discuss them with each other and with me.

One of those images is featured on the cover of *The Art of Photography,* titled *Chair and Shadow, Convento San Miguel, Maní* (figure 3–10). When the wife of one of my students took the set of Polaroids I made that day and came to that image, she burst into tears and said, "I've got to have that photograph!" It was a completely surprising and overwhelmingly gratifying response to one of my images, and it was just a small Polaroid image.

I told her that it would be an 11×14-inch print, and I hadn't even developed the negative yet. An important size consideration for me, which I didn't discuss in chapter 2, is the idea that a photograph should yield some visual surprises when viewed closely, compared to your overall impressions when you look at the photograph from a distance. I want to discover some previously unseen details when I come close to inspect the image carefully. With *Chair and Shadow,* I felt that an 11×14-inch image would have all that was needed; a larger image would simply be a larger image. It has always been printed as an 11×14-inch image, never larger, never smaller. I knew that would be the size I would print it when I exposed the negative.

Let me further explain my inner thoughts about the scene in *Chair and Shadow* when I encountered it, for the affect it had on me was immense. Several workshop students were in the large, barrel-vaulted room when I entered, so I first worked with them on their compositions. It was a workshop, after all, and I was one of the two instructors. It's possible that one or more of the students had moved the chair before I entered the room, or even after I arrived, but I never noticed that, and I did not touch the chair. But when I saw it there, I immediately called out, "Don't touch that chair!"

In order to make the image that I saw in my mind's eye work for me, I had to stabilize the door, which was flapping open and closed because of a strong wind. I walked out onto the balcony beyond the door, picked up a piece of broken plaster to put under the door to keep it from moving, and positioned the door so that it blocked the opening when looking at it from where I first saw the image. After stabilizing the door with the lump of plaster, I placed my camera in the spot where I had stood when I first noticed the chair. The stabilized door still allowed light from the opening to hit the chair, maintaining the shadow. I had to work a bit to set up the image, but only by stabilizing the door.

► *Figure 3–10: Chair and Shadow, Convento San Miguel, Maní*
This is a simple composition, almost a haiku since it is so simple, but it is filled with deep meaning to me. Upon seeing the lone chair with its shadow created by the light coming through the open door, I was almost able to hear Pablo Casal's tones of Bach's Cello Suites still echoing in the bare room, even after he had finished playing and walked out of the room through the door.

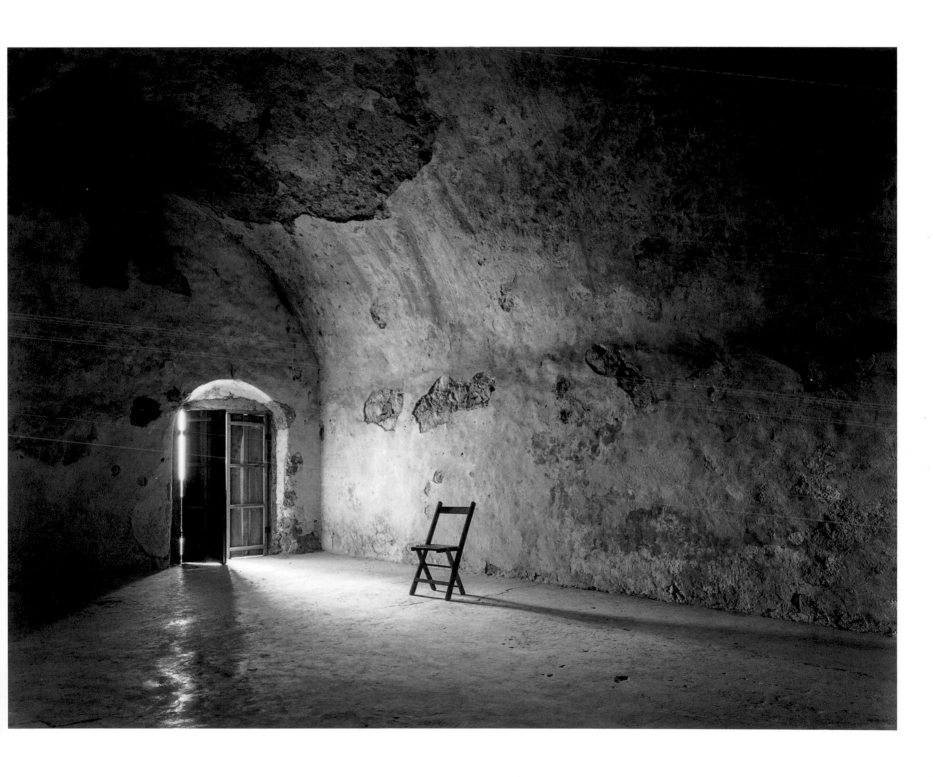

I did all of this for a reason. I saw an entire story in that chair and shadow within the large room. The great cellist Pablo Casals had been sitting in that chair practicing the Bach Cello Suites. He had just finished, gotten up, and carried his cello out the door to the left, and I could still hear the music echoing in the room.

One of the most startling incidents of my photographic life occurred several years later as I was showing prints during one of my workshops. I put a print of *Chair and Shadow* on the easel and awaited any comments or questions from the students before I would say anything about the image. One student quickly said, "I can picture Pablo Casals sitting in that chair practicing the Bach Cello Suites, and leaving through that door when he finished." I was utterly dumbfounded to hear those words.

The Psychological High of Photography

Abraham Maslow was an American psychologist who pioneered a different track of studying mental health. Instead of trying to understand various psychoses and other mental problems, and how they could be treated or overcome, he concentrated on what made the most successful, most competent people tick. He looked into examples of superb mental health for clues to how each of us may be able to improve our mental health and our approach to life. He studied and wrote about self-actualized people who propelled themselves along.

In his studies and writings, Maslow uncovered what he termed "peak experiences." These are such intense positive moments in one's life that the person lucky enough to experience one remembers everything around that event. It turns out that few people can point to such peak experiences in their lifetime, whereas some of us have had several.

My personal experience as a photographer, and my observations of other photographers, has led me to believe that we may be in a very special class. I can recount many images I have made that could qualify as epitomizing Maslow's peak experiences. I can remember approaching the scene, setting up the camera, focusing it, and making the image. I can remember the exact weather conditions, the breezes and smells that accompanied the moment, or the conversations that I had with others who were with me at the time. This is not an isolated, one-time experience for me; it's one that has occurred many times.

Interestingly, I have talked with dozens of photographers, both amateur and professional, who can tell me extraordinary details surrounding a number of their images. It seems to me that the act of setting up a camera may be the trigger for a peak experience. It may be that squeezing a cable release or pressing a shutter release is an act so filled with meaning that everything around it is remembered. Needless to say, this isn't true of every exposure. It's true of very few, but it is true of some. It is true of enough of them that I believe photographers have peak experiences more often than the average person, and in fact, more often than the high-functioning people whom Maslow studied.

If you have been photographing for any length of time, it's a good bet that you can point to at least one of your photographs that is so meaningful to you that you remember everything associated with that exposure. If so, you've had a peak experience, one that is deeply etched into your memory.

I cannot say if painters, sculptors, writers, composers, or people in any of the other arts have that peak experience because I don't know many in those fields. But none of those arts have anything comparable to the moment of exposure that we photographers have. Even an extended-time exposure begins in a single moment when you press the cable release or shutter release. We're a lucky group.

For me, that's part of the fun of being a photographer. I wish you the same pleasures that I have experienced multiple times.

Finding Inspiration for Realism or Abstraction

INSPIRATION CAN BE FOUND EVERYWHERE; it largely depends on you and your openness to things around you, often things that you can easily overlook. Some people get ideas from the most mundane things. Others find inspiration in remote areas that only they work with or have access to. You simply have to pay attention to the things around you, things in your daily life, from your background, or even in your thoughts and dreams. In previous chapters I have discussed how my life-long interest and academic background in mathematics and physics helped me find a deeper meaning in the slit canyons of northern Arizona and southern Utah, and also in the cathedrals of England. Both of these examples reflect a wonderful statement that Minor White made, "We photograph something for what it is, and for what *else* it is."

I photographed the cathedrals in 1980 and 1981, and considered the project finished at that point. I began photographing the slit canyons in 1980, and will consider that project finished when I no longer have the strength and stamina to hike into such canyons. However, my work in Antelope Canyon ended in 1998, when I became too depressed by the overriding commercialization of these magnificent places to continue visiting them. These places felt truly sacred to me, but, in an ironic twist, seem to not be sacred to the Navajo upon whose land many of them are located.

Since 2000, I've been photographing the sand dunes at Stove Pipe Wells in Death Valley, where I made my first true abstract photograph way back in 1976 (figure 1–5). I returned to this area to start a workshop with my co-instructors Jay Dusard and Jack Dykinga, and quickly reestablished my interest in the dunes. I

◄ *Abstract Raindrops, Skrova*
Despite the title, these are not raindrops. This image was, indeed, made on the Norwegian island of Skrova, but its abstract nature masks its reality.

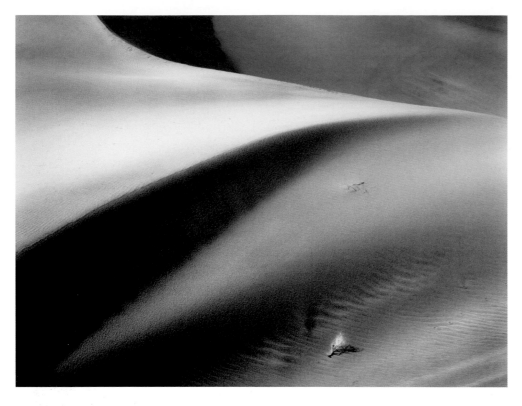

▲ *Figure 4–1:*
Wedge and Bush
Photographed the morning after a rainstorm (yes, Death Valley gets rain at times) the dunes took on the texture of stucco, with just a tiny bit of typical sand rippling. I was drawn to the interlocked, softly curved triangles coming in from the left and right, all apparently balanced on the fulcrum of a sunlit, broken piece of dried sage near the bottom center.

find them to be among the most peaceful places I've ever encountered. I've also found that it's impossible to be in a single spot on the dunes more than once because the wind changes the sand patterns constantly; the lighting is always different based on the time of year and time of day; and it's hard to simply *locate* the same place on the dunes twice. I recognized the endlessness of the photographic possibilities quite quickly when walking over the dunes. I didn't need a lot of time to gather my thoughts and turn them into photographs.

I still show the 1976 image as an integral part of my sand dune study, but now I have a whole portfolio of dune images to go along with that pioneering photograph. I think my evolution in seeing over the years influenced my renewed interest in the dunes, particularly my growing recognition of the importance of relationships of line and form, and the overwhelming importance of light. I have found that the dunes present opportunities for the purest study of light and form imaginable. I think I was self-influenced in my new passion for photographing the dunes a quarter-century after I first encountered them.

The difference between my work on the dunes and my work in the slit canyons is that the canyon photography opened up a whole new photographic field that had never been explored previously. Creativity virtually came with the imagery. But it was also the interpretation of the canyons as force fields, rather than an attempt to portray them as simply extremely narrow canyons, that contributed to my creative effort. Sand dunes, on the other hand, have been photographed by numerous photographers for well over a century; there was nothing new about the subject matter. The challenge, therefore, has been to produce imagery that is both good and different from the many who preceded me. I leave it to the viewer to decide if I've been successful. I cannot reproduce a complete portfolio in this book, but figures 4–1 through 4–3 and 7–10 through 7–12 show a sampling of what I've been up to.

These are some of my stories. Hopefully within them are some bits of information or inspiration that are of value to you. But let's turn the focus directly to you. How and where can you find inspiration for your photographs? This is the key question that I'm always asked at workshops, via emails, and in many other ways. In chapter 2 I suggested trying a variety of photographic genres and subjects—landscapes, cityscapes, portraits, street photography, family and friends—to see which ones draw you in again and again, and which ones prove uninteresting. I also recommended that you look to the work

▶ *Figure 4–2: Curved Hollows*
I found these magnificent forms at the close of a morning workshop field session on the sand dunes. I set up my 4×5 camera with a wide angle lens and made an exposure. Then I stepped forward about a step and a half, which had no effect on the distant top of the image but a profound effect on the wonderful nearby shapes, and exposed a second negative. Again I stepped forward, this time hardly six inches, which once again had a striking effect on the foreground curves, and exposed my third negative. I have shown the print from the third and final negative since then.

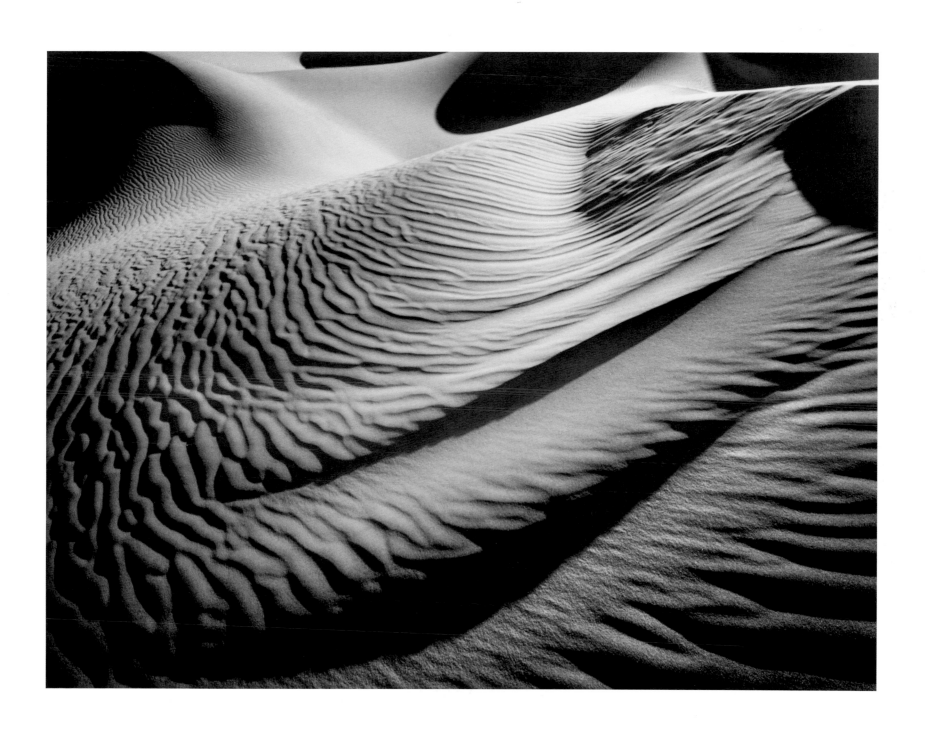

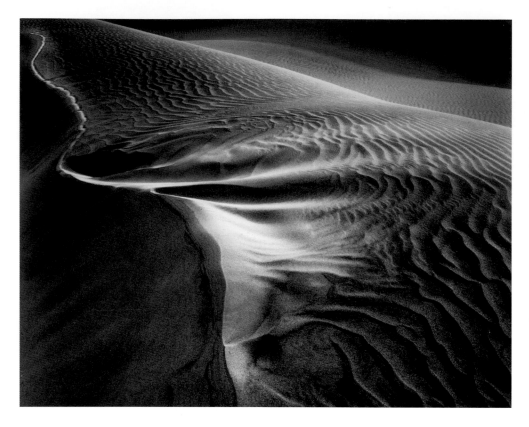

▲ *Figure 4–3:*
Serpentine Ridge, Sunset
This image was made at the close of an afternoon workshop field session, just as the sun was about to set. After finding the serpentine ridge, I worked as fast as I could to set up my tripod and 4×5 camera, focus quickly, make a fast light meter reading, and insert the film holder to expose the negative. Within a minute of the exposure the sun went below the horizon, and the brilliance of the serpentine ridge and the fascinating hollows adjacent to it disappeared. Sometimes, even with a large format camera, speed is necessary. And sometimes you can do it in time.

of your favorite photographers to provide further clues as to what interests you. Now let's look in some other directions and try to uncover some of your interests.

Inspiration from Daily Life

Have you ever thought of finding photographic inspiration and valid subject matter in the place where you spend much of your day? Is there any aspect of your daily work that is of visual interest to you? Do you work with others in an office, store, laboratory, or some other place where you may have the opportunity to photograph those working with you? I know of medical doctors who have asked their patients if they would be willing to be photographed. In many cases, the patients are not only willing to pose, but are actually thrilled that their doctor has taken such deep interest in them.

Can you photograph in your workplace? Sometimes it takes a little tenacity to get past the barrier of a boss saying no, but maybe in time he'd give it a second thought and allow

some photography. Perhaps your work takes you outdoors, where you may be able to do some photography along with your activities. Whether you work indoors or outdoors, look at the whole scene as well as the details. There may be a lot of wonderful photographic possibilities hidden within them. Consider whether there are aspects of your work that could inspire your interpretation of things you see when you're away from the workplace, just as my math and science background inspired my interpretation of the slit canyons.

Several years ago a medical doctor attended one of my workshops. He is a Vietnam War veteran who returns to the country each year to volunteer free medical work. At one of the print review sessions he put up a set of nicely mounted landscape images, and on the counter beneath them he laid down several unmounted portraits of patients he worked with in Vietnam. I suggested to the group that we first discuss the mounted landscape work. I purposely asked to review those images first, for reasons soon to become clear.

After we reviewed the landscape work I turned to him directly and asked, "Why didn't you mount the portraits? They mean so much more to you." He immediately broke into tears.

Perhaps he thought that as a landscape photographer, I would be primarily—or even exclusively—interested in seeing landscapes. Perhaps he felt his hospital patient portraits would be viewed as uninteresting, extraneous images. That's not my approach in my workshops. I try to look at all of the images that students present with an eye toward helping them improve their own vision, their own interpretation, their own goals. I'm not trying to produce clones of the type of work that I do. (First and foremost, of course, I don't want or need the competition.)

We discussed this student's portrait work for the next 45 minutes, during which he broke into tears several more times. Those photographs were, indeed, far more important to him. That was clear to me as he put his work up, and that's why I suggested reviewing the landscapes first, recognizing

that if we talked about the portraits first, we'd never get to the landscapes.

I recommended that he temporarily put the landscape work aside and concentrate on the patient portraits, placing them virtually on par with his medical services during his subsequent visits to Vietnam. Deep inside I suspect he knew that, but he had to hear that suggestion. So his inspiration was right in front of him in his line of work. Yours may be, too. I recommend you look into it. And if you already have but you dismissed it, look again, and look deeper.

Photographic Inspiration Near and Away from Home

Have you looked carefully around your home? Have you looked not only within your home, but at the entire structure itself, or at the neighborhood in which it's located? Again, have you looked not only at the broad scene, but at the details within it? You may walk around your home or neighborhood without ever noticing its photographic potential, but it's worth giving it some thought. After all, you spend a lot of time there, and it may prove to be a treasure trove of opportunities.

Ruth Bernhard, a fabulous photographer who died in her late 90s and is primarily known for her nude studies, once said, "You have to learn to take pictures within 15 feet of your bed." Have you ever thought of doing that? Have you thought of taking pictures within 15 feet of your dining room table, kitchen counter, or living room? I encouraged many of my workshop students to attend one of Ruth's workshops before she grew too old to do them anymore, and many did. One such student, who was fully involved in landscape photography, heard her comment and immediately said, "I can't do that!" Ruth asked why not. He answered, "My bed is too heavy to carry out there!"

Most people don't do too much photography until they travel. Often, they'll be drawn to the people they see on the street in foreign countries. But how often are they drawn to people on the street in their own country, their own city, the nearby shopping center, or their own neighborhood? Based on what I've seen in 40 years of looking at student work in my workshops, it seems the answer is that people "over there" are interesting, but people "right here" are not.

Really? Maybe the answer is that they feel a bit scared about aiming their camera at folks on their home turf, but there's some type of safety in doing so abroad. I've seen some awfully fascinating looking people wherever I've gone, so it seems to me that the opportunity lies equally here and there.

Too many people take walks around their location regularly but only take out their camera when they travel to somewhere like Yellowstone. I once heard a good photographer wryly comment that most people have a photographic button in their butt, and it has to be jiggled by at least 500 miles of travel before it turns on. I think there's some truth to that observation.

It's worth trying to overcome the need to travel in order to photograph. In general, you have no more than three or four weeks of vacation travel each year, leaving you about 48 weeks of non-travel. Don't put your camera away during those lengthy times at home. Look around you and open yourself up to the countless possibilities within reach.

Inspiration from Literature

If you are reading this book, I'll assume you read regularly... or could. You may find great inspiration from literature, poetry, histories, or any other reading material. I have found tremendous inspiration in Japanese Haiku poetry. I don't read or understand Japanese; I read translations of the Japanese poems or poetry written in English that conforms to the basic rules of Haiku. Haiku poems are just three lines long and, in their purest form, have just 17 syllables. The first line has

five syllables, the second has seven, and the third has five. In such a short poem, very little can be said, so the writing relies on allusions to vivid imagery to supply the meaning, such as in the following example:

A bitter morning:
Sparrows sitting together
Without any necks.
—J.W. Hackett

If you're like me you immediately conjure up a picture in your mind. What do you see? Do you see two or three sparrows, or a whole flock? Do you picture a backyard, an open natural meadow, an urban sidewalk, or perhaps sparrows lined up on the branch of a snow-covered tree? Do you see any colors, structures, or other trees? Everyone sees a different picture. But the fact remains that *you* conjured up the picture; nothing in the Haiku directed your specific picture. It's quite remarkable. Sometimes your picture is extremely complex, with elements not even alluded to in the Haiku itself.

If this example whets your appetite, I'd recommend searching for Haiku poetry in bookstores, libraries, or online. These short poems are delightful to read, and they may prove to be inspirational for your photography.

Haiku has made me wonder if I could conjure up thoughts or allusions to things that do not actually appear in my photographs via my photographs, perhaps thoughts that I never even had when making the photographs. It's encouraged me to simplify my photographs to emulate the elegant simplicity of Haiku, while still communicating a message.

Haiku is just one form of poetic literature. Poetry of all types can provide visual inspiration, as can prose. Novels, historical novels, and non-fiction of all types often serve as starting points for visual inspiration. If the books you are reading stimulate anything visual for you, it's worth trying to translate the imagery to your own photographic imagery. Haiku didn't push me to photograph sparrows in the snow, but it made me think about simplicity as a means of photographic expression. Maybe the same thoughts could have been inspired by Shaker furniture, which is simple and sparse, yet elegantly designed. The inspiration that I got from Haiku could easily have come from going into the right furniture store. The key is trying to keep your mind open to new ideas, and translating those ideas to your photographic goals.

Inspiration from Music

We all know that music has a profound effect on us. It varies widely from rap to hard rock to jazz to country to classical, and that's only a few types of music regularly performed in the United States. The music of China, the Arab world, India, central Africa, and many other parts of the world may seem utterly discordant and irritating to American and Western sensibilities, yet have undeniable emotional effects on those who have lived with it all their lives. This shows the effects of culture on our thinking and emotional states.

But staying with the type of music you understand and enjoy, you know that it can be tremendously moving, whether its martial music that gets you excited; popular love songs or operatic arias; orchestral or solo instrumental music that brings tears to your eyes; or upbeat music that makes you smile, tap your feet, and spontaneously start to dance.

But how can you translate musical ideas and emotions directly to photography? It would be impossible to outline an exact formula for this; nobody can tell you how to translate one to the other. But just as you may be able to find and transfer inspiration from your workplace, home environment, educational background, or other visual art forms to your photography, you can transfer inspiration from music to your photography. Perhaps you can draw upon your emotional response to a particular piece of music to inspire your

composition or your choice of subject matter. Or you may be able to apply your thoughts about the ways in which music is performed or the creative processes of musicians to your photographic process.

I know with certainty that music has inspired my thinking in several very clear and understandable ways. I am drawn to classical music, particularly chamber music, and I enjoy everything from solo performances to groups of up to 10 musicians, where I can generally pick out the individual instruments throughout the piece. I attend concerts and I have rather extensive vinyl record and CD collections. Within those collections are recordings by different ensembles of the same musical score, each with a different interpretation.

These variations in the way music can be performed has opened up my thinking about the many possible variations in the way any scene can be exposed and then printed. As noted in chapter 2, Ansel Adams has said of traditional black-and-white photographic processes, "The negative is the score; the print is the performance." Translated to digital imagery, this could be: the RAW file is the score; the tiff is the performance. I realize that with a negative in my enlarger, there is a wide range of ways to print it that could be valid, but the way I choose to do so probably comes down to a very specific set of tonalities and the final size of the image that most closely reflects my feelings about the scene I photographed. So I realize that I have to plumb the depths of my thoughts and feelings in order to determine how I want to present that image. Another photographer could print the same image with a very different set of tonalities, and could choose a different size print. And while their interpretation may be wonderful, it may not come close to the way I want to interpret the scene. There can be a huge difference between personal interpretations of equally competent photographers.

There's a second way that music has influenced my photography. As I noted above, I have purchased several different recordings of particular compositions, such as Bach's *Gold-*

berg Variations for piano, or Schubert's *String Quartet No. 14,* known as *Death and the Maiden,* and many others. I am often drawn to a segment of one recording that I find particularly pleasing, but more drawn to a different segment from another recording. The thought occurred to me that one could create the "ideal" recording by combining my favorite parts from the various soloists or ensembles into a single recording. This would produce the finest of all possible recordings for my ears and my emotions.

With that thought in mind, it occurred to me that when I'm printing a negative or working digitally on a RAW file, I should be able to optimize each portion of the print to create the best of all possible images. I can lighten or darken certain areas of the image, increase or decrease the contrast level, enhance or subdue the color intensities, or make any other desirable alterations to achieve the effect I want in the final image. Of course, I must stay within the limits of logical light throughout the final image; for example, I can't have sunlight coming in from the left in one area, and from the right in another area of the same landscape. In my evaluation of any new image that I produce in the darkroom or on my computer, I not only look at the complete image, but also at each portion of the image to see if I have optimized the separate component areas to the benefit of the complete image.

Please note that I'm talking about *optimizing* each section of a photograph to make the best possible image, not *maximizing* each section of the image. The distinction is important. I can increase the contrast or color saturation, or in some manner jazz up any area of a photograph if I wish to do so, but I have to consider the entire image. If I were to increase contrast or saturation everywhere, the viewer's eye would jump around, attracted equally to each part of the picture. That defeats the composition and communicative purpose of the image. It's important to direct the viewer's eye in a measured manner to the areas of the image you want him to concentrate on the most. So you have to be subtle and

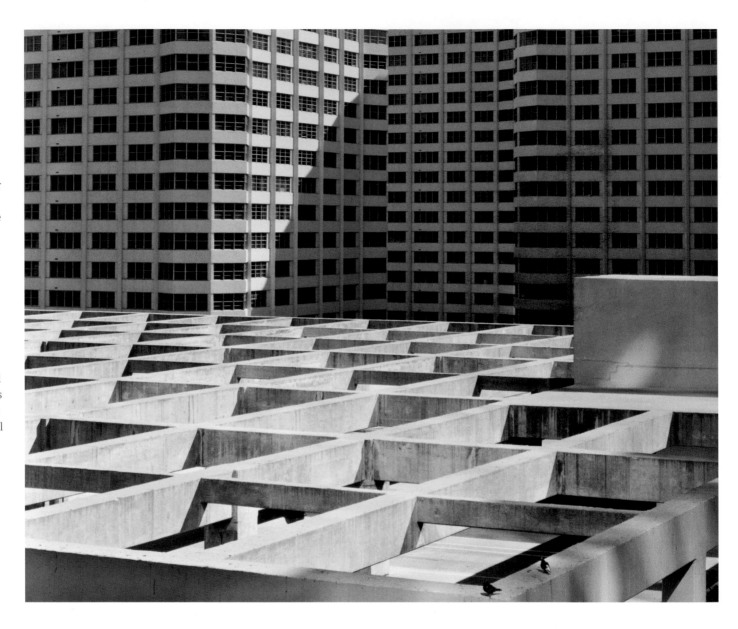

► *Figure 4–4:*
Urban Wildlife, Miami
A set of enormous buildings set the stage for this decidedly tongue-in-cheek comment on the barrenness of modern urban life. A couple of pigeons are the only visible life in the vast concrete scene. Yet, beyond the satiric nature of the scene is the interplay between the criss-cross geometries of the parking structure and the rectilinear geometries of the buildings, which to my eye had enough visual interest to draw the viewer into the deeper statement of the barenness of it all.

subdued in some regions in order to make them subordinate to the whole, while helping to support the whole. This can be compared to the way in which some instruments in a string quartet or symphony are subdued but audible, while other instruments carry the main theme.

Music may also influence my photography in terms of the way I see my surroundings. I often see harmonies or rhythms within a scene that subliminally resonate with me. In my English cathedral studies, I saw the "frozen music" that Goethe spoke of in the march of columns, arches, and vaults.

But these are manmade structures that were purposely designed to bring out such musical repetitions and make the parishioners feel that they were truly in the presence of God. What about a natural landscape, where there is no intentional design? In such settings I may set my camera down because I see and feel the same frozen music that reaches a pinnacle from a particular point of view. I know that I have often talked with those around me about the roll and flow of the land from some viewpoints, because that's how I've seen it. I may or may not be consciously aware of this musical influence, but

it may be there nonetheless. I have felt that in a very different way with my "urban geometrics." In these studies of modern urban architectural interactions, I feel a more jazzy, staccato, herky-jerky rhythm when looking at the relationships within the scene (figure 4–4).

There is another aspect of music that fascinates me, but I have to approach it by backing my way into it. Over the years I have talked to people who are drawn to photographic abstraction and some who are completely turned off by abstract photographs. One of the things I have heard from those who dislike photographic abstraction is that abstraction carries no emotional content. Apparently they can be emotionally moved by a portrait, landscape, war photograph, or any number of other genres that portray subjects they can immediately identify, but they are not moved by abstraction, a term that usually connotes that the viewer will have difficulty quickly identifying the subject matter.

Yet these same people can be deeply moved by music. Now, when you break it down, music is really a set of tones, rhythms, and timbres that are about as abstract as anything can be. How can you identify a piece of music in the same way that you can identify a portrait, landscape, or any other "realistic" photographic subject? You can't. Of course, you may be able to relate to the words in a rap, a rock song, a country western song, or an operatic aria, but what about the instrumental music or rhythmic beats alone? Separated from the lyrics, the music is still a decidedly abstract entity. Yet it can still have a remarkable emotional effect on the listener.

Since music has an undeniable emotional effect on all of us, with each of us responding to our own specific musical sensibilities, I strongly urge you to see if you can find inspiration for your own photography from the music that affects you most strongly. You may not be drawn to classical music, as I am, but that's immaterial. You surely have your own corner of musical pleasure, and that's where to turn for your potential inspiration.

Interpretation of Realism and Abstraction

I believe that photographic abstraction contains no less emotional power than a realistic photograph; it's just that some people do not respond to visual abstraction. Recognizing that fact frees you, the photographer, from being negatively impacted by those who may not like your abstract imagery. During my first few years in photography, I was intimidated by those who reacted negatively to any abstraction that I put in front of them. As I've written, that all vanished in a flash when I saw Brett Weston's images in 1979, just 4 1/2 months prior to walking into Antelope Canyon, where I produced the most abstract imagery I've ever created. Many viewers have been deeply moved by those images, while others have not. I've learned to accept that and not be intimidated or bothered by it.

To me, the idea that each viewer brings his own background into the image has become part of the attraction of abstraction. Let's go back to my first photograph in Antelope Canyon, Circular Chimney (figure 1–6). One day I was delivering prints to the Stephen White Gallery to replace those that had sold. As I walked into Stephen's office to give him the replacements, I found him sitting behind his desk speaking with a man who had his checkbook open and a pen in his hand. There was a mounted print of Circular Chimney on top of the desk leaning against the wall. It was obvious that a sale was about to be completed.

As I entered the room, Steve looked up at me, turned to the gentleman across the desk, and said, "Here's the artist." The man looked at me, confirmed that I had made the photograph, and said, "This is the best wood detail I've ever seen."

I quietly chuckled, and he noticed my mirth. So he asked, "Isn't this a wood detail?" I said, "No, it really isn't." And then I tried to describe what it actually was. He listened, shrugged his shoulders (obviously not comprehending my description of the canyon), filled out the check, and walked out with the photograph.

The interesting thing here is that he had defined what the photograph was, and after being told that his definition was incorrect, he still liked it enough to purchase it. Abstraction can do this. You can see something for what it is, or for what it isn't, and still be drawn to it. I have heard a variety of interpretations of my slit canyon work from viewers whose backgrounds are radically different from mine. What they see is a product of their life history and interests, and it is quite different from my interpretation of the canyons as forces in nature, which I saw and felt as a result of my life history.

Can you get this same effect from more realistic imagery? I think so. For example, one evening I was sitting at dinner with my wife, wondering aloud why *Basin Mountain, Approaching Storm* (figure 2–15) was so popular. I asked her what she saw when she looked at the image. She said that she first saw the peaceful meadow in the foreground. I almost gasped. The photograph is titled *Basin Mountain, Approaching Storm* because I see the mountain and surrounding clouds first, and the meadow is almost a backdrop to the real essence of the image, which is the approaching storm that is about to engulf the mountain. But the moment she uttered those words, the mystery of the image's popularity was solved. For the first time I understood that two people can love the image for different reasons—one sees it as a pastoral scene with a stormy background, while the other sees it as a stormy scene with a pastoral foreground. In other words, the composition and the interpretation of the scene can be successful in two different ways. This dualism had never occurred to me.

Portraits can have multiple interpretations as well. Of course, the most famous is Leonardo da Vinci's painting of Mona Lisa, which has been the source of innumerable essays, discussions, and debates for centuries. Photographic portraits can also have divergent interpretations. Sometimes you may want that leeway; other times you may want to portray the subject as sweet and lovely, or sullen and removed, or aggressive and scary, or authoritarian, or shy, or any other type of characteristic you see in the person. It's tricky to successfully translate your assessment of the person into a photograph that conveys that set of characteristics to a viewer who has never met the person. But that's the genius of a great portraitist: the ability to convey the character of a person. Through the use of appropriate lighting, the right facial expression or body language, the right camera angle, or any number of other techniques that require intense study of human characteristics, you can do it.

Color in Realism and Abstraction

Another issue that interfaces with issues of realism and abstraction in photography is the question of color rendition of an image as opposed to black- and-white rendition. Often, a color image is judged to be too saturated in color, whereas a black-and-white image rarely has the equivalent objection, except perhaps that it is too high in contrast. Today, digital techniques make it extremely easy to increase color intensity with a slider, and too many people are seduced by higher color saturation. They go over the line.

But where is the line? Obviously it varies for each of us. When a group of French painters in the late 1800s made paintings featuring intense colors, they were labeled "Fauvists," meaning "wild beasts," for their extreme use of color. Some people loved the paintings; most hated them. Today, they are a historic tidbit, with about the same percentage of us loving and hating the paintings today as when they first appeared on the scene.

One thing stands out for me in evaluating color saturation: the more realistic an image is, the more it must be confined to realistic colors. I feel that grass, sky, skin tones, and other such recognizable entities have to be kept in check or they simply look wrong. As subject matter becomes more abstract, color saturation becomes less confining, and when subject mat-

ter becomes totally abstract, it may not matter if the greens are pink or the yellows are purple. In other words, the more abstract a color photograph becomes, the less fragile the color or degree of color saturation is. Colors can hold up to wider departures from reality as abstraction increases.

The degree of color saturation has always been a concern in color photography. The advent of digital photography ramps it up greatly because it's so easy to increase saturation and it's so addictive. Nothing in digital photography *forces* this onslaught of overbearing color, but the vast number of options makes it too easy to engage in these abusive behaviors, and too many photographers get sucked into the vortex. It's avoidable. It's possible to show restraint and subtlety. If you want to produce realistic colors in your photographs it may be wise to review some of the great paintings in museums or in well-reproduced books to see how the great painters dealt with color—both color balance and color saturation. Compare them with the degree of saturation in your own digital imagery. The comparison will prove to be very instructive.

A black-and-white photograph is one step of abstraction away from a color photograph, and a further step away from reality. Hence, it affords greater flexibility. The black sky in Ansel Adams's *Moonrise, Hernandez, New Mexico* is perfectly acceptable in black and white, but would look extremely awkward in color. Yet the image is considered a realistic photograph, not an abstract one. In general, I feel that black and white offers far more artistic interpretation than color because of its inherent abstract underpinnings.

The Importance of Defining Your Expressive Goals

Sometimes a photographer has an idea of what he wants to accomplish, but he doesn't really know how to achieve that goal. Mapping out that pathway can be the most difficult part of the process. Prior to that, figuring out exactly what you want to say about your subject matter—whether it's the character of a person you want to bring out in a portrait, the forces in nature found in the sandstone walls of a slit canyon, or anything else—can also be challenging. This is where the combination of drawing upon your deepest interests and fully understanding the technical aspects of photography—digital or traditional—gives you the tools you need to accomplish your goals.

Allow me to return once again to my initial image from Antelope Canyon (figure 1–6). As I explained in chapter 1, the canyon walls instantly reminded me of force fields in nature. It was so compelling to me that I wanted to *use the canyon* to convey those forces I felt so strongly rather than simply *show the canyon*.

With this as my overriding objective, I made a number of decisions when composing and printing the image in order to convey my intended meaning. Most notably I didn't place a person or any recognizable object that would give a sense of scale in the frame. Forces exist at the subatomic scale and at the cosmic scale, and since I saw the canyon as representative of those forces, I wanted to remove any visible sense of scale. I didn't show the floor or the walls on either side that indicate how narrow the canyon is because, again, I wasn't interested in *showing* the canyon or how narrow it is; I was interested in *using* the canyon to depict forces in nature. I aimed the camera straight up, thereby eliminating anything recognizable in the image. It's virtually impossible to tell which direction the camera is pointing (straight ahead, downward, or upward), which is what I wanted because forces have no inherent direction.

So I wanted to eliminate any sense of scale or direction. I wanted to make the image as abstract and evocative as possible. In printing the image, I burn in (i.e., darken) the large central black area, which contains discernible detail in the negative but not in the print, to allude to a center of intense forces around which an entire galaxy or a cloud of electrons is

swirling—perhaps the black hole at the center of many galaxies, or the dense core of protons and neutrons forming an atom's nucleus.

In exposing the negative of *Circular Chimney* and then printing it, I was lucky that I knew my goals and had the technical knowledge to carry them out. Specifically, I knew that my goal was depicting *forces,* not the canyon itself. The sweeping lines marking the walls of the canyon provided the means to that end with an impact more powerful than any I had ever experienced previously. I was able to draw upon my technical knowledge of exposing the full range of the negative and dramatically lowering contrast to achieve that goal. Most people feel that I have increased contrast to achieve the image. To the contrary, I greatly decreased it.

So while I feel it's foolish to separate the technical aspects from the expressive, I also feel that you have to first know what you want to express to properly employ the necessary technical options. In this image—and so many subsequent images made in the narrow slit canyons—my expressive goals were the driver and I employed my technical skills to achieve my goals. In other imagery, the technical aspects may be simple, requiring nothing new, different, or heroic, but the expressive goals have to first be determined for you to make a meaningful statement.

As your technical skills increase, you'll see more ways in which you can use them to make additional visual statements. I certainly needed them to produce *Circular Chimney*. But however great or small your technical skills may be, it is the expressive goals that will drive your creativity, whether the goals veer toward realism or toward abstraction. Along the way, you do the best you can with whatever knowledge you have, and as you expand your knowledge base, you will surely enlarge your opportunities and accomplish more.

We See Similar Patterns in Different Subjects

Your seeing will change—and likely expand—along with your technical skills. It has been my observation that each of us seems to start out hard wired, perhaps programmed, to find similar line structure, shapes, patterns, or color relationships in widely divergent subject matter. Each of us seems to have been attracted to certain personal preferences early in life, and those things seem to remain attractive to us through adulthood. Either that, or each of us tends to look for repetitions of visual patterns in widely divergent subjects. Or, perhaps, each of us simply finds repetitions that please us in different things. From that base of early visual attractants, you may be able to expand into other pleasing lines, shapes, patterns, color relationships, etc., as your seeing becomes more mature and refined.

Let's delve into the idea of seeing similar things repeatedly. Look at figure 4–5, which shows a cottonwood root I found in Silver Falls Canyon in 2012, and then compare its composition to that of figure 1–6, which I made in Antelope Canyon in 1980. Note how the massive dark form pushing into the center of the Antelope Canyon image from the right side is virtually the same shape as the lighter wood form pushing into the center of the cottonwood image from the right edge, and at almost precisely the same angle. I was amazed to see the similarity in design in these two different images made 32 years apart.

But that's not the first time I've found compositional similarity in my work that reflects a similarity of seeing, looking, or finding that may have been ingrained and repetitive from childhood. One of the commercial architectural photographs I made in November of 1972 in the Los Cerritos Mall highlights the curved ceiling within the mall corridor (figure 4–6). One year later, in November of 1973, I made a photograph of the Sierra Wave Cloud from the Alabama Hills, immediately east of the crest of the Sierra Nevada (figure 4–7). It is uncanny how the two images are almost identical in composition, with the

◄ *Figure 4–5: Cottonwood Root, Silver Falls Canyon*
A small, scraggly cottonwood tree somehow remains alive in the streambed of Silver Falls Canyon, surviving both long periods of drought and periodic flash floods. At its base, bark has been torn away revealing a marvelous wood grain pattern. I first saw and photographed this wood pattern in 1992, and then surprisingly came upon it again in 2012, photographing it quite differently. This is the 2012 version.

A comparison of this composition with that of *Circular Chimney, Antelope Canyon* (figure 1–6) is surprising, for they share many compositional similarities. Then compare the next two images (figures 4–6 and 4–7) for an even more startling comparison of similarities. Perhaps these comparisons indicate that what pleases a person's eye may remain unchanged throughout their lives.

same overall forms and proportions. Without ever realizing it, I had photographed two completely different things capitalizing on virtually the same compositional elements. Apparently they appealed to my eye, and I photographed them without realizing until years later that I had, indeed, repeated myself.

I still enjoy the compositions of both images. Perhaps those shapes and proportions, and even some of the tonal similarities, are ingrained in my seeing. Perhaps I was hard wired to find these particular shapes and proportions pleasing from birth or early childhood. I suspect you'll find that your eye is similarly attracted to your own visual cues repeatedly. You will seek out those attractants, or you'll find them by chance, either as the full composition, or as a major element within the composition. When you do find them, you'll jump at them. But beware: if those same shapes or proportions or tonalities or colors or contrasts resonate with your audience, your photographs will be well received; if they don't, you're in trouble. Then you have a decision to make. Do you try to abandon this strong visual attractant of yours or do you steadfastly stick with it? Are you as stubborn as the impressionist painters

waiting for the critics and the public to catch up, or do you capitulate in recognition of the idea that your way of seeing is confusing, skewed, or irritating?

I don't think there's an easy answer to this question. Looking back at the history of French Impressionism, we can confidently say today that Monet and Renoir and Cézanne were brilliant and correct. But if Impressionism had never caught on, we would find their names in the dustbin of art history and proclaim them to be a bunch of foolish whackos.

Whatever attracts your eye initially, you may be able to expand your seeing to other attractants, in time. Perhaps it will come naturally, without effort on your part. Perhaps you'll actively work at looking for, and finding, other linear structures (both straight or curved), other shapes, other patterns, other color relationships or combinations that start to attract you as much as your tried and true lifetime attractants. This is all part of personal growth, and all of it feeds into expanding your creative process.

◀ *Figure 4–6: Los Cerritos Mall Corridor*

This is one of many shopping mall images I made for my most important commercial architectural client (Burke, Kober, Nikolai and Archuleta; later Charles Kober Associates) in 1972. I was attracted to the graceful curve in the ceiling of the mall corridor with its recessed lighting.

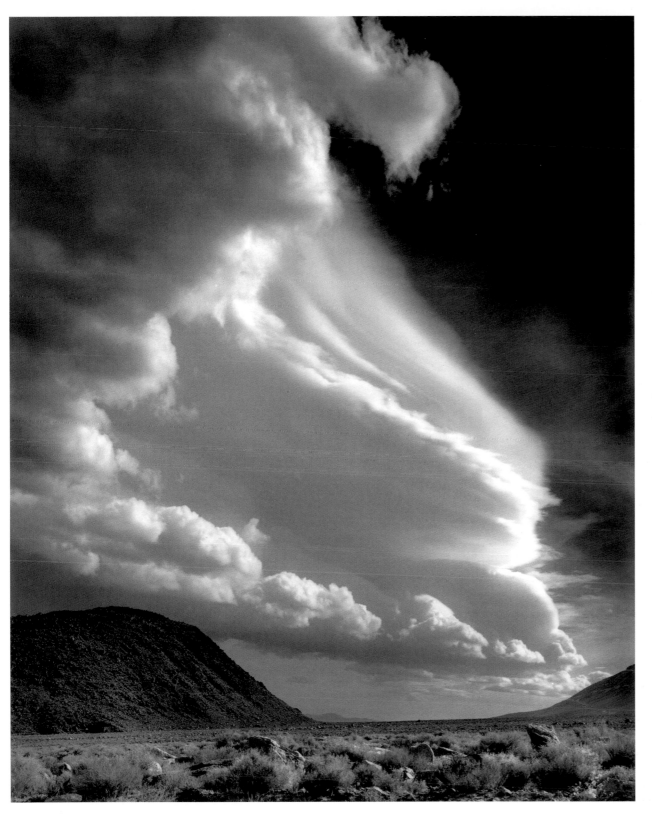

◄ *Figure 4–7: Sierra Wave Cloud*
The day after I photographed *Basin Mountain, Approaching Storm* (figure 2–15) from the town of Bishop, California, before the start of a weekend Sierra Club workshop, we had to leave town because of blowing rain and snow. Sixty miles south in the Alabama Hills we were treated to lenticular clouds undulating overhead, east of the highest peaks of the range. I made three successive photographs, stopping after the third because the shape was so pleasing to me.

Several years later I realized that I had effectively duplicated the composition I made a year earlier in the Los Cerritos Mall—one of a man-made subject, the other drawn entirely from nature. Those forms still strike me as pleasing. Perhaps it's part of my DNA. Perhaps we're all drawn to similar forms time after time. To this day, the cloud in this image remains the most awesome one I've ever seen, closely followed by the one in figure 6–2, *Lenticular Cloud Over Duck Lake*.

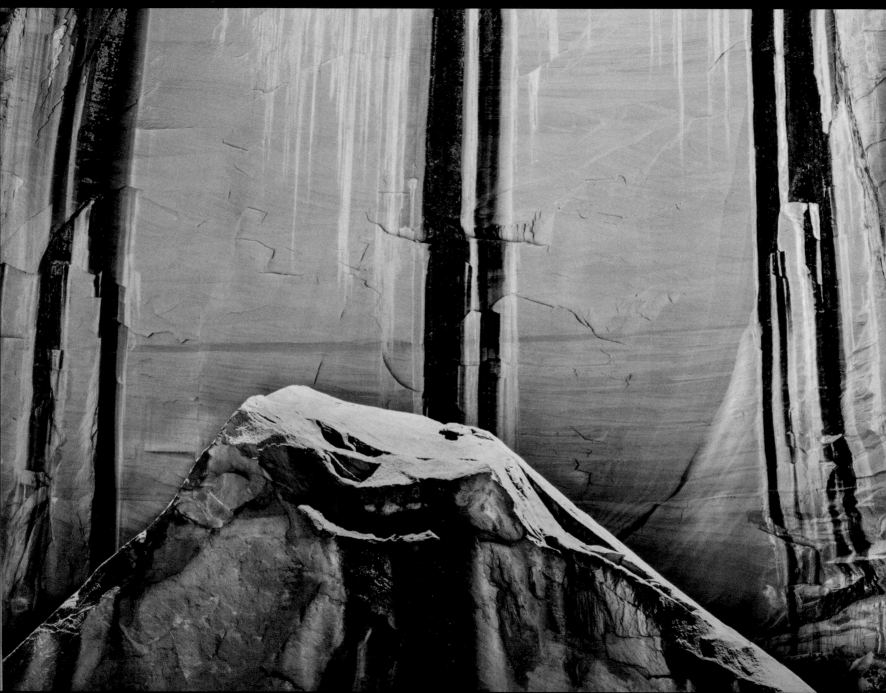

The Heart of Intuition and Creativity

INTUITION IS SOMETHING WE ALL HAVE to one degree or another. It doesn't seem to be something that can be learned or taught, but it can be discussed, and it can be recognized as a valuable asset that can be utilized when appropriate. Most importantly, intuition can be developed, because it is basically a product of long-term observation and understanding. It should certainly not be dismissed as meaningless.

I feel that intuition and imagination go hand in hand, and both are prerequisites for creativity. But they don't come out of thin air. Behind them is a vast amount of deep interest, observation, knowledge, and involvement with the subject. Nobody can be intuitive or imaginative in a realm in which they have no knowledge, interest, or involvement.

Beethoven learned musical composition from the best composers of his day, with the likes of Haydn and Mozart as his prime models. Then he went beyond them, far beyond. Beethoven changed the way music was understood, composing pieces unlike anything that had ever been written as he probed further into the emotional depths and content of the medium. He could not have accomplished all that he did without a solid grounding in the field of music, an overwhelming passion for music, and direct involvement in composing music.

A century ago, an obscure man with a strong background in physics asked what the universe would look like to a particle traveling at the speed of light. The question itself was a leap of imagination. It was pure intuition and a remarkably brilliant mind that then led Albert Einstein to the special theory of relativity, and 10 years later to the general theory of relativity, which answered some anomalies

◀ *Rock and Wall, Silver Falls Canyon*
The relationship between the water streaks on the boulder
and those on the huge sandstone canyon wall was inescapable

in the orbit of Mercury around the sun that even Newton's theories failed to explain. It also lead to the famous equation E=mc2, which showed that matter and energy were two sides of the same coin, an astonishing transformation in scientific understanding. This all started with insight, intuition, and imagination, all based on a deep understanding of and involvement in the field of endeavor.

Mark Twain, a great writer for at least half a century, ended his career with *Letters from the Earth*—in my opinion, the best book ever written—which showed Twain's full grasp of human characteristics and foibles, proving that Twain was easily a hundred years ahead of his time, and always will be. It was withheld from publication for over 20 years by his daughter, who thought it would harm his reputation. But this extraordinary, short book is a tour de force of insight, imagination, and creativity, not to mention sarcasm and humor.

Other geniuses, too numerous to mention and in so many diverse fields, have changed the direction of our thinking—from Rembrandt to Dali in painting, Newton to Feynman in physics, Bill Gates to Steve Jobs in personal computing, and Jeff Bezos in marketing. All of these people have had dramatic impacts on our lives, even if we are not aware of it. They exhibited remarkable insight, intuition, and creativity. None of these qualities are exhibited by inactive minds. These people were all well versed in their fields and were looking to go beyond anyone who preceded them, and they succeeded in doing so.

Creativity Requires Preparation

Paul McCartney, perhaps the most storied of the storied Beatles, told of how he sat in his room one day trying hard to come up with a new song. He was devoid of ideas and was about to slump into bed tired and defeated when suddenly the song "Nowhere Man" jumped into his head in its entirety—words and music. It was there, complete, start to finish.

Most of us hear a story like that and say, "I want to do exactly that in my field." Of course we want to do that. So what's the key? How do we do that? Needless to say, there is no formula for doing that. There's no key. When we hear that dispiriting news, most of us say, "So that proves you can't *teach* creativity." That's probably correct. I've already said that you can *prepare* for creativity, but you probably can't *teach* it in the sense of making it happen. The key to creativity is preparation.

The six prerequisites listed in the following section are the basis for creative thinking in any field. Total involvement is a great part of that preparation. That doesn't mean you have to be engaged in your pursuit 24 hours a day, but you do have to think about it often and deeply, you have to love doing it, and you have to want to get back to it even during those times when you're obligated to do other things. Does this mean you have to be obsessive? Maybe, but not necessarily. It simply means that you have to be deeply involved in the issue.

McCartney was deeply involved in music. Not just the type of music that he produced with the Beatles when they were working together as a group, but also on his own after they split up. He was open to all forms of music, from classical Western music to sitar music from India. He knew a lot about music. It was running through his mind at all times. Maybe he was obsessed, maybe not; we can only speculate about that. But it is certainly true that he was deeply immersed in music.

I have been involved in photography for more than 40 years. I think about it all the time, not continuously to the exclusion of other thoughts, but throughout the day as I go through life. I see lots of things in terms of "pictures," as if I had my camera in hand at every moment. I think of possibilities of doing new and different things in the field, in the darkroom, or on the computer. In short, I'm involved even when I'm not actively engaged.

You can do the same thing, but you have to start with a solid basis of knowledge in the field. That's where most people

fall short: they want to be creative, but they don't want to put in the time for proper preparation. McCartney put in huge amounts of time understanding music, so thoughts that he wasn't even consciously aware of were regularly stirring around in his head. Looking back at the list of formidable people at the beginning of this chapter tells you the same story: they were all deeply knowledgeable in their respective fields, and were prepared to work their way into new realms of creativity.

There is no substitute for adequate preparation. But if you work your way to the highest realms of knowledge in your field, if you earn a Ph.D. and go on to the most esteemed post-doctoral program, it still doesn't guarantee that you'll make startling breakthroughs in your chosen field. It means that you are at the top of your field, and you're probably as smart as any of the other folks around you within that field, but it doesn't assure that you'll achieve the key breakthrough in thinking that turns you into the next Einstein, Monet, or McCartney.

What does? You, and you alone. There can be no guarantee. But if you have the background and are willing to try some new things, some new ideas, some new combinations—with the recognition that failure is possible—you may be ready for something truly creative. Nobody can give you the "aha! moment." Nobody can define how it happens. Often it requires the ability to ask the right question, to make the right adjustment to an unexpected finding or situation, to put several things together in a way that nobody has ever put them together in the past. That's the key to creativity.

What Drives Creativity?

What are the differences in forces behind one person who is highly creative and the next person who simply "goes along to get along," just completing the day-to-day tasks without any true creative drive? Why does one photographer strive to create new, different, deeper imagery, while another photographer is content with producing good, solid imagery, but imagery that fails to set itself apart as creative and insightful?

In *The Art of Photography* I discuss creativity and intuition in the latter chapters of the book. I list five requirements for creativity: desire, thought, experience, experimentation, and inner conviction. I have no reason to change my mind about what I said in that book, and in fact, some of it bears repeating or further discussion here because I believe it is the core of creative thinking. In this book, I want to add another requirement: enjoyment. Go through the following six requisites, applying them to the innovators cited at the beginning of this chapter, and it's easy to see how they all fit together. When you consider these people and others discussed between the covers of this book, it's clear that creativity is not the realm of dullards. Only people who are bright and deeply engaged in their field, people with deep knowledge of their field, and people with a deep passion for their field will prove to be creative in that field.

Let's look at these requisites for creativity, with special emphasis on photographic creativity, for these are the driving forces behind it.

DESIRE: It's hard to imagine anyone being creative in any field—science, business, art—without a desire to go further than anyone else has gone, to dig deeper, and to come up with new insights. Creativity implies doing something new that has never been done before, and doing anything new is difficult. Are you willing to do the hard work, and do you desire to do the hard work that can lead to new or deeper ways of seeing?

Where does the passion to do something, new, different, better, deeper than anything done before come from? I am quite convinced this comes from within. It is unlikely to be forced upon you from the outside. You can be influenced, stimulated, and inspired by others, but it's unlikely you'll be

pushed or forced into truly creative ventures by anyone other than yourself.

I often wonder if the most creative people are reclusive to one degree or another. In order to accomplish their cherished goals, do they have to go it alone? Perhaps studies have been done about this, but I don't know of any, and I doubt that any such study would be conclusive. But it does seem to me that creative efforts are usually accomplished alone, or within a very small circle of collaborators. (This, to my mind, is something different from, say, thousands of experimental physicists and engineers searching for—and finding—a previously undetected particle that theoretically gives mass to many other particles. This finding has already led to a Nobel Prize for physicist Peter Higgs, who predicted its existence decades ago. The search for Higgs's particle was a massive collaborative scientific effort, quite different from Higgs's or Einstein's individual insights and revelations.)

THOUGHT: Are you willing to put thought into your photographs before you start on any new project, or even before you release the shutter for each new image? Are you thinking of all the controls that you have at your disposal, each of which has a large effect on the outcome of the image? How much have you considered camera position, the exact location in space of your camera lens that will maximize the interesting compositional elements? Have you thought about the exposure of the image and the development of the negative if you're shooting film, or the exposure and potential need for HDR if you're shooting digitally? Have you considered the final image as you look at the scene; not just the scene in front of you and your camera, but the final photographic image you want to present to the viewer? This is akin to asking yourself how you want the photograph to *look,* which is the same as asking yourself what you want to *say* about the scene. How you transform *the scene in front of your eyes* to *the photograph you place in front of the viewer's eyes* is your interpretation of the scene.

Are you aware of problems or distractions within the scene that can destroy your photograph? Have you thought of ways to eliminate those problems prior to snapping the shutter? You probably haven't created the scene—whether its a landscape, portrait, architectural study, macro detail, or whatever—but you will create the final image. You have immense artistic leeway, but only if you choose to exercise it. And that begins before you snap the shutter.

Just prior to publication of this book, my close friend and longtime workshop colleague Ray McSavaney succumbed to lymphona cancer. In response to a letter I sent out to friends, another friend and former student recalled a session with Ray in the ghost town of Bodie during one of our workshops. After carefully setting up his 4×5 film camera on an interior room, Ray spent an extended period of time adjusting the setup—moving a chair slightly, adjusting his camera position slightly, and lowering or raising the camera on the tripod, each time inspecting the image carefully from behind the camera. After watching this slow dance for some time the student got bored and left the scene.

When he returned some time later, he found Ray taking down the camera, and asked, "Did you like what you got?" A smile slowly came across Ray's lips and he said, "I didn't make an exposure."

The thinking process can be a double-edged sword. Along one edge there is the careful observation that Ray put into the potential setup, undoubtedly accompanied by his mental review of images he already had. Even after much alteration and preparation, the image fell short of Ray's desire, so he walked away. This type of deep thought and reflection—followed by a rejection of the image entirely—is almost unheard of in today's digital world, where it is more likely that each of the arrangements would have been another digital capture, with the best to be determined by comparison and editing later.

The other edge of this sword is the possibility that Ray was wrong. Maybe the image was a strong one, but he just didn't

see it at the time. Perhaps he should have made the exposure and decided later if it was worthy or one for the unprinted archives.

I feel that too little initial thought is involved in today's digital world. On the other hand, I can see the potential benefit of making an exposure and deciding later if it is worth anything. I have noted in this book how I have discovered old, overlooked negatives years after I made them, and found some to be among my best.

In this case, however, my guess is that with Ray's careful, analytic, and supremely artistic mind, he made the right choice.

EXPERIENCE: Experience can give you ideas and insights that you surely don't have as a beginner. You can reach back into this trove of knowledge to help you with different or even similar situations, and acheive new and richer outcomes. On the other hand, experience can make you lazy, and you may end up doing the same things over and over because they've worked well in the past. If that's what experience does to you, then you've used your experience to put yourself in a rut. Experience used well can be a great benefit; experience used improperly can be a great impediment.

EXPERIMENTATION: Any time you're trying something new and different, you're experimenting. Any time you're not experimenting, you're probably doing the same thing repetitively. Creativity requires some experimentation. You've got to get out of the rut of engaging in a routine simply because it has worked in the past. So ask yourself, how often do you try something new or different in a situation in which you're already comfortable? If you don't experiment with some new approach, some new way of seeing, some new way of thinking (even about old, well-explored subject matter), or some new way of digging deeper, you're probably not creating any new imagery. Yes, it may be a new picture, but it may not be

a new idea. You've got to explore new ways of thinking, new techniques, or new materials or equipment (see chapter 7). If you don't, you are simply reinventing the wheel and will get nowhere on the road toward creativity.

I am always questioning my own level of creativity, or lack thereof. It's easy to lay back and work the same way you've worked in the past in situations that are similar to those you've previously encountered, knowing that the result will be successful. Sometimes that's the way to go, and trying something new and different will end in disaster, but once in a while you have to go out on a limb and try a different, experimental approach. If nothing else, this keeps your juices flowing, and it also keeps your interest level high.

Experimentation often ends up in failure. That's to be expected. The famous lubricant WD-40 failed 39 times before its chief researcher came up with the successful formula on his 40th try. Are you willing to fail 39 times before finding success? Probably not. But it's worth trying and failing at least a few times before you hit something successful. The problem is that most people hate failure so much that they'll do anything to avoid it, including staying in the same rut that they consider success, but that soon becomes boring repetition. They won't experiment. They're afraid of experimentation because they're afraid of failure. But just consider this: when you fail at a photograph, you're probably the only person who will know it. So you may be disappointed, but at least you won't be embarrassed.

INNER CONVICTION: You may be hesitant to go where you haven't gone before. I surely was when I cautiously put my toe in the water of abstraction. This can only be overcome with an inner conviction that going there is simply okay. As I have noted, I received a critically needed push from Brett Weston that resulted from just seeing his abstract images. Maybe I would have gone there myself; I was close enough. But Brett's images pushed me into the pool, where I've remained happily.

You may need encouragement from others. You may be able to do it yourself. But one way or another you must have the inner conviction to move forward, even in the face of disapproval from others. You have to believe in yourself and in what you're doing.

You shouldn't be a knucklehead about it, doing utterly stupid or useless things that everyone tells you are patently foolish. It's worth listening to others. But you have to make the final decision. And if you feel that the unusual work you're doing has some value to it, you must pursue it. Don't be bullheaded about it, but on the other hand, don't be a wimp when it comes to creativity. You have to have the inner conviction to go with your passion.

ENJOYMENT: Perhaps more than any of the five requisites listed above, enjoyment has to be part of the mixture. You can call it enjoyment, fun, enthusiasm, or any other appropriate word, but it all comes down to the same thing: you've got to love doing whatever it is you're doing. You can't force yourself to love doing photography; you simply have to realize that you love doing it. It's fun. It's rewarding. It's fulfilling.

I'm sure that the great innovators I named at the beginning of this chapter loved doing the work they were doing above all else. They were engulfed in it, and couldn't (or can't) wait to get to it each day. It's their passion. You don't have to be as brilliant as Einstein to be innovative and creative in photography, but you do have to love doing it, and you have to be open to the other requisites listed above.

"Know Thyself"

So let's see how this can be applied to your photography. If you're a good observer, a careful observer in the fields that interest you most, you'll begin to recognize where and when the opportunities are, and where they're far less likely to be. A street photographer quickly knows where the action is likely to be, and where there's likely to be little or none. A fine portraitist will be someone who understands people, their thoughts, their characteristics, their body language, and the best way to interact with each person to a far greater degree than that of the average person. If you're one who is drawn to people in that way, and likes to interact with people, it's quite likely that you can make fine portraits, either in a studio setting or out on the urban streets, or in the lonesome roads and farmlands of rural America, or in foreign countries.

Perhaps you are not drawn to all people, but to specific types of people. Cowboys, for example, carry a romance for many people who are drawn to them not only for the work they do, but for the wide open spaces in which they do it and the total lifestyle that it represents. It's a whole package. Above all, cowboys tend to draw photographers who want to depict the individuals who have dedicated their life to that type of work, individuals who are simply different from, let's say, your typical office worker on the 35th floor of a building in New York, Chicago, London, or Buenos Aires. If you're drawn to people working out in cattle country rather than those folks on the 35th floor, you would do well to get into the ranches where they reside, away from the big cities.

While this is obvious, it seems that a lot of photographers who dream of photographing cowboys don't connect the dots. They live in cities themselves, and view the wide open spaces with a degree of interest, but also with fear and anxiety. They think they want to go to the country to photograph the cowboys but they're scared to do it.

This is just one example of people who want to photograph a specific type of subject matter—any subject matter you can conceive of—but are restrained by unknown forces that they apply to themselves, preventing them from doing what they think, or claim, they want to do. I think it's all phony. People who *deeply* want to do something do it! Those who claim they want to do something, but really lack the enthusiasm and

inner fire, don't do it. It's really that simple. They're fooling themselves about claims of real interest where none exists. You have to level with yourself about what really turns you on and what doesn't; what you'll push for to the exclusion of other important things, and what you'll idly dream about if you had the time or money to do it.

I'm not a portraitist. I've made a few portraits over time, and even a few that I like, but it's not my forte. Years ago at one of my workshops, an older gentlemen introduced himself by name and occupation during our opening introductions, and then added, "...and I like people in particular, but I don't like people in general." When he said that I nearly leapt out of my chair as if my team had just scored a touchdown. He had perfectly expressed my own thoughts, and I've stolen his words many times since then.

If you're going to do portraits or street photography well, you have to be drawn to people. Maybe to specific types of people. I'm not. I don't try to fool myself about that. I'm drawn to the land. I'm drawn to abstracts. I'm drawn to architectural subjects. I'm drawn to creating new, imaginary worlds through my composite images. I'm not drawn to people as photographic subject matter.

Creative, expressive photography is not simply the act of pointing a camera at something and clicking the shutter. Anyone can do that. It's the act of truly saying something visually that makes others take notice. In order to do this, you have to discover what it is you're interested in and what you want to say. And conversely, you have to recognize what doesn't interest you, and identify the subjects about which you have little or nothing to say.

Applying Insight and Intuition to Photography

In the mid-1900s, the great street photographer Arthur Fellig, known as "Weegee," developed a camera with an extended lens, which was actually a tube with a mirror in it set at a 45-degree angle. This allowed him to photograph a scene that was 90 degrees to his right, even though he was pointing his lens straight ahead. He would show up at crime scenes or auto accidents, and while it looked as though he was aiming his camera at the carnage in front of him, he was actually photographing the onlookers viewing the scene, who often revealed a variety of reactions from revulsion to outright glee. Fellig showed that such incidents were almost carnival-like in many ways, providing real entertainment for the gawkers. It was tremendously insightful, creative work. But it could only have been done by someone who first noticed the various reactions from onlookers at such events. Once again, keen observation and deep insight were key to his imagery.

Landscape photographers tend to "sniff out" weather and lighting conditions that are likely to produce good images. Ansel Adams lived half the year in Yosemite Valley for decades, but he didn't photograph there on a daily basis. Although the cliffs were just as impressively high every day, the weather and lighting conditions varied greatly, and he recognized that. He photographed when ephemeral lighting and weather conditions were likely to yield a better image.

I had never been to Peru or Machu Picchu when I was first invited to teach a workshop there in 2009. So I initially asked, "When is the wet season, and when is the dry season?" Then I said, "I want to time the workshop for the transition period between the two." I knew in advance that I didn't want to be there when it was pouring rain all the time (making it tough to even take my camera out), nor did I want to be there when there wasn't a cloud in the sky (when all the postcard pictures are made). I wanted to be there when conditions were in flux. I felt

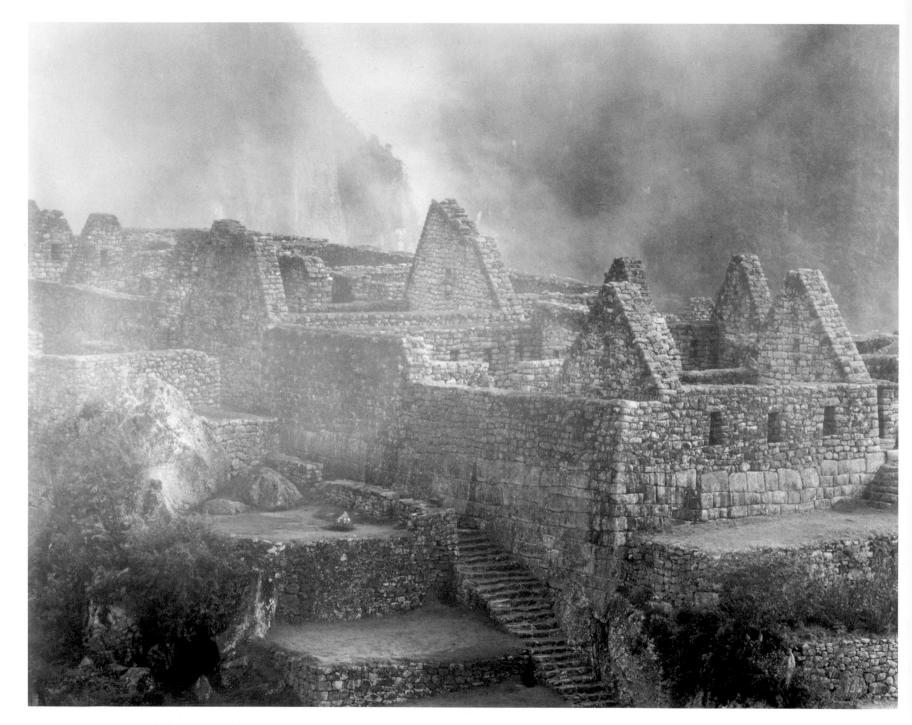

▲ *Figure 5–1: Rooftops in Fog, Machu Picchu*
Atmospheric conditions, specifically clouds and fog, turn the remarkable Inca ruins of
Machu Picchu into a dreamlike experience. On a clear day, perhaps in bright sunlight, the
structures would still be quite striking and wonderful; seen through the mist and fog the
scene takes on a thoroughly different character.

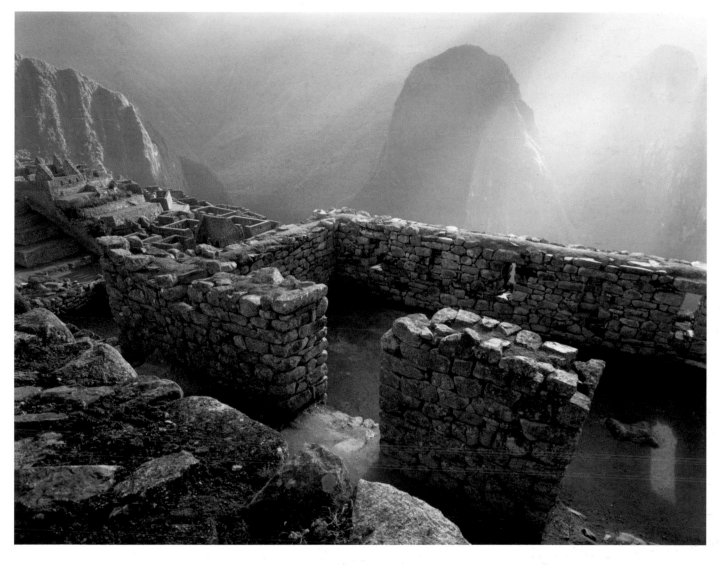

◀ *Figure 5–2:*
Sunlight Through the
Mists, Machu Picchu
Even on a morning with
no clouds, there was so
much humidity in the air
that a magical quality of
light hung over the region
like a gauze veil. The brief,
unexpected period in
which there were no
clouds came to a quick
end, as fog and clouds
soon boiled up from the
canyons and down from
the high mountain ridges
all around. That, too, was
an ephemeral, dreamlike
experience.

that would be the perfect time for some good photographic opportunities (figures 5–1 and 5–2). Observation and experience give you insights, and then you can let your intuition and creativity take over.

Like so many of us, I had seen many photographs of Machu Picchu before I went there. So I knew what I was about to see; that is, until I walked through the entry gate. The scene in front of me was so utterly different from any photographs I had ever seen that I was astounded. I felt like I had never seen a photograph of the place. It was magical. The mountainous, tropical-jungle setting overwhelmed the extensive Inca ruins set atop a nearly knife-edge ridge. The surrounding moun-

tains would disappear before my eyes and then become visible again as clouds and fog moved through the area, sometimes sweeping upward from the deep canyon below, and other times cascading downward from the higher mountains that seemed to go on forever. It took several years of photographing there, for just a few days each year, for me to be able to fully take advantage of the rapidly changing atmospheric conditions. Eventually I put together a small set of images that most closely parallels my basic thoughts about Machu Picchu: that Machu Picchu doesn't actually exist; it's but an evanescent dream.

My initial questions about the timing of the wet and dry seasons, and my desire to work in the transition period between the two, were based on my experience with weather conditions that could be beneficial for good outdoor photography. Over time, such experience becomes so deeply entrenched in you that you really don't even think about it. You just go for it. It didn't take me a nanosecond to think of asking those questions; they were simply there. The transition period was the obvious time to go. Observation and experience over time led to intuition.

Similarly, although I have written about looking at lines, shapes, contrasts, and all the other compositional elements of a photograph, it turns out that when I'm setting up the camera, some of those concerns may be on my mind, but it's more likely that none of them are. Most of the time a composition simply "feels right." It can't be any other way. My guess is that I've internalized my reactions so completely that little of it is conscious thought; it has become part of my subconscious procedure. It's basically intuitive, not cerebral.

Perhaps later I can explain why I did what I did—why I set up the camera in exactly that location, why I chose a specific focal length, why I framed the image exactly the way I did, and all the other things that went into the exposure. But I know with certainty that I was actively thinking about and was aware of the *light* on the scene. I was aware of how light affected the scene, and if there was anything that needed to be (or could be) altered to improve the light.

I suspect that Ansel Adams didn't give much compositional thought to *Moonrise, Hernandez, New Mexico* while setting it up. In fact, he wrote that he was working as fast as he could before the sun set, and after making the exposure, he went to turn his negative carrier around for a second exposure, but the sun set before he could do so. For Ansel, the composition simply felt right and he rushed to capture it. I doubt that Beethoven spent much time thinking "what comes after Da Da Da Dummm?" It was perfectly obvious, and was the only way

to go. I doubt that Picasso spent a whole lot of time thinking about the compositional elements of his monumental, deeply haunting painting *Guernica*. All of these things were internal and unavoidable.

But let's face it, nobody starts out like that. Einstein, Bach, Rembrandt, Jobs, and all the other greats of their respective fields achieved their status by knowing a great deal, observing a great deal, and putting a great deal of their insights into their work. Insight and intuition aren't just there; they are products of observation, knowledge, and experience. You can't be intuitive or insightful about anything you don't know. You have to work to get yourself there.

I chose the several examples that start out this chapter because people like Einstein, Beethoven, and Jobs represent great insight, intuition, and creativity in science, art, and business. I do not believe the basic approach to intense creativity is different in any of those seemingly diverse fields. It always starts with a great deal of interest, a great deal of knowledge, and a few insights that others who were equally brilliant never saw. You don't have to be as brilliant as any of them to connect a few dots in ways that nobody ever has before. And that's often what creativity is: the simple act of putting together two or more well-known ideas in a way that nobody has ever put them together. The ideas were there, but nobody ever looked at them in relation to one another in that way. That's creativity. But I doubt that it happens without a deep understanding and knowledge of the field.

Trusting Your Intuition

Just as most people place obstacles in front of themselves that prevent them from doing things they want to do, or claim they want to do, I have found people who have a great deal of knowledge and insight into things, but they never move forward because they're afraid to apply their own well-founded

intuition to the task at hand. They feel that intuition is silly and often wrong. It is unscientific. It is something to be overcome with any number of carefully considered measurements before proceeding.

Insight and intuition are attributes to be relied upon, not avoided. Small insights can lead to small breakthroughs, and sometimes even large breakthroughs. If or when you have a "feel" for something, it's worth going for it.

Have you ever met people who display uncanny intuition about other people? They seem to know who is good, who is honest, who can be trusted, and who cannot be trusted. These are people who have simply observed and experienced human behavior for so long that they can see through the many veils we all hide behind. These intuitive folks are not considered geniuses like those listed at the beginning of the chapter, but they are as keenly observant as those listed above, and have parlayed those years of experience into valuable insights into other folks' characteristics. But even this doesn't come without work, even for those intuitive folks who never thought they put any work into it; they just internalized it all along the way.

If you are already doing photography and reading this book, chances are you have already invested a good deal of time in your photography. Photography is important to you. You love doing it, and you are constantly striving for better results, not just to impress your friends or family, but primarily to satisfy yourself. I'd recommend that you start to use more of your intuition wherever you can, even where you have generally thought you couldn't or shouldn't.

Let me give you a couple of small examples from my workflow that may help free you up in terms of trusting your intuition. In the darkroom, when I am printing, I use a much more dilute developer than Kodak recommends. Kodak recommends Dektol diluted 2:1 with water. I dilute it 5:1, but I also develop for an extended time. Kodak recommends 1 1/2 to 2 minutes as standard developing time, and I develop for about 5 minutes. I never time it, I just do it. Students at

workshops over the years simply don't believe that I can tell when five minutes are up, so they first assume that I must be counting out the time. I point out that during my printing demonstrations, while I'm agitating the print in the developer, I talk to the students about what to look for in the developing image, what I'm doing, what I plan to do next if the image still isn't satisfactory, or any of a number of other things. I can't be counting out the time while I'm talking about other things.

So they turn to the next means of sleuthing out what I'm up to: they surreptitiously time the full development, obviously skeptical that I'm really developing for five minutes. Amazingly, they find that I'm within seconds of the stated five minutes. I know that I have a feel for that time, so I just do it. It's intuitive. I tell students to loosen up and try it themselves rather than start a timer as the print goes into the developer. If it's not intuitive at first, it probably will be in a short time. The benefit of my procedure is that I get repeatable results, so it's not just a silly thing; it's essential for the quality of the prints I produce. But I do it intuitively.

Another quick example: I don't use a typical 1 degree spot meter to measure light levels in the field. I use a broader 7.5-degree semi-spot meter because it has greater sensitivity in lower light levels. I can intuitively see the range of brightness in a scene, so I don't need to point the meter to the extreme shadows and highlights. I need the meter to determine the basic brightness level, but not the brightness range. I rely on that intuition, and I'm accurate.

Too many photographers feel they have to measure everything. They are scared to rely on even the smallest bits of intuition like these two examples. If you are too afraid to use your intuition for small things like this, you'll never use it for anything bigger. In short, you won't use it at all. That's a loss that you've imposed on yourself. Therefore, only you can power past these impediments to using your intuition. Loosen up. Use your intuition wherever and whenever possible. It's an extremely important tool.

Finding Opportunities for Creativity

Upon reading the material presented so far, some readers may feel that unless you're spending your entire life doing photography you may as well forget about doing any creative work in photography. That's certainly not the case. You don't have to spend all of your waking hours thinking about or doing photography to be creative or to apply insights to your work. What counts is not the *time* you spend with photography, but the *thought* you put into it. In chapter 3 I discuss the differences between the options of a photographic hobbyist versus a professional. Let me return to those ideas and expand upon them, because it's important to recognize that you don't have to be a professional photographer working at it for a living to be creative; in many ways the hobbyist could be in a better position than the pro.

A hobbyist can give some thought to his latest projects at any time. He does not need to think about generating income with his photography, so he's free from worrying about making images that will sell well. The pro is often too occupied with the current job and the next job to give personal work much thought. Of course, professionals can, and often do, bring real creativity into their work, but so can amateurs. I know of sports photographers who have put some wonderful creativity into their work. Maybe the time lapses between sports events give them more time to seriously think about doing a better job professionally, and maybe they have more time to do some of their own work between the sports events they're covering. From what I've observed, professionals with studios—specifically storefront portrait studios—appear to have the least amount of time to devote to thinking about creative ideas.

As I explained earlier, the professional architectural photography I did for about 14 years was quite lucrative, but it was also very sporadic. Due to the fact that I had significant breaks between assignments, I was able to devote a lot of time and thought to my own photography. An amateur may be in the same position while earning his keep in an entirely different field. You could be like the American composer Charles Ives, who became quite wealthy as an insurance man and devoted time to writing his music on the side. He did not need to earn money from the music itself, which freed him up to pursue his own creativity as he pleased. While critics have praised his music, the public has been somewhat less enthusiastic. But regardless of the response he received, he did what he wanted to do as a pure amateur. There are some good lessons to be learned from his example.

I frequently have short stretches of time to do some photographic work and planning, but not enough time to get into the darkroom for a full session of black-and-white printing. Instead, I spend time poring over contact proofs—the direct, straight prints from the negative—to see which ones are worthy of printing. I use cropping Ls to see if cropping one or two edges or a larger portion of the full negative improves the image. Sometimes I rotate the negative to look at it from an angle that is different from the original orientation of the camera, often finding a different and stronger dynamic when the image allows such rotation. I consider the benefits of raising or lowering contrast, overall or section by section, perhaps making the entire image lighter or darker than the contact proof. I contemplate any other alteration that could produce a fine image. Basically, I lay down plans for how to work on each specific negative when I have the time for darkroom work. This turns out to be very valuable time that puts me on track to produce the print I want, and saves enormous amounts of time and money in the darkroom.

For my digital photographs, I work through my most recently downloaded RAW files, searching for those that show real possibilities. Then I work on them in both Lightroom and Photoshop, moving toward a final image. If the progress I see using Lightroom doesn't put me on a high enough plateau, I drop the image. I continue with those that show promise,

and usually end up doing some amount of finishing work in Photoshop.

Similarly, you can devote some of your idle time to thinking about what you've produced photographically, what you may want to do in the future, and how you can improve on the things you've done in the past. That's not wasted time. To the contrary, it's extremely useful, productive time that will prove its value the more you engage in it.

Beware, however, that digital imagery may possess within it a problem not present in film photography. As memory storage changes and improves, today's memory systems may grow outdated, just as floppy disks, zip drives, and, more recently, CDs have been cast into the dung-heap of history. So older imagery may have to be updated to stay accessible. But this raises the question of whether you update all of your past imagery or just your most important imagery. How can you determine which is the most important imagery? As I've already noted, my experience has been that some old, overlooked negatives are among the best I've produced, but I failed to recognize it for years. With film, I can access everything I've ever done at any time. That luxury may not be readily available as digital processes evolve.

As I pore over new or old contact proofs that could possibly turn into really wonderful images, I look beyond the image seen in the proof print to the possibilities inherent in the final image. Sometimes the two are vastly different. In the final image, I may have cropped out meaningless areas that seemed worthy when I framed the image at the scene, but no longer strike me as being needed. Perhaps I've dramatically raised the contrast of the remaining portions, or made other alterations that transform the bland contact proof into an exciting final image. Keep in mind that the contact proof is simply a straight record of what is on the negative, nothing more. This is the final stage of transformation from the original scene that caught my attention, to the negative (or RAW file) that starts the photographic process, and then to the final image.

Personal Examples of Creativity

The question of where creativity comes from is probably impossible to answer in a precise manner. Nobody could determine how Einstein came up with the thought of how things could look to a photon traveling through space at the speed of light (which is what photons do), perhaps not even Einstein himself. The same imponderable would apply to how Beethoven went so far beyond the music of his day.

I've experienced moments of inexplicable photographic creativity a number of times over the years. Following are stories of four different experiences resulting in photography projects that were different from anything I had done before.

Example #1: The Darkness and Despair Series

On January 20, 1993, a fierce windstorm blew along the Pacific Coast from Oregon through Washington, uprooting tens of thousands of trees. It hit our 20-acre forested property in the North Cascade Mountains north of Seattle, with a microburst uprooting so many trees that we were forced into a tree removal operation that took out 17 truckloads of uprooted trees. In the clean-up that followed, I found a small log that was no more than 6 feet long with a string of tightly wound burls along one edge, and I set it next to the trail I was rebuilding to photograph later. Strangely, although I passed that small log nearly every day on my dog walks, I failed to pull out my camera to photograph it. I basically ignored that small log for years, not even studying it for photographic potential.

During those years I was deeply engaged in a major local environmental battle, leading a group of local residents and other concerned citizens fighting a proposed sand-and-gravel mine and hard-rock quarry down the road from my home. We won every major environmental legal battle in front of the county hearing examiner, a pseudo-judicial position created

▶ *Figure 5–3: The Centrifuge*
I initially photographed this as a
horizontal image, but I realized that if I
turned it 90 degrees, it looked like a
head cut in half, with the brain
removed from the skull. It helped make
the statement I wanted to convey
stronger.

by the county to decide land-use conflicts. Ultimately, he denied a permit for the project. But the county council illegally overturned the hearing examiner's decision, and granted the company its permit. We won every legal battle, but we lost politically.

I was teaching a workshop in Norway just prior to the county council's decision to grant the permit, knowing that we were about to be trampled by the politics and enormous amounts of money behind the project. One night, while reading in my room prior to going to bed, I looked up at the wall behind the desk and said almost out loud, "I've got to photograph that log!"

At that moment, I knew with 100-percent certainty that photographs of the burls on that log would express my anger, frustration, and rage about being bulldozed in this long-running environmental battle. I cannot explain how I suddenly focussed on that log while sitting 5,000 miles away from it, nor can I explain my absolute certainty that it would supply the required imagery to express my feelings. I simply knew I had to photograph that log, and that it would give me the expression I so desperately needed. It turns out, it worked perfectly (figures 5–3, 5–4, 5–5, and 2–6). I call the series "Darkness and Despair."

Generally I look to landscapes, abstracts, and most other potential imagery for their beauty and general uplifting qualities. Here I was seeking imagery that would express the darkest and most negative of emotions. In essence, it went against anything I had ever done. But deep negative feelings can be as valid as deep positive feelings, and these images had to be made.

So I photographed that log in 1999, more than six years after finding it, and just after the Snohomish County Council permitted the project. I photographed for about two hours on each of three days; under soft, cloudy lighting conditions; using my Mamiya 645 medium-format camera with extension tubes for close focus. No image covered an area of the log

▲ *Figure 5–4: Downward Spiral*

The thought in my mind behind this image was the downward turn that I was experiencing as political forces first tried to alter the legal hearing over the gravel pit project, and in the end, overturned the legal decision against the project, granting the company its permit.

▲ *Figure 5–5: Distortions*
Many viewers see a badly distorted, partially squashed face in this image, which was precisely my intent in creating it. In the end, we were crushed by the politicians who seemed to have patronage, not the law, in mind. But, of course, they are politicians.

more than five inches on a side. Due to the macro focussing, much of the area within each image was out of focus. In the printing, I blacked out most of the out-of-focus areas, printed much of the imagery to very dark tones, and bleached back the highlights to whites and near-whites. All of the images are printed at 16×20 inches.

In one sense, the images are impressionistic, with little in sharp focus. But while most impressionistic painting gently pushes you back from the image in order to see it as a unit rather than just the seemingly arbitrary brushstrokes, the "Darkness and Despair" images tend to push you back violently with their deep blacks, shrill highlights, and tightly wound forms.

The images gave me the expression I wanted, yet the series is a creative departure from much of my photography.

Example #2: "Spit Photography"

Titus Canyon is on the east side of Death Valley, and it is drivable via a 26-mile one-way road that narrows to a single car width toward its lower end. Within the deepest, narrowest stretch the towering walls are studded with small outcroppings of smooth translucent rock, which upon close inspection, looks like the inside of a geode. The smooth rock, however, is weathered, and while it remains quite smooth to the touch, its transparency is marred by the hazy patina that weathering has given it.

It would not be easy (and it would certainly be illegal even if it were easy) to go in and polish those outcroppings to achieve the transparency necessary to see the brilliantly colored, agate-like forms clearly beneath the exterior fuzziness. But upon seeing those forms and colors for the first time through the hazy surface rock, I quickly realized that all I had to do was wet the surface to give it a wondrous transparency.

Fortunately, I had a full canteen of water with me, so I took a full swig of water and sprayed it out onto the smooth rock surface. Voila! Suddenly the haze disappeared and the surface became transparent, allowing the forms within the rock to be seen with brilliance and clarity (figure 5–6).

I now take students into Titus Canyon with me on my Death Valley workshop, telling them to be sure to bring at least one full canteen of water with them. They think I'm warning them about staying hydrated in a very hot location, but it's really to give them the means to better photograph these remarkable outcroppings in their most brilliant state.

Here, once again, is a creative way of putting two disparate things together: photography and rock polishing. "Spit photography" isn't exactly the same as rock polishing, but it served the purpose just as well. Within minutes—sometimes within seconds—the water evaporates, and with it so does the transparency it imparts. You have to work fast under the

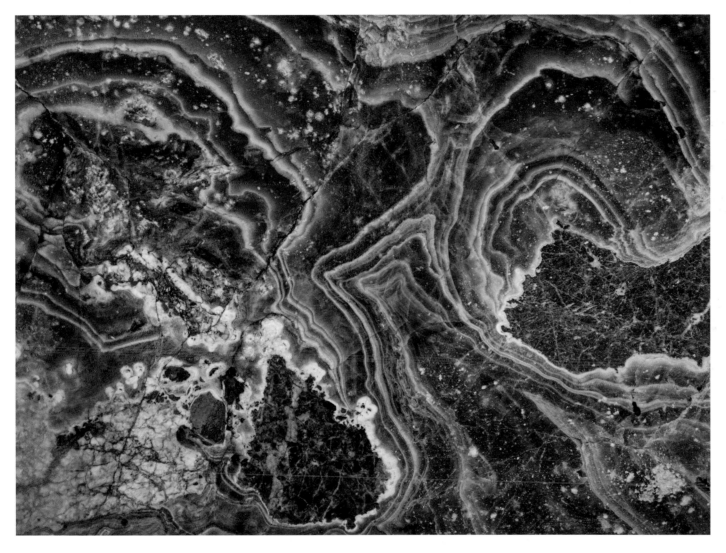

◄ *Figure 5–6:*
Nebula, Titus Canyon,
Death Valley
Pouring some water on the nearly horizontal surface of this smooth rock made it almost transparent, allowing the underlying crystalline structure to be seen in its full glory with all the vivid colors and flow of form unobstructed. It reminded me of the fabulous astronomical photographs we've all seen from the Hubble observatory of nebulae within our own Milky Way galaxy.

circumstances. And best of all, there is no temporary or permanent harm done to anything in the process.

Now, I have to admit that spit photography in Titus Canyon will never be recognized on the same level as Einstein's Theories of Relativity for creative genius. But I'm not trying to compete with Einstein. Nobody can. I'm seeking small bits of creativity wherever I can, and I think that could and should be the goal of every serious photographer.

Example #3: Labradorite

As I am writing this book, a whole new set of creative photographic imagery is unfolding to me. Again, it's strange and unexpected, but hey, who cares where it comes from? If it's there, take advantage of it.

If you look at the images first, you will probably be utterly confused by what you're looking at (figures 5–7, 5–8, and 5–9).

▲ *Figure 5–7: Gloved Hand*

Within the glistening spectrolite of this remarkable stone, any number of colors and forms can be discovered. If you move, some colors and forms may disappear while others emerge. It's like an interactive art project, so that as you move, it changes. And as the light source moves, it changes. In this image I saw the edge of a gloved hand, with the thumb slightly below the index finger and the rest of the glove behind it.

▲ *Figure 5–8: Stretched Galaxy*

Just as the wetted rock outcropping in Death Valley reminded me of a nebula, this elegant blue form stretched across the image reminded me of an image I saw of the aftermath of colliding galaxies, where one had been pulled apart by the gravitational tidal effects of the other.

Good! That's my hope. But it is also my hope that the imagery is interesting enough that you either try to guess what you're looking at, or you simply enjoy the imagery as something of mystery and beauty. If that is your reaction, then I have succeeded. If you turned the page, wondering what's next, then I failed.

Now for the explanation. About six months ago my wife and I went through a partial remodel of the three bathrooms in our home, tearing out old cabinets and formica countertops, and putting in new cabinets and polished stone countertops. One of the stone pieces we purchased possesses brilliant fluorescent crystals within it, which are visible only when the direction of the light hitting it and the direction of the line of sight from where you are looking at it (always two different directions) align properly. Then, and only then, do the crystals shine forth in brilliant blues, golds, coppers, greens, and an array of other efflorescing hues.

I was so taken with the qualities of this particular countertop stone that I asked the workers what they did with the oval stone pieces cut out for the bathroom sinks and the rough scraps from around the edges. I was told that they throw them away. I replied, "No, not these scraps. I want them all." I paid for it, so they gave them to me. I had no idea what I would do with them, but I was entranced by the sheer beauty and surprise of it all.

After having our new countertops installed, and now possessing some of the quite brilliant scraps, I returned to the showroom asking if I could have scraps of the same stone cut from other such projects, assuming that they would throw those away as well. They readily agreed to hold those aside for me, rather than just tossing them out. So I started collecting more, still not knowing what I would do with them. I considered making a tabletop, but at 3 centimeters thick and 40 pounds per square foot, a small 3×3-foot tabletop would

◄ *Figure 5–9: Criss-Cross*
One section of labradorite was especially unusual with its intersecting lines of spectrolite crossing one another at nearly 90-degree angles, another fascinating aspect of the internal structure of this rock.

weigh 360 pounds, making it almost immovable. So that idea was discarded.

With the weight as a severe restriction, I finally settled on the idea of making a mosaic on a walkway around one side of our home. It would be much like an interactive art installation, in which the so-called spectrolite would show up or disappear as you moved around the mosaic and as the direction of light changed during the day.

I bought grinding tools to smooth and polish the rough edges for the mosaic pieces, partially to prevent cutting myself on the sharp edges, but also recognizing that the front edges of the mosaic pieces would be visible, and so would some edges within the body of the mosaic. While grinding just days

before writing these words, it suddenly and perhaps belatedly occurred to me to photograph the brilliant spectrolite within the stone.

I've just begun, and I've discovered that it's difficult to place my digital camera at the proper reflective angle to photograph the spectrolite at its most brilliant without capturing my shadow or the shadow of the camera in the image, or catching the reflection of some distracting object in it's mirror-like, polished surface. I may have to look into lighting I've never used in the past, and do not own (like softboxes, for example), in order to fully bring out the forms and brilliant colors I wish to show. But in this preliminary state of unfolding photographic ideas, I'm also thinking of making

very large prints, which may be highly pixelated. Normally I would avoid that like the plague, but in this case, it may work spectacularly—a form of pointillism where you have to step back to see the image, while up close it may break up into a mosaic of tiny colorful squares.

Because the imagery is so thoroughly abstract, I have remarkable leeway. Are the colors accurate? So far, they seem to be quite accurate to me. But what if they aren't? Who cares? It means little to have accurate colors when the imagery is so utterly impossible to grasp without an explanation of what you're looking at. Some viewers may initially think these are photographs of stained glass with light coming through it. Some may see them as Hubble Space Telescope views of a nebula. Of course they aren't; instead they are reflected light off of some extraordinary polished stone. But without an explanation, viewers may have all sorts of ideas about what these images are. That's really wonderful to my way of thinking, and hopefully to yours as well.

I'm experimenting as I'm going. This is all new to me; I'm just at the beginning. What you see here in this book is little more than the start of a new project. At this point, as I write these words, I have no clear idea of where this will end up, but I'm wildly excited about the journey I'm just embarking on. I'm having a great time with this unfolding project that began as a partial bathroom remodel with no thoughts of anything remotely photographic.

Example #4: Aftermath

On October 23, 1978, I was exiting the 101 Freeway two blocks from my home in Agoura, California, when I looked across the road and saw the start of a fire in an empty lot covered with dried grass. It was a day of hot, dry, 70–100 mph Santa Ana winds from the deserts that rake Southern California in the autumn, turning it into a tinderbox. What I saw was the start of the Agoura-Malibu fire that burned 25,000 acres in 24 hours. I lived just north of the freeway, but the fire started south of the freeway and winds were pushing it southwesterly, so fortunately, I knew my home was in no danger.

Following the fire, I would take my dog for a walk each morning in the burnt area, carrying my camera equipment with me and photographing an eerie, charred, black-and-white landscape. I would expose just one or two negatives during each outing, often taking only one or two sheets of film with me. I was having fun walking my dog; the photography was an extra highlight.

Somewhere along the way, perhaps by the time I had exposed 80 or 90 negatives, the thought occurred to me that I had a distinct set of images that were completely different from my other landscapes. Furthermore, I had a story. It was a story of death, but one that would be followed by rebirth, for the plants of the region make it a "fire ecology," which actually depends on fire for seeds to sprout. Suddenly, the random photographs made on the dog walks became a project, a story, one that now needed an ending.

Weeks later I found the ending I needed in a cluster of mullein plants growing out of the charred soil. Ten of the images became my limited edition "Aftermath" portfolio, showing the aftermath of the fire—first the death of the land, then the ensuing rebirth (figures 5–10 and 5–11).

Once again, this is different from anything I had done before that time, or anything I've done since. At first, it was simply a different landscape that was also convenient to where I lived. It was a good area to let my dog run around at will, while I played with him and looked for a photograph here and there. Only toward the end did it become a serious photographic project.

In addition to these instances in which I've explored new subject matter or techniques, I've experienced other unexpected moments of creativity that I've discussed elsewhere in this book. I used the very dilute developer (which I learned

from Ray McSavancy) and a totally new approach to exposing negatives to achieve my initial slit canyon images. The images and the technical methods I used to create them were completely new. I used the same technical methods to then open up another new body of work, the English Cathedrals. I later created a combination of negative developing techniques—my so-called two-solution developing technique—to yield even more from a negative exposed in an exceptionally high-contrast situation. Other major and minor creative acts have come along during my years in photography.

Who knows where creativity comes from? But you can't get there if you close your mind off from it. You have to have an open mind and let things as seemingly unrelated as a bathroom remodel inspire a photographic project, or turn a walk through a burnt landscape into a photographic project, or photograph tiny wood burls on a log as a source of emotional expression. If you're open to it, almost anything can turn into a worthy photographic project. Free up your mind to the unexpected, and you'll find creative ideas where so many people have looked, but none have seen what you're seeing. As I have already said, some creative leaps come from little more than putting together two or more well known ideas in a manner that has never been explored previously.

Creativity abounds everywhere, but always comes from deep knowledge and involvement. My wife, Karen, is a really fine cook (she'd never admit it, but she is). Often when we have guests over for dinner, one of them will ask, "What did you do to make this?" It's delicious, and they want to do it themselves. All too often Karen replies, "I don't know." She's not trying to avoid answering; she simply doesn't remember.

She has such a storehouse of knowledge and experience in mixing spices and other ingredients together that she simply knows that a little of this and little of that will end up as a really delicious combination. Her cooking creativity flows out of her so intuitively that she does it without making the mental notes of what she's done. Unless she were to consciously write

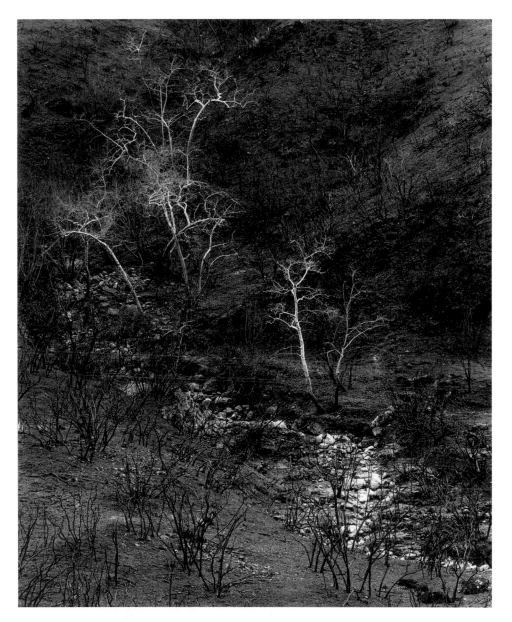

▲ *Figure 5–10: Silver Sycamore Trees in a Canyon*
As twilight settled in, a line of sycamore trees standing beside a seasonal stream stood out like little fluorescent tubes against the charred ground surrounding it. None of the trees were killed in the fire, which swept through so quickly that it merely blackened the lower portion of the white bark without harming it.

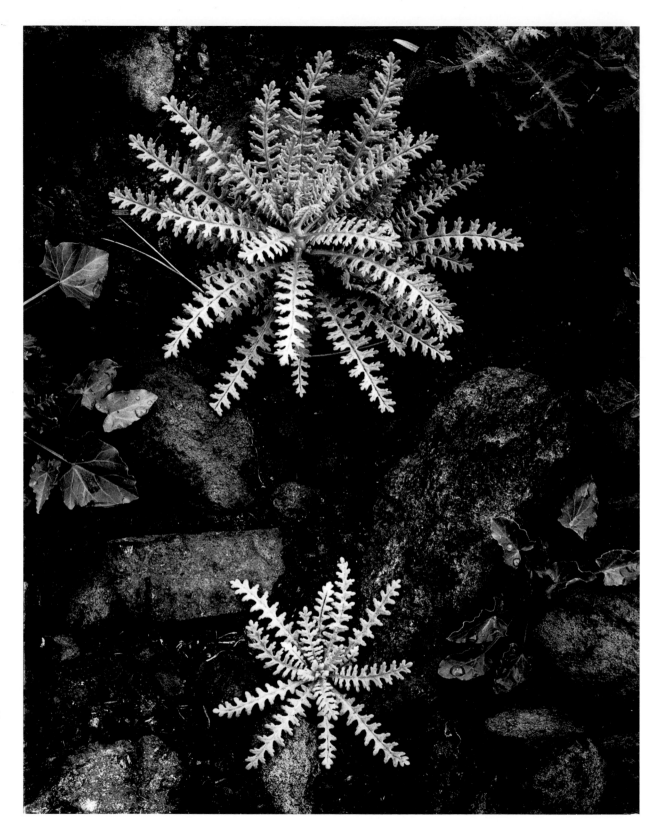

▶ *Figure 5–11: New Growth*
This photograph of lush new growth just starting to spring out of the ashes represented the end to my story of the death and rebirth of the land. Like most of the others, this image is simple and sparse, perhaps even a bit like a visual Haiku.

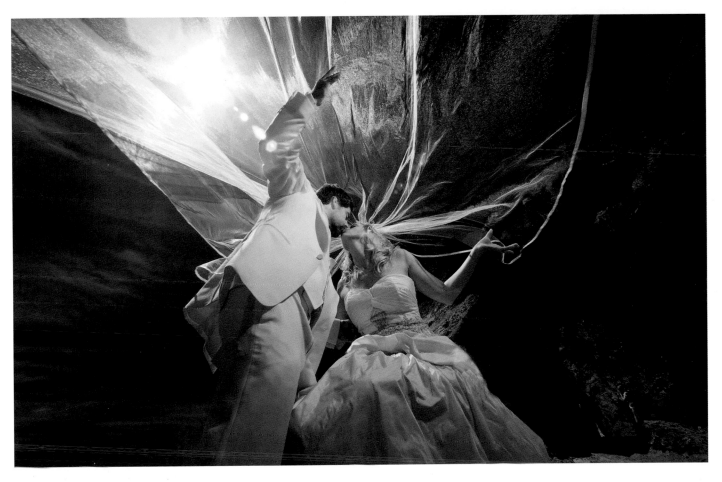

◄ *Figure 5–12:*
The Sunlit Bridal Veil
(courtesy of Clay Blackmore)
A spontaneous moment, when a gust of wind blew the bridal veil above the couple. Blackmore instinctively clicked the shutter to quickly record the unexpected.

down each step, listing each new ingredient and the amount of each, she probably couldn't produce the same meal twice. Each one is a creative endeavor. And I have no objection to that!

Creativity in Unexpected Places

A wedding photographer is generally one who photographs one wedding after another, catching the obligatory images of the bride, the groom, the bride and her family, the bride with her bridesmaids, the groom with his family, the groom with his best man, the moment the vows are made in front of the officiant, and the other expected wedding shots. But, like any other field of photography, there is room for real creativity here as well. Much the same can be said for portraits,

which are usually done in a studio following well-known guidelines.

Clay Blackmore is a Washington DC-based wedding and portrait photographer who has gone against the grain, putting real creativity into his work in the process of building a national and international clientele. He does most weddings in color, with some black-and-white infrared for extra punch. Beyond that, he has fun with photography, engaging in things that most commercial photographers would rarely think of doing, even after an exhausting day of commercial work. His success is based on loving the work he does and loving the people he works with. With an approach that revolves around "pose, light, refine, and then shoot," he says he can begin to work from the heart. "I simply don't think; I feel."

One of Blackmore's favorite photos is an infrared image of a bride and groom walking on the beach in Laguna, California,

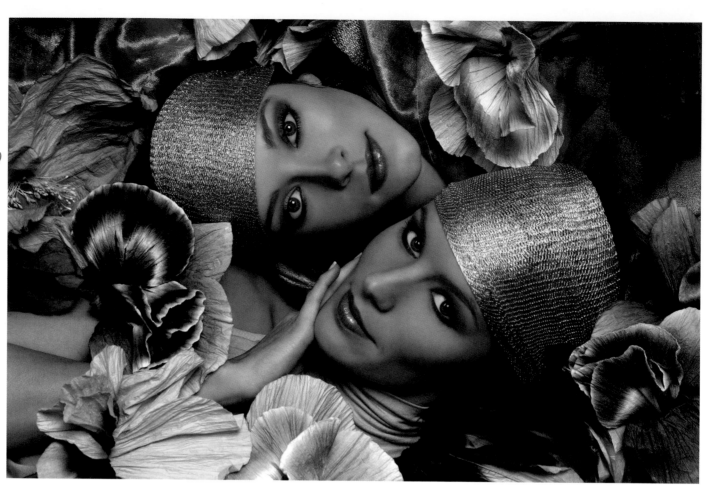

► *Figure 5–13:*
Faces and Flowers
(courtesy of Clay Blackmore)
Contrasting the beauty and soft skin tones of the models with the saturated colors of the flowers, Blackmore created an image that is design-oriented, eye-catching, and almost abstract all in one.

the day after their wedding (figure 5–12). "You need to feel relaxed to create magic, so that's why we photographed the couple the day after their wedding," Blackmore says.

Using a Canon 1DS Mark II adapted to take infrared images, and a 14mm wide-angle lens, Blackmore worked at high noon, with direct sun presenting a major challenge. "Instead of competing with the bright sun, we joined in," Blackmore says. A strong Q flash off-camera, dialed up to full power, was the answer. He set the camera to 125 at f/16, and placed the flash six feet away.

"We started with a few posed images around the water's edge, then we encouraged the couple to walk, laugh, and love. We began capturing the spontaneity between them," he says. "We went low to shoot up toward the sky, creating dramatic backlighting. Just at that moment, the wind picked up the veil and WOW! A few seconds later, it was all over. The moment was

there; we captured it. And then it was gone. That's the beauty of photography."

Blackmore was prepared. He knows that the veil of the bridal gown is one of the iconic symbols of a wedding. When the wind blew it into the air, he acted. He reacted instinctively; he didn't think about it. In a way, it's much like a basketball player working with teammates on a fast break—it's fast, it's in real time, and it's utterly instinctive. At the same time it's totally creative. Blackmore saw the moment and reacted.

The sunlit veil is the obvious attention-getter in the image. But the kissing couple ties it all together in the most perfect manner. It makes a wonderful statement, and it does it with extraordinary pizzazz.

As Louis Pasteur noted, "Chance favors the prepared mind." This quote applies perfectly to Blackmore's image, and in so many ways to any fine image, from Henri Cartier-Bresson's

many celebrated Decisive Moment images to Edward Weston's *Pepper #30* to any other great image in the history of photography. It comes from a person looking, seeing, and instantly recognizing a superb situation. It's not just being in the right place at the right time; it's being in the right place at the right time, recognizing it, and responding quickly.

Another one of Blackmore's favorite images was taken during a photography course he was co-teaching with his former mentor, Monte Zucker (figure 5–13). At the end of the course, Blackmore wanted to create a finale image to dazzle the crowd. He saw a bag of papier maché flowers nearby and had the spontaneous idea to lay two faces side by side, in opposite directions, surrounded by the flowers. Blackmore shouted, "Monte, come up here and join me, I have an idea." They began arranging the models and carrying out Blackmore's vision.

Blackmore had the idea, and together they were playing around with it. "We were really hamming it up to the audience," Blackmore says. The two of them were on stage, so the large audience could not see exactly what they were doing. "It was a show. However, once the image flashed on the screen, I think we were as surprised as the 400 people watching the screens. It was exactly what we wanted: faces, and yes, feelings." Sometimes the best photos can come from unexpected moments when you're just having fun, Blackmore says.

This image is a perfect example in which intense coloration works perfectly because of what the image is. This is not a case of supersaturated colors being inappropriately employed. Rather, intense colors are used appropriately for an image that straddles the border between pure design and abstraction, yet is held together by the realism of two young, beautiful women. (It's unlikely to have worked well with a couple of grumpy-looking old men. So the entire concept had to be carefully thought through for it to be successful.) The choice of colors enhances the image, putting a smile on the viewer's face. Furthermore, you can trade virtually any color with any other, and the image would still be successful, and would still attract your eye. But also be aware that in the area of pure realism—the models' skin tones—the colors are subdued and realistic.

Another example of creativity in an unexpected moment comes from Pei-Te Kao (pronounced Pay'-tah Cow), a student and friend of mine. Not long ago she boarded one of the ferry boats traveling across the Puget Sound in the Seattle area. It was dawn, and still quite dark. As the ferry left the dock, she wondered what would happen if she aimed her traditional film camera at the lights surrounding the dock and in the nearby area. Of course, it would require a somewhat extended exposure, more than a second long. With the ferry boat engines pumping to the maximum extent, it would matter little if she placed her camera on a tripod or held it in her hand because the ferry boat was shaking quite perceptibly.

Under such circumstances, there are likely two thoughts that could go through your mind. The first is that there's no point making an exposure because it will be out of focus. After all, Pei-Te had learned the importance of sharpness in photography, so making a hand-held photograph from a moving (and shaking) boat would be senseless.

The second thought is simply to try and see what happens. Most people stop at the first thought. Not Pei-Te. She considered both options, and decided to see what would happen. (Of course, today most photographers use digital cameras, so they can get instant feedback, but Pei-Te uses film, so there was no instant feedback. The results would have to wait for a later time.) The resulting image is a very fascinating set of squiggles and lines, which would be totally confusing and completely abstract if you had not already been told what you're looking at, but it makes sense once you learn what it is (figure 5–14).

How often have you thought about making a photograph, but talked yourself out of it simply because you thought it wouldn't work? I'm embarrassed to say that I've probably done it too many times, but I can also say that I've pressed ahead a few times as well. This is the essence of experimentation

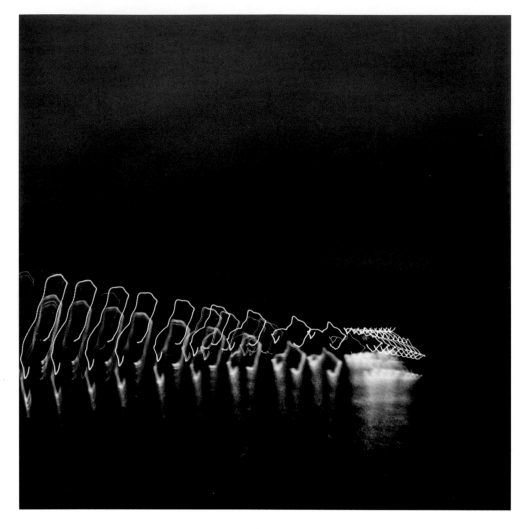

◄ *Figure 5–14: From the Ferry Boat (courtesy of Pei-Te Kao)*
Taking a gamble to see what would come of photographing lights on the receding dock from the deck of a boat as it left the dock, Pei-Te Kao was rewarded with a fascinating abstract image of moving lights in an extended exposure. Too few photographers are willing to take the chance at something new, something different, and perhaps something of interest to an unknown audience.

and some teachers are more creative than others. The list goes on because creativity can be pulled from any field whatsoever. It's up to you to do the job as told and expected, or to invent new and innovative ways of doing it that may be far better, far more appealing, far more productive, and far more interesting to you.

Moving Ahead with Creativity

In order to do insightful, creative work in any field you have to be thoroughly grounded in the field of endeavor, and you have to have put a lot of thought into where you want to go beyond the norm. All the iconic people who are highlighted in the beginning of this chapter had a great deal of knowledge in their respective fields. But don't get discouraged if you think that you have to be a Beethoven or Einstein or Steve Jobs to do outstanding work. You surely have to be at the very top of your game to do work as innovative as those folks, but you don't have to be a genius to do extremely good work. You can accomplish virtually anything you can think of doing, if you:

1. can think of doing it;
2. learn what is needed to do it;
3. enjoy doing it;
4. do it with enthusiasm; and
5. put time, thought, and effort into doing it.

that can lead to lots of disasters, but also to a few surprising triumphs.

The photographs from Clay Blackmore and Pei-Te Kao are examples of creativity in areas of photography where few people expect or strive for creativity. This should be proof that creativity is hidden within any field of photography, and probably within any field in life, artistic or otherwise. It's up to the creative mind to unlock it and set things off on a new road, one never previously traveled. Creativity stems from you, the creator, not from the subject matter at hand. That's why some photographers are more creative than others, some artists are more creative than others, some scientists are more creative than others, some businessmen are more creative than others, some salesmen are more creative than others,

Notice that being a genius is not one of the requirements. I fully subscribe to the concept I once heard from a high school teacher who said, "There are three components to success: talent, hard work, and enthusiasm...and you can make it on just two of those attributes as long as enthusiasm is one of the two."

That may be the most profound insight I've ever heard about success. I can't see how anyone can achieve success at anything without having unbounded enthusiasm for doing it.

Learning the ins and outs of exposing and developing film and making prints in the traditional darkroom, or learning the ins and outs of digital capture and Lightroom and Photoshop (or its various equivalents), is not a terribly difficult task. Lots of people understand those things. As you're learning the basic skills of photography you have to monitor your level of enthusiasm. If you're learning those things and wanting to learn more, play with them, experiment with them, and think more about them, and you're enjoying the entire process, you'll do well. It's inevitable.

Pushing Yourself versus Pressuring Yourself

When you go out with your camera in hand do you set a goal for the number of photographs you want to make? Do you have a minimum number of "good images" you want to nab in a day's outing, or in a week, or however long your trip may be? Or let me ask these same questions another way: How important is it to you to expose images during your outing?

That last question may seem absurd because of course you want to expose images when you go out shooting. But what I'm getting at is this: Are you pressuring yourself to make exposures even when nothing really excites you? Almost all of us do this because we want to produce new images.

But there's a huge difference between "pressuring" yourself and "pushing" yourself. If you're pressuring yourself, you're often forcing bad imagery just for the sake of producing something. Some people feel that if they've been out for 20 minutes, or an hour, or maybe three hours without making a single exposure, there's a problem that demands a solution. They've got to do *something*.

That's the wrong approach. You simply can't do any creative work when you're under pressure, even if you're the one ratcheting up the pressure. It's certainly worthwhile to try to push yourself to look for things that are really different from your usual subjects. This is a way of pushing yourself into new realms. But don't pressure yourself to do something just for the sake of doing *something...anything*. Some people will knowingly make a useless photograph just to "get things going." But pressing the shutter release or squeezing a cable release is not an athletic event; you don't have to warm up to make a good photograph. Instead, you have to find something that excites you. You have to engage your seeing and your thinking, perhaps in new and different ways.

The great bulk of my photography can be called landscape work. For me, the reward is simply being out in the woods or the mountains or the canyons. If I expose some photographs, that's good. If I make a truly exciting photograph along the way, that's even better. I'm always looking for potential photographs, and I tend to look carefully for both overall general landscape images and details within the landscape, but the greatest reward is simply being in the landscapes that I love, surrounded by nature. I push myself to look for photographic possibilities, but I never pressure myself by making useless photographs simply to break through some imaginary impasse.

I recommend you do the same. Find subject matter that is so compelling to you that just being in its presence provides a huge reward. Otherwise, you're "stalking" photographs, you're not seeking them. If you become frustrated with the lack of exposures you're making during an outing, stop to assess what's really wrong. Perhaps the light is wrong. Perhaps the location

is wrong. Perhaps the subject matter just isn't working for you that day. Try to shift your thinking to more properly encompass the conditions in which you find yourself. Perhaps you have other things on your mind, and you're just not involved in photographic seeing. If so, it may be best to quit for the day.

The same holds true for darkroom printing or digital finishing work. Sometimes the images I've chosen for final printing or final digital processing don't pan out as well as I thought they could. That, too, can be frustrating, but I try to adopt the attitude of "you win a few; you lose a few." That's the attitude you need to take, even while you're trying to produce really good work. Sometimes I'll come back to the losers and find that my approach had been wrong, and surprisingly there was a fine image in there after all. I may have simply needed some time to roll my approach around in my mind—perhaps subconsciously—before the right printing or processing procedure came to me. I allow those possibilities to occur. I recommend you do the same.

Putting Everything to Use

I tend to approach darkroom or computer work with a combination of a studied and an intuitive manner. I always have a backlog of negatives waiting to be printed. Some are recent exposures; some are old negatives that I initially overlooked but now strike me as having good, expressive possibilities; and some are ones that I previously printed and discarded, and now I'm seeing them differently. First I study them carefully to put them in an order of preference for printing them: this one excites me the most, that one second, that other one third, etc. I also study each one to map out a basic strategy for printing it: exactly how I want to crop it (if I crop it at all), the overall contrast I'll use, the level of lightness or darkness, and where I'll have to dodge (lighten) or burn (darken) and at what contrast level, area by area.

Then, based on a knowledge of the speed of the enlarging paper I'm using, I guess at the basic exposure, and do all the burning and dodging I've already decided upon, with the goal of making my first print a "perfect print." Usually, I'm fairly close. Once in a while I'm dead on, but that's rare. Sometimes I'm far off the mark, but a careful evaluation generally puts me quite close by my second effort. But it's all based on a combination of planning, intuition (which is born of experience), and careful evaluation. From that starting point, I work toward improving the image until I get what I want. Sometimes, along the way, I see new things that I had missed before, and those new finds or problems have to be incorporated into the printing strategy.

I never make test strips; I go for it. I'm convinced that I get to the final image far faster this way, and I'm much looser about the process along the way. So it's really a very intuitive approach.

For digital images, I do much the same, evaluating each RAW image that exhibits good possibilities carefully before making any moves in either Lightroom or Photoshop (I use a combination of the two at this time), and strategizing in terms of what I need to do to obtain my desired image. Although I can always start anew with nothing lost but time, I approach digital imagery the same way I approach traditional imagery, trying to envision my final image before making any moves, and trying to work out a strategy in advance to get to that final image.

I should add that at this stage, all of my 4×5 view camera work is black-and-white. All of my digital work is color. All of my previous color transparencies of value have been scanned and turned into digital files. Periodically I sift through unscanned transparencies to see if I've missed one that should be scanned. I feel I obtain the best possible quality in both with this dichotomy of processes.

To date I have no digital printer and have had no color digital files printed for display, from either original digital

captures or traditional transparencies. If I decide to do that it will bring in another set of complications to the process, and it may happen soon due to my photography of the spectrolite in the polished stone that I'm just now starting to explore. So only my black-and-white photographs have been exhibited in galleries or purchased by museums or private collections. My color images have been confined to book reproductions. Up to this point, I've been quite satisfied with this dichotomy. I take both color and black-and-white equally seriously, devoting a good deal of thought to each one.

Whichever process you decide upon—digital or traditional—I simply recommend that you do the best you can, and along the way, if you become disenchanted with either the process or the final product, try the other, and then work to do the best you can with it. Both produce visual imagery, and both are capable of high quality.

Learning Through Photography Workshops and Associates

I BELIEVE APPRENTICESHIP IS ONE OF THE FINEST teaching and learning methods of all time. Unfortunately, in the United States it has largely fallen by the wayside over the years. Today, it is virtually a dead issue. But it shouldn't be. Who better to learn from than those who are the finest practitioners in their fields? I think this applies to all the major fields: art, science, and business. There is a huge amount to learn from those who practice their craft regularly and do it well, assuming they know how to teach.

Aye, there's the rub. A lot of people who are good at doing something are not particularly good at teaching it to others. Conversely, there are those who are not top-notch in their field, but are excellent teachers, whose students often go on to outdo the teachers who inspired them along the way. If you had to choose between the two, I'd recommend learning under the good teachers, not the good practitioners. This is certainly true for photographers and photography instructors. But, of course, the best of all are those who are skilled *and* can teach the subject.

So, how do you determine who are the best photographers and simultaneously the best teachers? The best photographers are those whose work you admire the most. That part should be apparent. Assuming that some of them are still alive, look to them for potential classes or other learning opportunities. But how can you determine if they are good at teaching? That's far more difficult. If possible, try to contact some of their former students to get their evaluations. They can generally tell you if the instructor conveys information in an understandable or a confused manner, is encouraging or demeaning, treats students with respect or is condescending, makes learning enjoyable or pure drudgery, or any of the other issues that should be of concern to any student.

◀ *Ferns in Alcove*
The question mark of the isolated unfurling fern between the hanging ferns in the mountain alcove proved irresistible

Photography Workshops

I've been teaching photography workshops of one type or another for over 40 years, so I clearly feel that workshops are a great way to learn. And I believe I can support that built-in bias with solid facts to back it up.

In a workshop there is no set curriculum that has to be followed, so the workshop can proceed at a speed that is based on the initial level of knowledge and pace of learning of the group. Nothing is set in stone for any specific point in time. The student group can alter the basic direction of the class to suit its goals, and in a good workshop, the instructor should be flexible enough to go with the flow. While the instructor may have initial goals for the workshop, if student preferences veer off in a different direction, the workshop can and should accommodate them.

Directed field sessions that allow the instructors and students to work side by side are another great benefit of workshop or apprentice learning. These field sessions give the instructor real-time opportunities to see what a student is composing, what is in the frame, where the camera has been placed, and why the student has chosen the location, the focal length of the lens, and the subject matter. The instructor can also ask how the student plans to work toward the final image—whether they plan to crop the image, what they envision in terms of the overall contrast or color saturation, or what other variables will come into play to create the final image.

On numerous occasions I have looked through a student's camera only to see a distraction that the student had completely overlooked. Pointing out those distractions sharpens a student's search through the ground glass, rangefinder, or monitor for such distractions in the future. Other times, I've suggested moving the camera—sometimes by mere inches—to improve the relationships within the frame, or I've recommended pointing the camera down and to the left a bit to eliminate a dead area in the upper right and pick up a tidbit of interest in the lower left. Of course, I've also had the pleasure of looking through the camera at wonderfully well-composed images, allowing the student and I to discuss the real potential of the image.

When instructors and students work together in the field, students also have the opportunity to see how an instructor is composing an image. I usually have my camera with me during field sessions. I work along with the students and invite them to look through my film camera or review the monitor on my digital camera at any time, and they are able to question anything and everything about a photograph I'm planning to make. We discuss what I am planning to do or what I have already done. I have made some of my prized images during workshop field sessions, always open to student questions while doing so, and never ignoring my duties as an instructor in the process (figures 6–1, 6–2, and 6–3). In fact, as students will attest, I have used my own search for images as a valued teaching tool during workshops.

Another great benefit of workshops is that nobody is graded, so you can *learn* from the instructor without having to *please* the instructor to get a high grade. In my workshops, we review all student work as a group and make our best recommendations about the work, but it's up to the student to accept, accept in part, or reject those suggestions. There's no penalty for any of the three paths, which isn't the case in any school.

▶ *Figure 6–1: Canyon Aurora, Little Death Hollow*
Dried, cracked mud in a narrow side canyon of Utah's Escalante River pushes up against the side wall. Diagonal patterns of salt, leaching out of the sandstone, create brilliant white patterns against the dark wall. Less distinct horizontal lines on the wall mark levels at which receding waters from the most recent flash flood paused as they slowly receded. I made this image during one of my llama-assisted backpack workshops in the canyons.

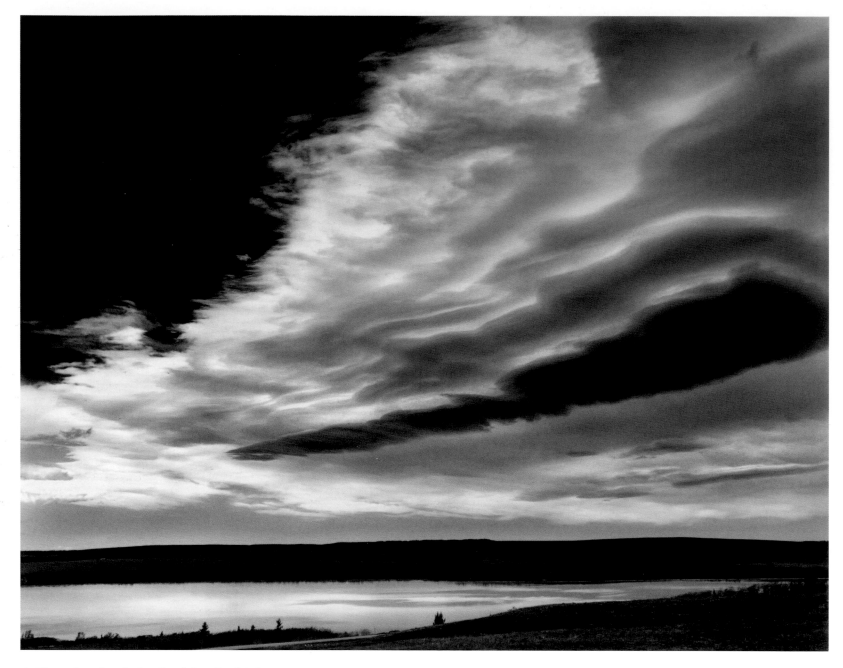

▲ *Figure 6–2: Lenticular Cloud Over Duck Lake*

On a workshop in and around Glacier National Park we had a sunrise field session in the rolling ranch lands east of the park. After we returned to our motel and conference room, I noticed strange clouds forming over the ranch lands, and quickly summoned the students to grab their cameras and head back there with me, for things were getting very interesting. Working alongside them on a gravel road leading down to Duck Lake, I made six successive images as the lenticular cloud built to astounding proportions. This image was from the final negative exposed, when the astounding layered cloud reached its peak.

Grading students presents clear difficulties. I once asked a college photography professor how she graded her students, and after first allowing that it was indeed difficult, she mentioned attendance in class. But that's part of how you grade kids in elementary school, not in college. Then she mentioned participation in class, and then the quality of work they turned in. So I asked, "What if a student doesn't show up in class as much as the others, and when she does appear, she fails to participate very much, but she turns in the best work?"

She said, "Ooooh, that's a tough one."

It shouldn't have been tough at all. It strikes me that the student turning in the best work deserves the highest grade. Period. The reclusive, abrasive Vincent van Gogh would have fared poorly in a class based on that professor's criteria. Hidden here is the fact that the "best" work is still a subjective judgment made by the instructor, so the student has to please the instructor to get a good grade. This strikes me as something akin to commercial client-based work, which I discussed in chapter 3. The student can't truly pursue his or her own vision, but must produce work that pleases the instructor. That's not the best way to proceed.

In a workshop, the instructor may not be attracted to a student's work, and will surely voice appropriate opinions and hopefully make useful suggestions, but it ends there. The student cannot be stigmatized or intimidated by a bad grade.

This brings up another benefit of workshops: because there's no bell-curve grading system like there is in many university classes, there's no competition between students; instead there is cooperation. I have seen for years that the more advanced students in my workshops regularly step forward to help those who are less experienced. As a result, less experienced students tend to rocket forward since they are surrounded by willing, eager teachers. The experience is beneficial for everyone.

In addition to serving as an environment in which students and instructors work together in the field, a workshop

▲ *Figure 6–3: Wolverine Canyon Alcove*
On another backpack workshop, I made this image in Wolverine Canyon, crouched down on the ground with the camera aimed nearly straight up to the magnificently carved sandstone sweeps above my head. Sunlight was reflected into the alcove from the canyon floor just outside of it, providing exquisite lighting for the elegant forms I was working with. I always use field sessions as excellent teaching and learning experiences in my workshops.

also allows students to interact with one another and the instructor more informally and personally throughout the day, including at breakfast, lunch, and dinner. This promotes deeper insight into the instructor's thinking, methods, materials, and overall life philosophy that is generally unseen in an

academic setting. You can see if the instructor has a sense of humor or other personal traits that give you insight into how he or she deals with life, not just photography.

A workshop strikes me as the closest thing to apprenticeship in existence today. Nobody in a workshop has to be there; it's completely voluntary. Each student is learning because he has a desire to learn. He's not there because he needs to get good grades or obtain a degree that is expected to be helpful for landing a job. Furthermore, the student is learning directly from photographers whose work he is drawn to.

Of course, workshops also have limitations. A workshop is generally a week long—maybe more, maybe less—and it's not accompanied by any other educational opportunities. In an academic setting, students take other classes in addition to their photography classes, so they're getting a rounded education that no workshop can match. There's a balancing act here that any serious student must evaluate to determine which venue serves him best. In general, I feel that a graduating high school student is far better off going to college and getting a good education than taking photography workshops. However, for a person who is already in the workforce, and who already has a good education, a workshop is incomparable. Obviously there are exceptions to this recommendation, proving James Thurber's statement, "There is no exception to the rule that every rule has an exception." You have to look at your circumstances to see which would serve you best.

Misguided Education in the Arts

It's hard for me to discuss the art education system without addressing an academic incident that I found to be revealing and absurd, and that gets to the heart of a deep-seated conviction of mine, which is that today's colleges and museums, above all other institutions, are at the forefront of misdirected thinking in the arts. The incident took place at Arizona State University. It is a true story, which I heard about directly from the person involved, as well as from the late Bill Jay, a good friend of mine and a noted history of photography professor at ASU. Other names are withheld to protect the innocent.

The person in question was a student in the Master of Fine Arts (MFA) program at ASU. He had completed all of the classroom work for the MFA and had to propose a final photographic project to the MFA advisory board for approval. An advisory board may be comprised of a single professor or a small group of professors involved in the program. Once the project is approved, the subsequent work must be submitted to the same committee and deemed worthy, after which the student receives the MFA degree.

The MFA candidate proposed a project that involved the landscape and it was rejected by the MFA committee. I do not know the details of the proposal, but let's set that aside for the moment. At the same time the landscape proposal was rejected, a fellow MFA student submitted a proposal in which he outlined his plans to make a set of 36 photographs, arranged in a 6×6 grid, of his own fecal matter in the toilet, with a list below each image detailing everything he had eaten in the previous 24 hours. This proposal was accepted.

Now, my only question about this incident is this: *How bad could the original landscape proposal have been?* (To complete the story, the person in question submitted an alternative proposal, which was accepted and ultimately approved, so both students received their MFA.)

As improbable as I find this story to be, it's true. It happened. Beyond its startling absurdity, I feel that it brings up a very deep philosophical issue regarding trends in current art education methodologies. I believe many important skills can be learned by emulating the past masters. This is true in the visual arts, as well as in musical composition, literature, and every other art form. Students can draw upon these skills as they attempt to pursue new realms of creativity. However, some art institutions eschew this view, and seem to believe

that trying to emulate a past master is little more than copying, and is ultimately worthless. It is my understanding that this is largely a Western cultural bias, whereas in Eastern cultures (China, Japan, perhaps India), learning by emulating past masters is looked upon very favorably. Go back to chapter 2 and reread the story of the newspaper review and critique of my first major exhibit, and then the subsequent review. The critic initially called my work shallow because he viewed it as an attempt to copy the work of Ansel Adams.

Apparently, the MFA committee at ASU viewed the landscape proposal as old stuff, tired subject matter not worthy of consideration, whereas the subject matter of the second proposal was new and different, and therefore worthy. This assessment ignores the possibility that you can dig into old subject matter and uncover new insights without having to turn to outlandish subjects that have never been explored before. It ignores the real possibility of depth over breadth. Portraits, landscapes, nudes, still lives, and all variety of subject matter have been painted, sculpted, drawn, and photographed for centuries, and new insights are still constantly being uncovered. Yet in our contemporary culture, it seems to me that colleges and museums have become the strongest purveyors of breadth without depth. The episode that played out in the MFA debacle at ASU brings this syndrome to its apex.

I recognize that this is a single incident. It cannot be assumed that this is representative of the thinking at all colleges and museums. But other events and evidence of such thinking were leading me to develop a distinct negative opinion of colleges and museums long before I heard about this incident. So, while isolated and singular, this event falls into the framework of other such thinking that I believe dominates the teaching and displaying of art in those institutions, which influences the art world greatly. We seem to be caught in a web where shock value trumps deeper insight, and where the very concept of beauty is to be avoided at all costs. To me, this is unfortunate.

▲ *Figure 6–4: Abstract Sunset, Skrova*
Skrova is a tiny island off the Norwegian coast, north of the Arctic Circle, and is a center for Arctic cod fishing. I found an abandoned metal locker near one of the fishing boat docks and photographed the welded interior corner of it. Then I turned the image 90° to make it look like an abstract painting of a brilliant sunset scene. I think beauty and elegance can be found anywhere, even in an abandoned metal cabinet.

Pierre Auguste Renoir said, "For me a picture should be something likable, joyous, and pretty ... yes pretty. There are enough ugly things in life for us not to add to them." Edouard Boubat, a notable French photographer, shared a similar sentiment when he said, "There are certain pictures I can never take. We turn on the TV and are smothered with cruelty and I don't need to add to the suffering. So I just photograph peaceful things...a vase of flowers, a beautiful girl. Sometimes through a peaceful face I can bring something important to the world."

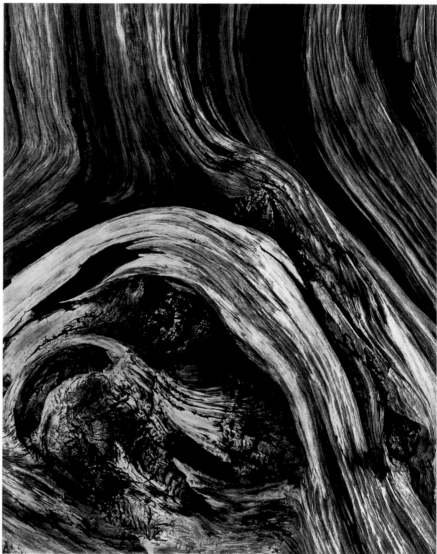

▲ *Figure 6–5: Diptych Wood Swirls*

I had photographed a section of a bristlecone pine tree in the White Mountains of California and a portion of a juniper in Utah, both with 4×5 film. While poring over contact proofs of various images I was considering for future printing, I noticed that these two images, which were photographed at different times and 500 miles from one another, worked together in a completely unexpected way. I printed them both and mounted them side by side on a single mount board as a diptych, seeing the combination of the two images as even more interesting than if either one was displayed individually. I had never done this previously, but why not try new things once in a while?

These two quotes come closer to my view of art than the view that I feel is projected by today's colleges and museums. I do not mean to *impose* my thinking on the reader or the prospective or working photographer, but I do wish to *express* my thoughts. You have to determine what works for you and what doesn't.

The Benefits of Photographing with Others

You can learn a tremendous amount from the people with whom you choose to photograph. Your photography companions are of great importance to your photographic education and development, and you can and should have a lot of fun with them as well. Of course, there are those photographers who have secrets—secret spots, methods, or materials, or anything else that they hold close to the vest. I've heard of people like this, and I've run across one or two in my lifetime; they are the ones to avoid under all circumstances. They are people who view you as a rival, not a friend or collaborator. It's a waste of your time to spend time with people with that attitude.

Don Kirby was initially a student at several of my workshops, then an assistant, and ultimately a co-instructor on numerous workshops. We also spent many wonderful weeks together camping, hiking, and photographing in the wilderness areas of Utah, the most remarkable landscape on earth (yes, Utah is #1; next you'll find #14) (figure 6–6). Neither of us ever had a thought that the other was a rival or that one of us would "steal" an idea or image from the other. In fact, we realized that if we were to expose two identical negatives with the same camera and lens set atop a tripod, and each of us took one home, we would develop and print them differently because we see differently and we think differently. That's true of any two photographers. So there's no sense in getting hung up on the issue of your partner stealing anything you may be doing.

One day I was hiking with Don in Surprise Canyon on the east side of Capitol Reef National Park, and I noticed him ahead of me looking up at an immense wall at a turn in the canyon. I looked at the wall and saw some wonderful pastel turquoise, pink, and orange colors, but little of photographic value. Don kept staring, and then he started to set up his tripod. Jokingly, I said there was nothing to photograph, but Don seemed determined, so I continued up the canyon, wondering why he had ignored my sage advice.

Months later, I saw the image he produced (figure 6–7). It's now one of the prized prints in my collection of work by other photographers. While I saw little but pleasant colors on that wall, Don envisioned a battle between the forces of good and evil in which the outcome was uncertain. That immediately became clear to me upon seeing his photograph. It needed no explanation. But back in Surprise Canyon, when both of us were looking at the same section of that wall, Don saw something important while I saw nothing. That's the reason it is beneficial to work with people who are supportive and cooperative, because no two people see the same way.

I have a similar friendship with Canadian photographer Craig Richards, my co-instructor for many workshops in Canada, Mexico, Italy, and the United States. We have headed out into the mountains many times to photograph together, and to enjoy camaraderie, laughter, and discussions about photography. We point out interesting things to one another; we don't hide them from one another or ever think that the other one would "steal" any ideas. This holds true for any of the other photographers I've worked with over the years. We all share ideas and help one another. I suspect that writers, painters, composers, and those in all artistic fields get together periodically to share thoughts and ideas. Scientists regularly collaborate, often on a worldwide basis. I think I'm correct in saying that such collaborations may not be the same in the business world, where rivalry seems to rule, but my knowledge of that world is admittedly limited.

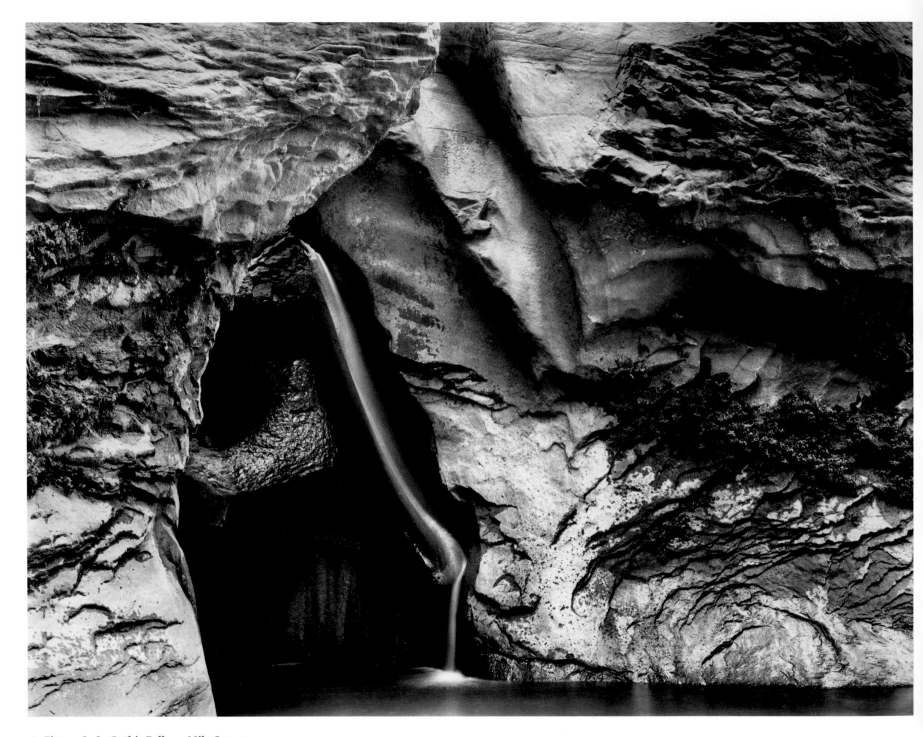

▲ *Figure 6–6: Gothic Fall, 40-Mile Canyon*
While Don Kirby and I were scouting for a future workshop in Utah, we came across this elegant waterfall in 40-Mile Canyon. Throughout the 1990s, while we conducted a series of camping workshops along backcountry roads in Utah, we often drove, hiked, ate, and photographed together, always having fun, always helping one another, and never worrying that one would "steal" an image from the other.

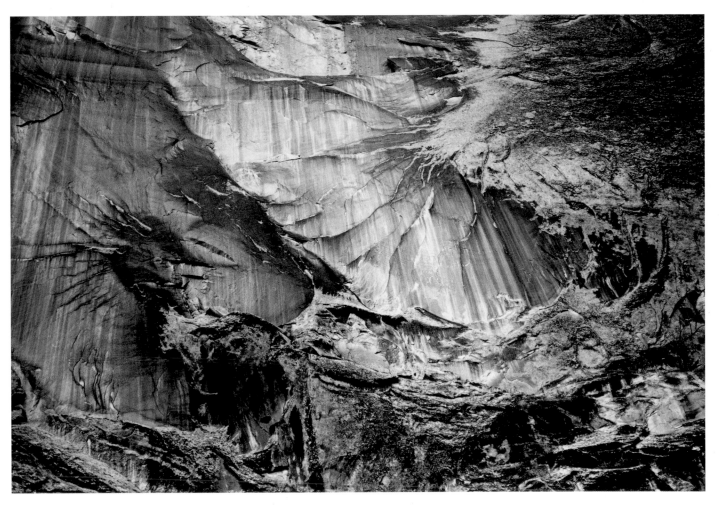

◄ *Figure 6–7:*
Surprise Canyon
(courtesy of Don Kirby)
Don and I were together
when he saw this pattern on
a turn in the wall of Surprise
Canyon. I saw a set of
wonderful pastel colors;
Don saw an entire story in
black and white. No two
people think or see alike. We
both recognized that. That's
why we worked together so
compatibly and
cooperatively.

A clear benefit of photographing with another person
(aside from basic companionship, fun along the way, and actu-
ally learning from one another, which all of my photographic
colleagues and I have experienced in abundance) is the issue
of safety. It's a whole lot safer to have someone nearby in a
place where you can fall and injure yourself, get lost, or run
into a variety of unexpected problems. I've gone out by myself
many times, but I think it's always better to head out into the
landscape with others—except, perhaps, on sand dunes, where
your companion's footprints can ruin your next photograph.

Reviewing the Work of Others and Vice Versa

Another beneficial aspect of working with a companion is the opportunity to honestly review one another's work. However, this can also prove to be a barrier when working with others. The problem is that some people are overly sensitive to any form of criticism, and some people are overly hesitant about what they should say to others. There can always be the underlying fear of "you better not say anything bad about my photographs or I'll do the same about yours." How do you get around that type of personal fear and retribution?

This is exactly the same problem an instructor has to overcome when reviewing student work in a workshop or classroom. The problem is often exacerbated in a traditional classroom because the instructor gives a final grade to the student. No such final word exists in a workshop where there is no grade. However, despite the lack of a grading system in workshops, students still shudder in fear when thinking about having their work reviewed.

I have tried to overcome this issue in my workshops in two ways. First, I never refer to the print review sessions as critique sessions, which seems to imply something very negative and destructive. I try not to even refer to them as print review sessions. Instead, I call them idea sessions, based on the thought that when you present your work for others to look at, you will hear *ideas* from fellow students and instructors about that work. You'll remember all of those comments and ideas because you're very awake and alert when your work is being reviewed. The real critique takes place later, when you take the photographs back home with you and, with your goals firmly in mind, decide which comments to ignore, which to accept in part, and which to accept in full.

Second, in order to make these idea sessions work successfully, my approach is to have everyone *silently* study the student's work that has been put up for review. I ask the students to form their own impressions, likes and dislikes, and basic suggestions without discussing these ideas with anyone else in the room. Then, before we start our discussion of the imagery, I ask the photographer whose work is being reviewed to express his or her overall goals for the work displayed—not image by image, but overall. After looking at the work and hearing the photographer's basic goals, I ask everyone to make useful comments that will help the photographer achieve those stated goals more successfully. I point out to the photographer that it's important to hear as many comments and ideas as possible because this will give him or her more things to consider when conducting the final evaluation at home.

I have found that while students still have some apprehension about showing their own work, they are far more open to comments than they were before I took this approach. I request that students give everyone the respect and attention that they would want from others when their work is being reviewed. Everyone stays focused, and these sessions are tremendously informative.

It's necessary to get periodic reviews of your work. If you don't, you can inadvertently fall into deep holes that you don't fully recognize. It's also necessary to take any seemingly negative comment as a good clue of what to do next, not as a personal affront. (Recall my story from chapter 2 of when Ansel Adams told me to stop shooting black-and-white.)

When I was a student in the 1970 Ansel Adams workshop, I had a print review session with Al Weber, one of the workshop's several co-instructors—a fine photographer and wonderful fellow, still doing his work in Carmel, California. He looked over my prints without a word for at least five minutes, or so it seemed to me at the time. I felt that he was quite impressed with the images I had put up.

Then, breaking the silence, he turned to me and asked, "Do you have a condenser enlarger?"

"Yes," I replied.

He said, "Maybe that's the problem!"

If you think I was surprised, maybe shocked, you're right. I was taken aback. I thought he was impressed, but apparently he was not. Instead he was deep in thought about the shortcomings of my images. So I asked, "What's the problem?"

He said that the images were all too high in contrast. They surely seemed perfect to me, but I had to take his advice seriously. After all, he had shown really wonderful personal work, and he was the instructor; I was the student. So I asked, "What's the solution?"

He recommended a diffusion enlarger, an alternative light source that softens contrast compared to that of the condenser enlarger. I inquired where I could get that type of light source, and he recommended a place near me in Los Angeles. Following the workshop I took his advice, bought the new light source, and installed it into my enlarger. The newly reprinted negatives were, indeed, improved.

The point I want to get across with this little story, as well as with Ansel's recommendation to me, is that instead of spiraling into a depression in the face of a negative comment by an instructor, or even a fellow student or friend, it's best to simply consider the suggestion and decide what to do about it.

If you attempt to create a group to mutually review one another's efforts openly and honestly, it's important to discuss and agree upon a set of "rules of engagement" at the start. It's necessary to openly discuss how to give and receive comments, which are usually given as constructive suggestions but often received as personal affronts, insults, or attacks. You'll have to surmount this trap by discussing it and even reviewing your group's rules or agreements periodically because it's easy to slowly work your way back into that trap, even if you avoided it at the start.

It's difficult to establish a group in which the members can and will honestly discuss each other's work. It's equally difficult, perhaps even more difficult, to keep it going. We tend to be both arrogant and overly sensitive at the same time. But, of course, we never see those qualities in ourselves, or really admit them to ourselves if we do, right? But if you can find the right group of people, your work will benefit from regular constructive feedback.

Finding Photographic Associates

It has been my observation that beginning photographers are rarely trying to find the *right* person to associate with photographically, and are simply looking for *anyone* with similar interests. At my workshops, students regularly tell me "there are no other photographers in my area." Well, there are, but you need to find them.

There are some established photographic groups that are part of nationwide networks, but many such groups are more social than photographic in nature. Many tend to promote photography contests. In my opinion, a photography contest is about as useful as pitting Rembrandt against van Gogh and asking who is better. The question is useless. No art form is contestable. Worse yet, to have contests, there have to be rules—and in this case, rules of composition, which are even more absurd than the contests themselves. I refer you to *The Art of Photography,* specifically chapters 2 and 3, for a detailed explanation of why rules of composition are not only useless, but stifling. If you're drawn to the idea of a local photography club, first check to see where it stands on issues like competitions and rules of composition. I suggest avoiding groups that promote either of those.

I'd recommend using various social networks, such as Twitter or Facebook, or doing other online searches that could put you in touch with photographers in your area who share your photographic interests. Try any other networking you can think of. For example, your classmates or fellow workshop students may know of photographers in your area that you are unaware of. It's always worth asking around.

Openness from Instructors

One of the things that awed me as a student in the Ansel Adams workshop I attended 45 years ago was his total openness about every aspect of his photography. In one particularly notable exchange I had with him toward the end of the workshop, I asked him about the printing of a portion of his marvelous photograph *Clearing Winter Storm, Yosemite*. I was amazed by the brilliance of light on and around Bridalveil Fall on the right side of the image, and asked him if he had dodged (lightened) that area in the printing.

I fully expected him to say, "I'm sorry, but I don't really discuss how I print any of my images." I would have understood, and would have simply apologized for the inappropriate question.

That's not what happened. Instead, he quickly said that the light was so brilliant in the area that he actually had to burn (darken) the region to bring out the necessary detail. That astonished me. I didn't really expect to get an answer to my question. But then he really floored me by going through the entire image and telling me where he burned, dodged, or did anything else to produce the final image.

I simply couldn't believe it. He not only answered the one question I didn't think he would be willing to answer, but he answered a number of other questions I never asked, and never would have had the courage to ask. All of the other instructors in that workshop were equally open and willing, even eager, to explain any aspect of their photographic art.

These are generous people who have no hidden doubts about their photographic work, and they want to share it. They all have the philosophy that if their ideas, methods, or choice of materials are picked up by their students, they will have the pleasure of seeing great images produced by their students.

I was so impressed by Ansel's response that I vowed then and there that if I were ever in his position as an instructor, I would do exactly the same. There would be no secrets, with one exception: sometimes I will not say what the subject matter is in a very abstract photograph to keep the mystery of it alive. Or, in the case of *Kelso Dunes,* I don't divulge which orientation is correct (figure 3–5). I pride myself on being honest, but I don't have to blurt out everything.

Over the years I have worked with a number of co-instructors in my workshops, and every one of them has the same philosophy, though most of them blurt out anything and everything. So I've never had to enforce that approach; it has come naturally for everyone I've worked with over the years. These are the people I love to work with, and the type of people I suggest you associate with. You'll learn from each other and enjoy each other's company.

Technical Knowledge, Materials, and Equipment for Creative Purposes

I HAVE BRIEFLY TOUCHED ON TECHNIQUE IN THIS BOOK, noting that technique and creativity are inseparable. Ansel Adams once said, "There is nothing as useless as a sharp photograph of a fuzzy concept." It's a quote worth memorizing. Basically, it says that technique by itself is meaningless. If your photographs are technically exquisite, but they carry no deeper meaning, nobody cares.

That said, technique is important for several reasons. First, if your technique is lacking, whatever you have to say is seriously compromised. The message is clouded because you haven't articulated it. It's like a three-year-old trying to explain something of great importance to her mother. She knows what she wants to say, but she doesn't have the vocabulary or understanding of pronunciation or grammar that is necessary to say it. So the poor mother is desperately trying to understand her daughter, but can't quite get the message, a situation that is hugely frustrating for the little girl and certainly for the mother as well.

If your technique is good, it can be a conduit for expression. Photography is a non-verbal form of communication, very much like any of the other arts, including the visual arts of painting, drawing, and sculpture, and non-visual arts of music and dance. In every case, the artist is attempting to convey an idea via the means of the art form. Each art form has its own language, its own grammar. In a very real sense, technique in every one of these artistic realms is very much akin to grammar in the spoken or written word.

In many ways good photography technique is like the clever use of words. My favorite writer, Mark Twain, is the author of so many short, pithy comments that one wonders how anyone can compare with his use of language (i.e., his technique). Let's just look at one: "Man is the only animal that blushes. Or needs to." It's short, succinct, to the point, funny, and insightful. You laugh, but it also

◄ *Gochsheim Wire Crates*
The geometric patterns of shipping crates stacked up on the warehouse loading docks in this small German town offered an unusual photographic opportunity

► *Figure 7–1: Albatross Wings*

When I made this photograph, I saw the shape of the graceful 10-foot wingspan of an albatross, a bird that can migrate 10,000 miles across the Pacific without touching down along the route. Viewers often wonder whether it's a sand pattern just below my feet or an aerial view including hills and roads. Does it matter? Technically, it's perfect, with extreme sharpness everywhere. But I photographed it because of what it represented to me: an albatross wing—and echoes of it —within its overall abstractness.

forces you to think. It goes beyond the comedian's typical one-liner, which makes you guffaw and then you forget it. Twain's comment sticks with you. Brief as it is, it has depth.

Dostoyevsky, Tolstoy, Dickens, Cervantes, and so many other great writers weren't as fast on the draw as Twain, but they were obviously extremely deep in their own writings. Nothing of what they were articulating could have had much effect if their writing technique was not superb. None of the great speeches by Winston Churchill, Martin Luther King, Jr., Abraham Lincoln, or any great speaker would have been considered exceptional if they weren't accompanied by extraordinary use of language—in short, technique.

Exceptional technique in photography is essential to a strong, meaningful statement. Depending on the statement to be made, it may be essential to have good sharpness or complete lack of sharpness, or even a combination of both; strong contrasts (figure 7–1 and 7–2) or extremely soft, subtle contrasts; dark, moody tones or light, ebullient tones; brilliant contrasting colors or quiet pastel colors; a riot of colors or a near monotone; a high-gloss paper or a matte surface. All of these and so many more considerations are part of the technique needed to convey your message.

You may be wonderfully creative, but unless you combine it with good technique, you'll get nowhere.

Using Technique for Creative and Educational Purposes

Don Rommes has been my co-instructor on my Escalante Llama-Assisted Backpack Workshops for over a decade. During that time, Don has spent a lot of time in the remote canyons of southern Utah photographing ancient Anasazi cliff dwellings and rock art (pictographs and petroglyphs). Visitation to these vulnerable sites had been increasing dramatically, and as a consequence, these prehistoric cultural treasures were being

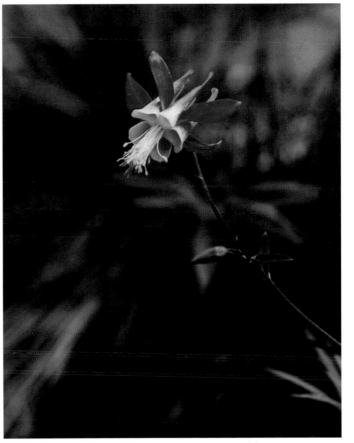

◄ Figure 7–2:
Red Columbine
I took this photograph at the edge of a small Sierra Nevada mountain creek in the late 1970s. The photograph includes brilliant colors on the flower, and soft amorphous colors on everything else. The flower is extremely sharp, and everything else is blurry. In its own way, it too, like the previous image, is technically perfect. One is black and white, the other is color. One is completely in sharp focus, the other is mostly out of focus. Both are necessary for the goals I wished to achieve.

quickly degraded. After consultation with locals, archeologists, public land advocates, scientists, and the Bureau of Land Management, it became clear that the best way to preserve the fragile sites was through education of the public. Don started by creating a book, *The Cliff Dwellers of Cedar Mesa,* co-authored by a leading archaeologist. Don's photographs are compelling illustrations of the beauty and vulnerability of the sites. The accompanying text educates the reader about the significance of the sites and makes an argument for their preservation.

Recently, Don has been exploring ways in which digital technologies might further enhance the viewer's experience.

▲ *Figure 7–3: Pictograph (as photographed), courtesy of Don Rommes*
This is how the pictograph looked upon close inspection. At first, the dim background figures were virtually invisible, but upon closer inspection, their presence was revealed, and they became almost impossible to miss.

▲ *Figure 7–4: Pictograph (partial digital enhancement), courtesy of Don Rommes*
This is effectively the midpoint in the digital transition from the untouched photograph to the full digital enhancement of all the background wall paintings.

He is now working on an e-book to go beyond what is possible in a conventional book. He started with a question: "How do I convey the experience of being at these sites to the reader?" He turned to digital techniques for answers. Let's look at two examples of what he has come up with, in his own words. First, an Anasazi rock art panel (see figure 7–3).

"This pictograph is one of many that were painted on a single canyon wall in southern Utah. This site must have had great significance for the Anasazi, because they visited this wall repeatedly over two millennia. During their visits, they made new rock art and modified the older rock art. The pictographs that are still visible were probably made in the two thousand years between 1,000 BC and 1,000 AD. Their intended meaning is unknown to us today, but they undoubtedly communicated something of significance to the local residents for whom they were intended.

"The two main pictographs clearly represent women and were probably made by women. When you are there in person, your attention is drawn to the dark red figures and handprints. However, in the right lighting, if you stand there and look long enough, other figures seem to materialize. I have been here when I could not detect the faint white human-shaped figures, or anthropomorphs, lying beneath the deep red triangles. But I have also been here when I could see a dozen of them, side by side. This ephemeral quality is probably due to both the characteristics of the ambient light and the receptivity of the viewer.

"A straight photograph (i.e., the RAW file) taken in the right light does show the faint white figures, but they are very easily missed. The figures need to be enhanced to be seen clearly. Showing a "before" photograph followed by an "after" photograph does communicate to the viewer what she might have missed on the first look, but it lacks subtlety and doesn't come close to the experience of being there. In person, the white anthropomorphs are effectively invisible. The more time you spend looking at the panel, the more obvious the figures be-

come, but the phenomenon takes a while. After having seen the figures, you can no longer fail to see them. In essence, they become progressively more apparent, as if they are asserting their existence.

"I wanted to give people a semblance of that experience. I knew what I wanted to accomplish, but I didn't know how to do it at first. After a bit of research, I found that an e-book would allow me to present my images dynamically so that my readers could interact with them. Of course, that meant that I needed to teach myself how to create e-books. For this pictograph study, I started by creating two versions of the image. The first was the straight digital capture presented without manipulation. In the second version, I enhanced the figures. I chose to lighten them by using a curves adjustment layer. Using the lasso tool, I selected a small portion of a white anthropomorph, then used the curves adjustment layer to lighten the tones to a level I liked. I then "painted" this effect on all the other anthropomorphs using a white brush on the mask that accompanied the curves layer. Finally, I chose Luminosity as the blending mode for this layer so that the colors of the anthropomorphs would be only minimally affected.

"Then, it was a simple matter of creating a transition between the two photographs. In a slide show, you would show the straight version first, followed by the enhanced version. A simple Fade transition would permit the first image to be replaced gradually by the second. The same effect can be achieved in an e-book with these two photographs. Since nothing in the images changes except the figures, the white anthropomorphs seem to slowly materialize—exactly the effect I was after (figures 7–4 and 7–5)."

In Don's e-book, the transition unfolds over several seconds. You seem to be looking at a static photograph, but then you gradually become aware of the white pictographs that you didn't notice at first. It's quite magical watching the older, faded pictographs come to life. According to Don, the expe-

▲ *Figure 7–5: Pictograph (full digital enhancement), courtesy of Don Rommes*
Full digital enhancement brings out the background paintings to their fullest extent, making them perhaps as brilliant as they were when first painted on the wall. It would be difficult to determine how apparent they were when they were originally overpainted by the obvious black figures, which are still so apparent today. In the e-book Don produced, you can see the startling transition from the full background enhancement to today's barely visible appearance of the earlier paintings.

rience is very similar to what it is like in person. Then the white pictographs fade to their former, real intensity, and you wonder how you could have not seen them in the first place. In this printed book, the best we can do is show three snapshots of that transition: the two endpoints and the midpoint. It's just not the same experience.

There is no doubt that creativity and technique cannot be separated in the work that Don Rommes has done. Don had a creative idea, but he needed to acquire the technical expertise to make it happen. But it also goes beyond that, because what Don has accomplished is also educational. In this work, we

see how Don has employed available digital technology in a variety of creative, educational, and artistic ways simultaneously. That's about as good as it gets.

The project is based on Don's original creative idea of trying to recreate what he experienced in front of the rock art panels. So how do you come up with a creative idea? Well, have you ever looked at something and wished it looked a little bit different? That, right there, could be the start of the creative process. If you wished it could be different, maybe you can make that wish come true. It's quite likely that was the start of

Don's work with the Anasazi rock art, and it is surely the start of much of my work. You have to take your desires and turn them into a viable image. That takes work, but once you start to think in terms of turning wishes into reality, you're at least halfway there.

The second example of what Don has been working on for his e-book is also worth discussing. Again, let's turn to Don's description:

"This dramatic locale is reached by a three mile hike with 1,500 feet of elevation loss. The last few hundred yards take

◄ *Figure 7–6:*
Anasazi Site Panorama ,
courtesy of Don Rommes
In Don's e-book, this
exceptional Anasazi site
unfolds slowly from left to
right, creating quite a
surprise when the closest
structure comes into view
on the far right.

you down a rather precarious rock fall to the ledge that holds
these structures. I hesitated before trying to reach the ledge
because I knew I had that mandatory uphill return hike to the
car. Besides, although I had a vague idea of the site's location,
I didn't know what was there. For that reason, and since I was
alone, I decided to leave my heavier cameras behind and take
a point-and-shoot camera, my lightest tripod, and a leveling
head for a panorama.

"When I finally reached the ledge, I still could not see any
structures. I followed the narrow ledge under a waterfall, passed
through a defensive stone gate, and continued around a prom-
ontory until I noticed the line of structures. The site exceeded
my expectations, perfectly illustrating the hidden, defensive
building locales chosen by the thirteenth-century inhabitants
of this area. After absorbing the full experience of the site, I
began to envision a photograph that would not only show its
inaccessibility and defensive nature, but would also mimic my
experience of gradually discovering the structures. The site was
so dramatic that I also envisioned a very large print displayed
in a museum or visitor center. It seemed to me that the best

way to accomplish both goals was to first create a detailed panorama of the site.

"Using my tripod and the leveling head, I turned the camera vertically to maximize the number of pixels and composed the picture. I started at the far left and gave myself a bit of extra room on the top and bottom for the inevitable cropping that comes later. With white balance, exposure, and focus set to manual, I made a series of exposures from left to right, each new exposure overlapping the previous one by 30–40%. There were seven exposures in all that were later stitched together in Photoshop to create a final image with a big enough native file size to make a very large print (figure 7–6).

"For the e-book, instead of showing the entire panorama at one time, I chose to display it as a slow, scrolling image. In other words, the e-book initially shows only a portion of the image—the far left side that shows the dramatic drop-off. But by swiping across the monitor with your finger, you can slowly reveal more of the ledge until you reach the far right side. I think the effect creates a sense of discovery for the viewer that is not unlike what I experienced at the site."

I recommend trying to replicate the experience of scrolling in the e-book by covering the right 4/5 of the image with a card, and then slowly moving the card to the right, opening up the image over a period of several seconds. This mimics the way your eye would see the full site if you were there.

Stitching images to make a panorama is not uncommon anymore, but few have the impact of Don's panorama here. Watching the image unfold in the e-book turns into a dramatic experience when you arrive at the closer structure at the far right. It produces a feeling of depth that is amazingly dramatic, and at the same time remarkably educational.

Obviously Don had to deal with a long, arduous, and precarious hike, which is quite a commitment itself. Beyond that, he employed well-known techniques in a unique way that is not only dramatic, but has the effect of placing you at the scene.

Here we have seen two examples of thoughtful use of digital technology for creative, artistic, and educational purposes.

Combining Known Ideas in New and Creative Ways

I have discussed how my knowledge of the exceptional contrast range of black-and-white film combined with my knowledge of negative developing techniques to control that range allowed me to make photographs in the slit canyons. I used those same techniques in the English cathedrals as well. In both cases, whatever degree of creativity I was able to muster was integrally tied to the techniques employed. Without that understanding of technique those photographs could not have been made.

Many of the instructors teaching film methods in those days warned students not to expose a negative above Zone 8 or they may lose information. Apparently they were unaware of the fact that film will hold excellent tonal separations into progressively denser zones up to the mid-teens (up to Zone 15, 16, or 17), effectively many, many times higher on the scale than those instructors recognized. Had I not known the true range of film, or had I listened to those instructors who were unaware of its real range, my photographs of the slit canyons could not have been made.

Once the negative was exposed to that expanded range, the key to controlling the full range of tonalities was developing the negative in an extremely diluted developer solution, which prevented the high zones from developing to excessive densities. I used that method of development in situations of extremely high contrast for 16 years.

Then, in 1996, I encountered a unique situation in Oaxaca, Mexico, that equalled or even exceeded the range of tonalities I encountered in the slit canyons. But in this case, I wanted to retain textural detail in some of the dark areas that I was

willing to dispense with in the canyons, letting them go black to preserve their elegant shapes unbroken by tonal detail (figure 7–7). In the Cathedral Metropolitana I wanted to see tonal detail in the carved wood on the massive panels holding the frosted glass with the etched saints on them (figure 7–8).

The tiny figure of the beggar sitting at the entryway is the essence of the image, despite the fact that she's so small and unobtrusive. You don't notice her immediately, but once you discover her presence, your eye keeps coming back to her. Had she not been there, I never would have exposed the image. In fact, I exposed five negatives in hopes of getting one useful image. I needed a full minute-long exposure to obtain the desired detail in the wood panels, but during any minute-long period, the beggar stayed still for only seconds at a time. I realized that if she were moving, the blur she would create in the photograph would have no meaning. She had to be recognizable. Out of necessity, I based my five exposures on the length of time she was motionless. The longest was 15 seconds, which I guessed from pure intuition since I had to keep my eyes on her to detect any movement, not on my watch. After five exposures, I gave up. It was apparent that she would never remain immobile for a full 60 seconds. I felt there was no way to get the image I wanted.

The problem was that developing the negative in the highly diluted developer would result in the loss of the lowest zones, the ones required for the carved wood detail, so I was stuck. Yet I had long understood that when using standard dilutions for negative development, the low zones develop the quickest, but then stall, gaining very little further density. Keep those two thoughts in mind.

Because I was so drawn to the image potential, the seemingly intractable problem remained foremost on my mind throughout the trip. It was still on my mind as I boarded the flight back home from Mexico. On the flight, I devised a new method of developing the negatives. I could first place the negative into a standard dilution bath to quickly bring up the low zones, and then transfer it to the very dilute solution to control the high (denser) zones. By combining these methods, I felt I could maintain the detail I so desperately wanted in the wood panels, which was lost when using the dilute solution exclusively, a technique I had used successfully for 15 years. I explain these methods in detail in chapter 9 of *The Art of Photography,* under the section titled "Two Solution Compensating Development for Negatives." In essence, the old cliché applied: necessity was the mother of invention.

I created a new technique by combining two known techniques for negative development in a way I had never heard of or read about before, simply because I needed to. Again, this is an example in which technique and creativity are wound together in one tight ball. There was no genius invention here; it was simply a new way of using existing knowledge. As I've written throughout this book, many new ideas come from putting together existing ideas in new ways. This is the essence of creativity, even it if comes from the technical side.

After coming up with this new developing technique, I've used it exclusively for extreme contrast reductions. Had the technique been known to me when I exposed *Circular Chimney, Antelope Canyon,* or the many subsequent images I made in the slit canyons, I surely would have used it. But I believe I would still print the negatives as I do today due to the abstract nature of the images; I want the uninterrupted, elegant black shapes to remain unblemished by tonal detail within. Perhaps I would have retained a bit more usable shadow detail in my English cathedral images. Surely the technique proved instrumental for the negative I exposed in Germany's Ehrenberg Castle in 2012 (figure 7–9). Fog filled the coachway that spiraled upward within the castle, and I wanted to retain as much detail as possible in the darkest walls, which had no direct light, and little indirect light, shining on them.

► *Figure 7–7: The Slit, Antelope Canyon*
I was perfectly content to have the black shapes in the lower right portion of this slit canyon photograph remain uncluttered, without any tonal detail, which I felt could detract from their elegance. They were playing off of the forms above and to the left of them, and details within them would have diluted the impact of this image.

▲ *Figure 7–8: The Beggar Woman*
Whereas I was satisfied to have no detail within the forms in the previous image, I wanted detail in this image—even barely seen detail, but tonal detail nonetheless. To my mind, large, featureless, black areas in the huge wood panels holding the frosted glass saints would have created cumbersome, heavy areas in the lower portion of this image. Detail was necessary, at least on the dark panel facing me.

► *Figure 7–9:*
Ehrenberg Castle
On a damp, windy, and very foggy day, I photographed toward the upper openings of a wide spiral ramp within this 12th-century castle. I wished to retain as much detail into the foggy mists as possible.

You Cannot Rely on Good Technique Alone

Look at the photographs created by your favorite photographers. I'd virtually guarantee that you are drawn to their technical methods as much as you're drawn to the subject matter and the way they've dealt with it. Their technical methods are an integral part of the visual statements that they are making. Hopefully you're not drawn *only* to their technical prowess—as some people inevitably are—but to the emotional resonance you feel when looking at the work. If you do feel an emotional response to the work, notice how the technique that the photographer used cannot be separated from the message they've conveyed so well to you.

Technical considerations are not only important, they are critical. They cannot be overlooked. Some photographers whose technique is lacking will implore the viewer to "forget technique; look at the image." The problem is that it's often impossible to see the image hidden behind wretched technique. Good technique must be integrated seamlessly into your approach.

I happen to like the crispness, sharpness, and clean appearance of the standard, traditional silver print on an air-dried glossy surface, so well pioneered by Edward and Brett Weston, Paul Strand, Ansel Adams, Ruth Bernhard, Paul Caponigro, Jerry Uelsmann, and so many greats of the past and present. I have been drawn to those technical characteristics—along with the subject matter—since I first became interested in photography. My attraction was so strong that those techniques became the basis for my own expression. I suspect that when you look at photographs that attract you the most, and then compare them with the photographs you produce (or want to produce), you'll find that you, too, are drawn to the subject matter and the technical aspects simultaneously. Some people are drawn to the look of the softer platinum/palladium print, with its brown tones on a matte surface. Some people are drawn to out-of-focus or heavily grained photographs, and it's likely they'll try to produce such imagery themselves.

Some photographers have combined digital techniques with platinum/palladium prints to expand their expressive capabilities, and in doing so, extend their creative possibilities. Starting with either a standard film negative that has been scanned or an original digital capture converted to a black-and-white positive, they burn and dodge or otherwise alter the positive, and then convert it back to an enlarged negative, thus preparing it for the straight contact print required in the platinum/palladium process. In this manner, a second generation negative is produced that is ready for use in the platinum/palladium contact printing process. It's a clever, creative technique to obtain the desired image. Employing Photoshop in this way, the photographer is able to manipulate the image, which is virtually impossible using traditional printing methods exclusively (except, perhaps, for some simple, broad overall burns or dodges). This opens up whole new possibilities for platinum/palladium printing, and as such, is a way of employing technical processes to expand creative and expressive possibilities. (Of course, there are direct Photoshop means of emulating the basic look of the platinum/palladium print, but to my eye, they don't quite cut it. I think they are passable simulations, but they're just not the real thing.)

So, technique can be used effectively as a creative, expressive tool. Too often, however, it's used primarily as a show of technical prowess. You still have to combine technique with the message you hope to communicate. This brings us full circle to Ansel Adams's quote at the beginning of the chapter. If you have nothing to say, if you're not moved by the things you're photographing, how can you expect anyone else to be moved by your photographs? So you can never rely on technique alone. There has to be something deeply felt inside you that you want to convey to others, and hopefully it's not just technique that moves you.

In his exceptional book *The Art Spirit,* American painter and educator Robert Henri says, "I do not want to see how skillful you are—I am not interested in your skill. What do you get out of nature? Why do you paint this subject? What is life to you? What reasons and what principles have you found? What are your deductions? What projections have you made? What excitement, what pleasure do you get out of it? Your skill is the thing of least interest to me."

Perhaps skill is another word for technique. I doubt that Henri was against the use of fine technique; instead, he was against the use of technique as a sole means to no real end. I'm sure that he and Ansel Adams saw eye to eye on this issue.

Good technique alone falls short in any field. Years ago a student who signed up for one of my darkroom workshops told me that he was a piano graduate of the Curtis Institute of Music in Philadelphia. That's an elite school, so I was quite impressed and very much looking forward to meeting him. Weeks before the workshop started, he sent me a CD of his piano music. To me, it was all technique with no soul. He was able to play exceptionally fast, with each note ringing through cleanly, but it seemed to me that he had no personal interpretation of the music or any real feeling for it.

I knew he would ask my opinion of his playing when he came to the workshop and I dreaded that moment. Sure enough, he caught me with nobody else around and asked the question. I told him that I was taken with his technique and finger speed, but I felt that there was a lack of personal feeling and interpretation. He responded, "That's exactly what my instructors at Curtis told me."

There has to be an underlying message, a deep passion within you, if you are going to say anything in any of the arts. As was the case with the piano player, technique alone won't convey anything but your mastery of technique. But good technique combined with a personal passion and ideas can create whole new worlds. Find the subject matter that excites you, learn the techniques that make it sing photographically, and you'll create some wonderful work.

Materials, Equipment, and their Openings to Creativity

It may not be immediately apparent, but working with different materials may lead to some worthwhile creative breakthroughs. The same can be true of working with different equipment.

How often have you tried using different materials just to see what visual differences they could produce? I'd recommend experimenting with the possibilities. If you use a film camera, try shooting the same scene with two different films to see what differences exist between the two. Digitally, perhaps try using two different cameras to photograph the same scene to see if the RAW files are equivalent. They may be similar, but not precisely the same. Make many such comparisons. You'll probably find that one type of film or camera serves your purpose well for certain types of subject matter, lighting, or levels of contrast, while another is better suited for other subject matter or ambient conditions.

What I'm suggesting for film or cameras could be equally true of scanners, printers, and papers. Each has its own qualities, its own look, its own "feel." It's rare that a single paper, for example, will satisfy all your needs.

Let me share some of my experiences using different materials, and how those materials have affected my work.

A number of years ago at one of my workshops that started in Death Valley, our morning field session took us onto the sand dunes, which I had already been exploring and photographing seriously for about five years by that time. On the dunes I generally seek side lighting (the sun coming in from the left or right) or backlighting (the sun coming toward me), for I find that those lighting directions offer the most dramatic

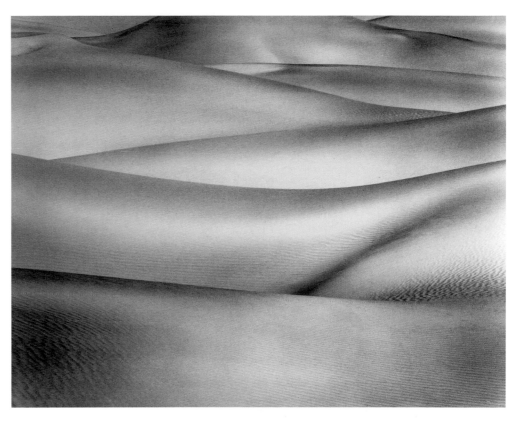

effects. I tend to avoid axis light (the sun coming from directly behind me) because it flattens out the scene so much. Not only do I tend to avoid it, but in essence, I hate axis lighting.

However, just as I was packing up to head back to the workshop's indoor conference room at the close of the field session, I saw a series of dune ridges lit by the flat axis light that looked so sensuous, luminous, and silvery that I felt I had to expose a negative (figure 7–10). I developed that negative to its maximum contrast using Kodak Tri-X film, and then in printing the negative I pushed my variable contrast paper to its highest level of contrast. In other words, I maximized contrast at two stages—negative and print—and still ended up with a high key, rather low contrast, but very effective image.

Several years later, I was on the dunes when smoke from enormous fires in Southern California filled Death Valley, turning the daytime into a bleak, murky scene, and virtually closing down whatever contrasts normally appeared on the dunes. I should note that sand dunes are inherently low in contrast, except when they are backlit at sunrise and sunset, because the shadows are generally filled with light reflected from nearby sunlit dunes. With smoke filling the atmosphere, contrast was at a near-zero level. It was grim.

But I had a film with me that Kodak used to produce called Technical Pan. I purchased and froze a number of boxes of it in 4×5-inch sheets. It was originally designed for astronomical photography through telescopes, with nighttime exposures that last up to many hours, where stars or galaxies would become very dense and the voids between them would be virtually clear.

So with contrast at a near-zero level and a film in hand that I jokingly said contained infinite contrast, I felt I could solve the age-old mathematical conundrum of seeing what happens if you multiply zero by infinity. I suppose my mathematics background surfaced yet again. Only this time, with a real, practical purpose in mind.

Of course, because I was using film I had to wait until I got home to develop the negatives to see if it worked. This is something that digital buffs cannot comprehend because they're used to seeing the image in real time, but to a film photographer, it's one of the magical things that unfolds later on. Turns out, it worked! Almost miraculously I was able to achieve very high contrast on scenes that were virtually devoid of any contrast by using Technical Pan film. I actually had to lower contrast in the printing to maintain the tonalities I desired (figure 7–11). I made the image when the sunlight and shadow were both compressed to insignificance by the oppressive smoke, and when the light meter's needle was virtually stuck without motion (equivalent to a histogram that spikes in a single location, with nothing showing elsewhere). Of course, this also proved that when multiplying zero by infinity, infinity wins.

It was an image that could not have been made with the standard Tri-X film I normally use. Based on that success, it occurred to me that in the future I could use Technical Pan film on other extremely low-contrast scenes beneficially. Now

▲ *Figure 7–10:*
Silver Sunlit Dunes
Full axis light (i.e., the sun directly behind me) made this a very low contrast, high key, silvery image, despite developing both the negative (Kodak Tri-X film) and printing paper to maximum contrast. It is the maximum contrast I could achieve with the materials available, ultimately yielding exactly what I wanted in the final image.

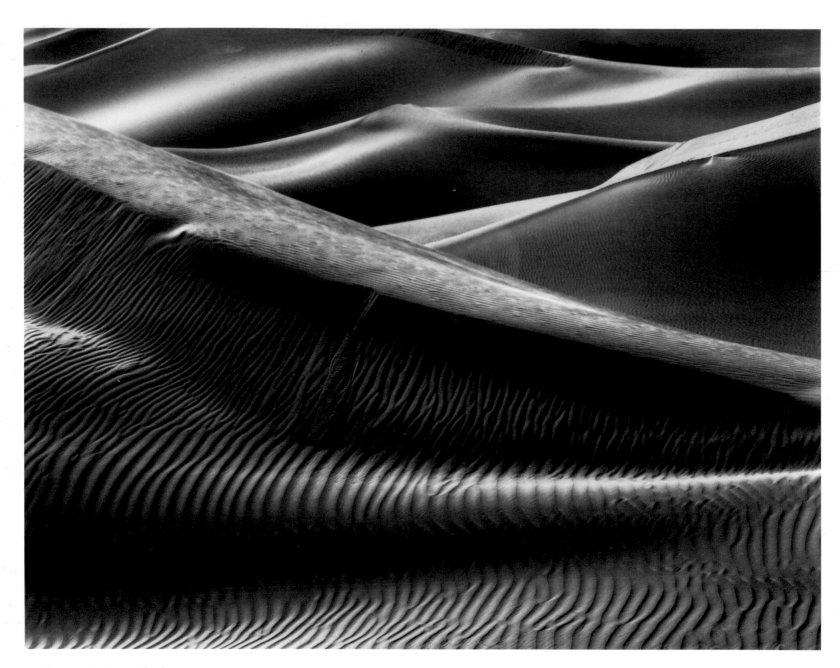

▲ *Figure 7–11: Dune Rhythms*
On a day when Death Valley was filled with smoke from wildfires in Southern California, and there was virtually no ambient contrast, I used Kodak Technical Pan film to achieve extreme contrast in this image. Using very different materials than those I used for figure 7–10, I was able to achieve a radically different set of tonalities.

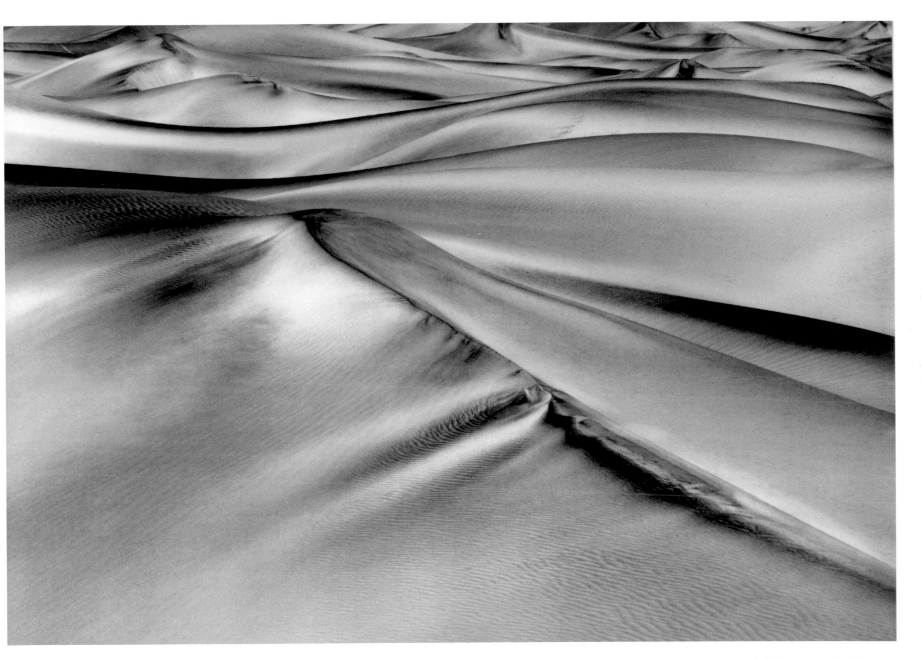

▲ *Figure 7–12: Satin Dunes*
Using Kodak Technical Pan film, I was able to achieve pewter-like or satin-like tonalities
under the same lighting conditions encountered in figure 7–10 (axis light).
It's very much worth trying new materials for their varied results, which lead to
greater creative options.

let me be clear, when I say extremely low-contrast scenes, I mean that in the extreme. That smoky day on the dunes was so low in contrast that I saw no discernible change in light value wherever I aimed my light meter. So I use that film only in the most extreme situations of low contrast.

Several years later, again with students on a field session on the sand dunes, I saw another axis-lit scene in which small deposits on the dunes—almost like iron filings that form interesting black patterns in some areas of the dunes— seemed to be the only discernible contrast. Admittedly, you could see the barest contrast difference between one ridge of dunes and the next, but it was tenuous, to say the least. Yet the forms I saw were exquisite, even while the contrast seemed to be nearly non-existent. Again using Technical Pan film, I photographed the *Satin Dunes* (figure 7–12).

Compare the tonal range of *Silver Sunlit Dunes* (figure 7–10) with that of *Satin Dunes* (figure 7–12). Both were photographed with axis light, but with the former exposed on a Tri-X negative and the latter on a Technical Pan negative. Surely the compositional designs of the two are different, but had the material been switched each would have a very different look and feel.

Having said all this, I have to admit to avoiding my own advice at times, perhaps too often. Yes, I've used different films, as explained above, but beyond that, I'm terrible. I have tried new and different papers over the years, but generally this is the result of a situation in which the paper I had been using was discontinued (often through company bankruptcy), forcing me to switch to another. I am now using the best black-and-white enlarging paper I have ever used in 45 years of darkroom printing: Fomabrom paper from the Czech Republic. It is outstanding. Having tried a few other papers currently available, I'm using Fomabrom exclusively. Maybe I shouldn't be. Perhaps I should employ others for specific images. But at this point, I simply can't imagine improving any image through the use of another paper. It's really that good.

Perhaps I should try different developers. I'm not. I'm using Kodak Dektol exclusively, which yields brilliant images with this paper. Other developers may produce different qualities, perhaps better qualities overall or for specific images. Have I tried any? No.

I should. And I chastise myself for that failure, even while I encourage you to do what I'm not doing myself. Perhaps it's simply lack of time; I am busy with a number of things in my life, but so are you. Perhaps I'm just being lazy. Whatever the reason, I can't give myself high marks for trying different materials often enough to see how they expand my creative capabilities.

However, in my defense, weak as it may be, I know that I like the look of a rich, glossy paper, air dried to a high gloss, but not to a mirror-gloss surface. I do not enjoy a matte surface, primarily because the deepest blacks obtainable are little more than a deep dark gray on a glossy paper. And while I often enjoy imagery that is quite different from my own, I find that I rarely enjoy images on matte papers (whether silver-gelatin or platinum-palladium or other processes), so working with the single paper I'm now using conforms to my likes, simplifies my process, reduces my inventory, cuts costs, and avoids my dislikes.

While I have settled in to a rather rigid, fixed mode with darkroom materials, I've made the far bigger move of working with digital cameras and techniques. After several decades of using nothing but film cameras, I obtained my first digital camera about seven years ago. I wanted to try digital approaches and I wanted to start exploring the digital world. Perhaps I am guilty of waiting excessively long to try using a digital camera, but I had been seeing images made by students and other photographers with digital cameras for many years, and I was watching the kinks in the process get corrected. When I felt that digital cameras started achieving a level of quality that justified some of the hype, I started using one.

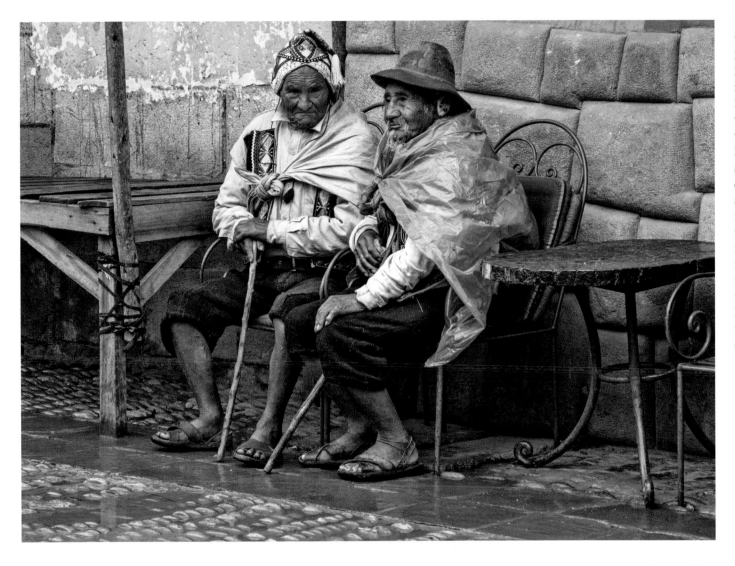

◀ *Figure 7–13:*
Two Old Men, Pisac
Pisac is an ancient Peruvian town upstream from Machu Picchu. Heavy rain was falling when we arrived during a workshop, so I grabbed a latte and sat down under an awning outside the corner coffee shop to avoid the rain. Two old men were sitting and talking across the intersection from me, and my digital camera allowed me to record the moment without them even knowing that I had visually intruded on their discussion.

My digital camera is, to be sure, my second camera, after my 4×5 film camera. But it's by far the best *second camera* I've ever worked with, allowing me to do many things I simply can't do with my 4×5: quick hand-held images (figure 7–13), extreme close-up to macro work (figure 7–14), photographing where tripods are not allowed (figure 7–15), photographing out of an airplane window (figures 7–16 and 7–17), and many other options not possible or easily accessible with my 4×5. (See figures 5–7 through 5–9 for more examples of digital imagery that may not be possible with my 4×5 camera.) Yet at the same time, my 40+ years of large-format work funnels me into thinking about the composition, light, relationships within the scene, and camera position (unless I'm looking through an airplane window, in which case I have little choice other than

► *Figure 7–14:*
Ice Crystals
At a United States Forest Service campground just up the road from my home, ice crystals were growing daily on a riverside picnic table during 10 days of dry, cold weather. Using my digital camera in macro mode, I was able to get so close to the crystals that the lens was pushing them over at times as I moved. I could never have moved in as close with my 4×5 large-format film camera.

In chapter 1, I discussed finding your own rhythm. I explained how I've discovered mine, how I tend to be very spontaneous and immediate in my responses to new subject matter, often making my strongest exposures right from the start. So it may seem logical that a digital camera would be the ideal camera for me, since I can use it so much quicker than my 4×5, which requires pulling it out of a backpack, putting it up on a tripod, focussing slowly and carefully, and then stepping away to put a film holder in the camera. It's not like a roll of film or a digital sensor that is always there inside the camera

to press or not press the shutter release). In other words, it has taught me discipline that I find lacking in most digital shooters today. For the most part, digital cameras have resulted in an explosion of the number of images produced, but a reduction in high-quality images. Digital imagery is capable of being high quality. There is nothing about digital approaches that forces poor quality due to thoughtlessly quick exposures, but there is lot that encourages it. Those undesirable urges can be overcome with discipline.

My 4×5 film camera is destined to be my prime camera into the foreseeable future. But I am enjoying my digital camera and my entry into the digital world immensely. Most importantly, my digital camera has opened up creative possibilities for me that were simply unavailable with my 4×5, or with any other film camera that I have ever used as a second camera.

just waiting to be exposed. So why not just ditch the old 4×5 and go digital entirely?

Well, there are good reasons. But it may be necessary to first explain that zeroing in on my thoughts and feelings about new subject matter quickly is not exactly the same thing as tripping the shutter quickly, though there may be some real relationships there. Even when I see something that instantly excites me, I set up quickly but thoughtfully, looking at the compositional relationships carefully, even if I'm working as fast as I can. I look at the quality of light. I look at the relationship of forms and whether a different camera position can improve them. I don't press the shutter release immediately even when I respond immediately. There certainly have been times when I worked as fast as I could under the pressure of

rapidly changing conditions, but I always give it some serious thought during my speedy maneuverings.

So, even with a digital camera in hand, I find it virtually impossible to immediately expose an image without some careful looking and seeing thrown into the mix. Needless to say, I can make a photograph far quicker with a digital camera than I can with my 4×5, and there have been times when I relished that speed. It has served me well, and I have enjoyed using it immensely. Most of all, I'm having a lot of fun using it.

Because the digital camera has opened me up to new areas of creativity that are not available when using my 4×5 camera, I think I can recommend that others try different cameras and different materials. How many people who started photography with digital equipment have opened themselves up to the possibilities of film or large format cameras? It is not only a different process, it offers different possibilities and it requires a very different discipline. In particular, it requires deeper looking and planning prior to exposure. You can't make a film exposure and then check the monitor on your camera to see how it looks. You can't delete the exposure if you don't like it. Those two thoughts may be enough to scare the hell out of people who use digital exclusively, but it's those very scary thoughts that force a way of seeing that is quite different from the digital approach.

Try to envision, for a moment, the discipline of Michelangelo as he carved the David statue. He couldn't chisel off a piece of marble and say, "Oops, that was wrong." Every gouge into that block of marble had to be meticulously thought

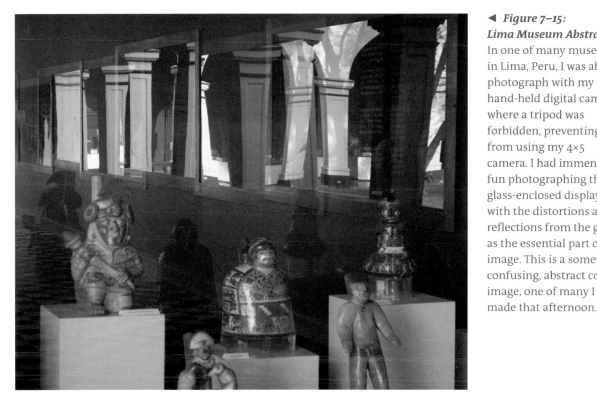

◄ *Figure 7–15:*
Lima Museum Abstract
In one of many museums in Lima, Peru, I was able to photograph with my hand-held digital camera where a tripod was forbidden, preventing me from using my 4×5 camera. I had immense fun photographing the glass-enclosed displays, with the distortions and reflections from the glass as the essential part of the image. This is a somewhat confusing, abstract color image, one of many I made that afternoon.

out and seen in advance, or the work was destroyed. It speaks to a degree of seeing, a degree of planning and a degree of discipline that is almost unimaginable. It is certainly unimaginable to the typical digital shooter who blithely says, "Well, I'll just delete that one."

Using film can dramatically sharpen a photographer's seeing. It forces careful seeing and planning that is too often missing in the digital world. So I recommend that those of you who have never picked up a film camera give some thought to trying it. Even if it fails to open up new creative possibilities, which I think is unlikely, it will surely sharpen your seeing right from the start, and it could help you work through your thought process to completion even before you start. That, in itself, can prove to be a major step forward.

▶ *Figure 7–16:*
Andean Summit, Peru
There is no possibility of successfully hand-holding a 4×5 camera steadily at the window of an airplane, and they don't let you set up a tripod at your seat either. But a digital camera allowed me to photograph this awesome Andean summit somewhere between Lima and Cusco.

▶ *Figure 7–17: Glacier, Greenland*
Flying at 35,000 feet above Greenland from Europe to Seattle, I used my digital camera to photograph the astounding mountains and ice below me. So while most passengers were either sleeping, tapping away at their computers, or watching inane movies, I was photographing the wonders of our planet that few people will ever see, even if they have the option to do so by simply lifting up the window shade next to them.

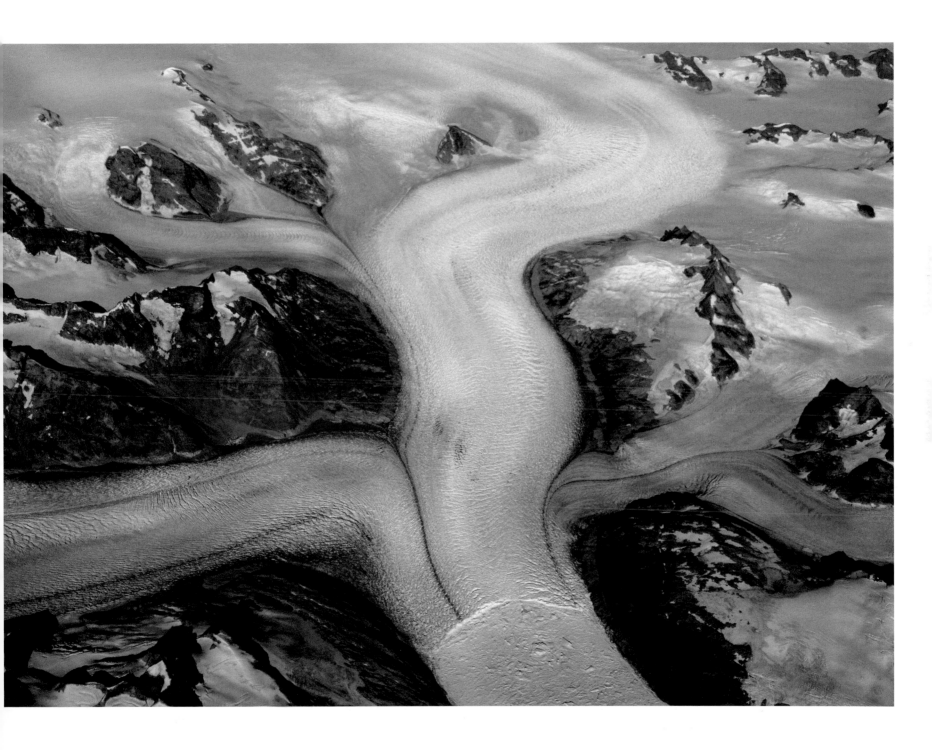

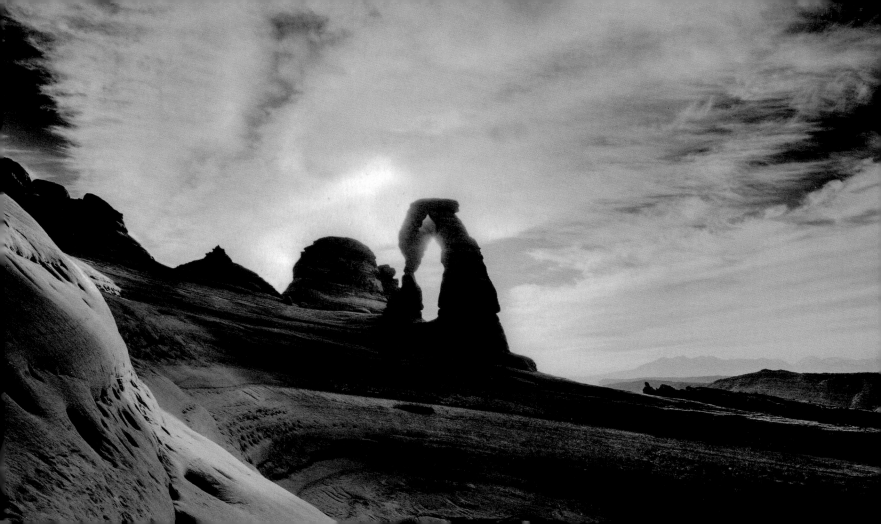

Breaking the Rules
and Following Your Passion

IN *THE ART OF PHOTOGRAPHY* I DEFINE GOOD COMPOSITION as the artist's way of forcing the viewer's eyes to work their way through an image in a planned, non-random manner. I cite several examples of this, including Ansel Adams's famous *Moonrise, Hernandez, New Mexico*, in which the viewer's eyes are immediately drawn to the moon (because it is bright and surrounded by black sky, making it the highest contrast node of the photograph), then downward to the lenticular clouds over the mountains, then to the mountains themselves, and then to the church and cemetery toward the bottom of the image, with each successive level progressively lower in contrast.

When looking at Adams's image, your eyes are effectively directed through the photograph in a very prescribed path. This says nothing about your response to the image (i.e., whether or not you like it); it just determines the order in which you view the various elements of it. Your eyes traverse that visual path quickly, so quickly that you're not aware of the visual journey you've just taken. Some people are highly moved by the church and the gleaming headstones in the the lower portion of the image, and say that they focused on that area first. They didn't. Scores of visual tests about how the human eye responds to visual stimuli have shown what the human eye is attracted to first, and none of them have resulted in information that would lead us to believe the church and crosses in Adams's image could possibly be the initial attractant. In fact, it's the moon, because the eye is first attracted to high contrast in any scene. That's what everyone sees first, and then their eyes move to other portions of the image. All of this occurs very quickly, and it has proven true for everyone.

◄ *Delicate Arch, Sunrise*
The famous Utah landmark continues to offer unique visual opportunities
when nature and light cooperate

When I walk the reader through my definition of "good composition" and the elements of composition in *The Art of Photography,* I do not discuss any rules for good composition. I avoid them because there are none. Every composition is unique, and following some concocted formula will not guarantee a good photograph. There are no formulas; there are no rules of composition. I strongly urge all photographers, beginning or experienced, to avoid any instruction that claims there are—it's bogus.

You have to be flexible at all times, and you have to work with the situation you're in, even if it's not the one you wanted. You'll regularly encounter unexpected conditions, so you have to learn to quickly adapt your seeing and thinking to situations you may not have planned for. Too often the photographer wants a specific condition so badly that he closes down his eyes and mind when he fails to get the desired light, or particular atmospheric conditions, or the look he wanted from a portrait subject, or any other condition that he desperately wished for. In the examples that follow, I first share how I've adapted to lighting conditions that were not what I wanted, and then I analyze two photographs and discuss how they may pass or fail when judged according to any number of rules or conventions, or any such set of conditions that define success. My intention here is to encourage you to expand your flexibility and free you up to proceed without concerns about any rules you may have encountered, such as the well-known—and utterly absurd—rule of thirds, or others you may impose on yourself, knowingly or unknowingly.

Working with Light

Many photographers feel that good light is found only during the hours around sunrise and sunset. But if you confine your photography to those hours, you lose a lot of valuable time and miss opportunities to capture potentially good images.

Following a workshop at my home in 2013, I went out with several students who were staying an additional day to photograph locally. It was a bright, cloudless day; one not conducive to photographing in a rather dense forest. I felt too lazy to put my 4×5 camera equipment into its backpack and throw it over my shoulders, so I took my small Canon G10 digital camera with me. As we sauntered down a nearby forest road, I saw that it was impossible to contain the range of brightness of the forest in a single image. So instead of trying to make the impossible work, I asked myself, "can I find soft light within this area that could allow me to make a serious photograph?" The students and I discussed the lighting and tried to alter our preconceived notions about what we would photograph in the forest.

Henry Fox Talbot coined the word photography by combining the Greek words "photo," meaning light, and "graphy," meaning to draw, for he viewed it as "drawing with light." It remains in that basic mode today. So I redirected my eyes from the high contrast of the brilliantly sunlit and deeply shadowed forest to subject matter that could be worked with under the circumstances.

I quickly stopped looking at the lovely forest in its entirety, and started noticing the sunlight edging the large plant leaves adjacent to the road and the other fully shaded leaves. Soon I was fully engaged with the large thimbleberry leaves (figure 8–1).

▶ *Figure 8–1: Thimbleberry Leaves*
When the lighting is not what you want, it's best to change your approach and photograph what you can in the lighting you have. Unless you're in a studio, you may have no control over the lighting, particularly in an outdoor situation. So on a bright sunny afternoon in a heavily forested area near my home, I avoided the high contrast of the overall scene, and concentrated on details either in the shadows or with soft light raking across them. The new thimbleberry leaves in full shade offered an ideal option for the existing lighting situation.

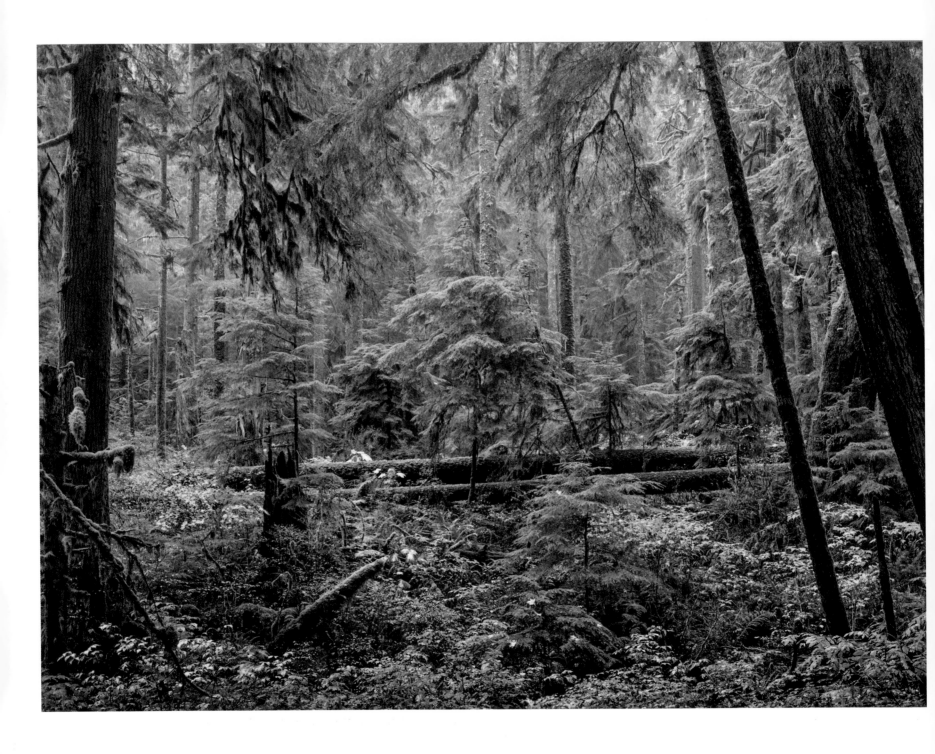

Within an hour, the sun went behind the shoulder of the mountain. Now everything was in shade and there was soft light everywhere, allowing us to photograph into the forest, which had been too high in contrast and too broken up into sunlit and shaded segments to photograph earlier. Finally we had the type of lighting I've seen so often along that lovely road—lighting that is not randomly broken up, but seems to smoothly bring out the sparkle and richness of the forest to the greatest extent (figure 8–2).

I have observed over the years that the reason so many photographers feel that good light occurs only during sunrise or sunset is that they are intent on making a specific type of image, one that they feel can only be made during those early or late hours. They need to open up their thinking to the different types of images that can be made during the middle hours of the day. Let's face it, there are a lot of hours between sunrise and sunset, and ignoring them reduces your output and your creative options greatly. I recommend that instead of putting your camera away during the many midday hours, you look for different subject matter that works with midday lighting.

If you're working on outdoor portraiture, the same concepts apply. Contrasts between sunlit and shaded portions of the scene may prove to be uncontrollable. If this is the case, consider positioning your subject on the shaded side of a building or under the canopy of a large tree. Fill flash can open up shadow areas (on a backlit face, for example) that would be virtually impossible to see without some artificial light.

◀ *Figure 8–2: Forest, Monte Cristo Grade Road*
This photograph was made along the same forested road as the previous image of thimbleberry leaves, after the sun dropped below the mountain ridge. With soft light I was able to work with the magic of the full forest at the base of Mt. Pilchuck, just across the Stillaguamish River from my home.

Alternatively, a large reflector just outside the picture frame could reflect light back into that same shaded face. Folded up, this could be easily carried in your camera pack or case. It's a simple solution, but one that may not immediately come to mind.

Cedar Breaks, Winter

I made this photograph in 1979, between twelve thirty and one o'clock in the afternoon, looking down into Cedar Breaks National Monument in Utah (figure 8–3). Together with my wife, our dogs, and several friends, I cross-country skied from Brian Head Resort to the image location, where we stopped for lunch. While munching on a sandwich, I noticed that the clouds that had filled the chasm of Cedar Breaks below us were beginning to rise and disperse, opening up some spectacular views of the layered cliffs below.

Without hesitation I set up my camera and aimed it toward the small conifer tree directly in front of me with the clouds and cliffs behind it. I wanted to create a feeling of depth and distance between the high plateau on which I was standing (at an altitude of about 10,500 feet) and the cliffs far below me in that National Monument. I chose the tree as an anchor point. I felt it would immediately draw the eye in because it stands apart from anything else in the scene and it serves as the high point of contrast against its surroundings. Furthermore, it would establish the feeling of depth that I was seeking between the foreground and background. I believe it accomplishes that goal.

Interestingly, several of my companions saw what I was doing and recommended that I step to the side and just deal with the deep canyon and clouds, thinking the tree would be a distraction from the main show. I felt the tree was needed.

I also wanted give the viewer a sense of the snow-covered slopes on either side of the tree. You can see how the ground

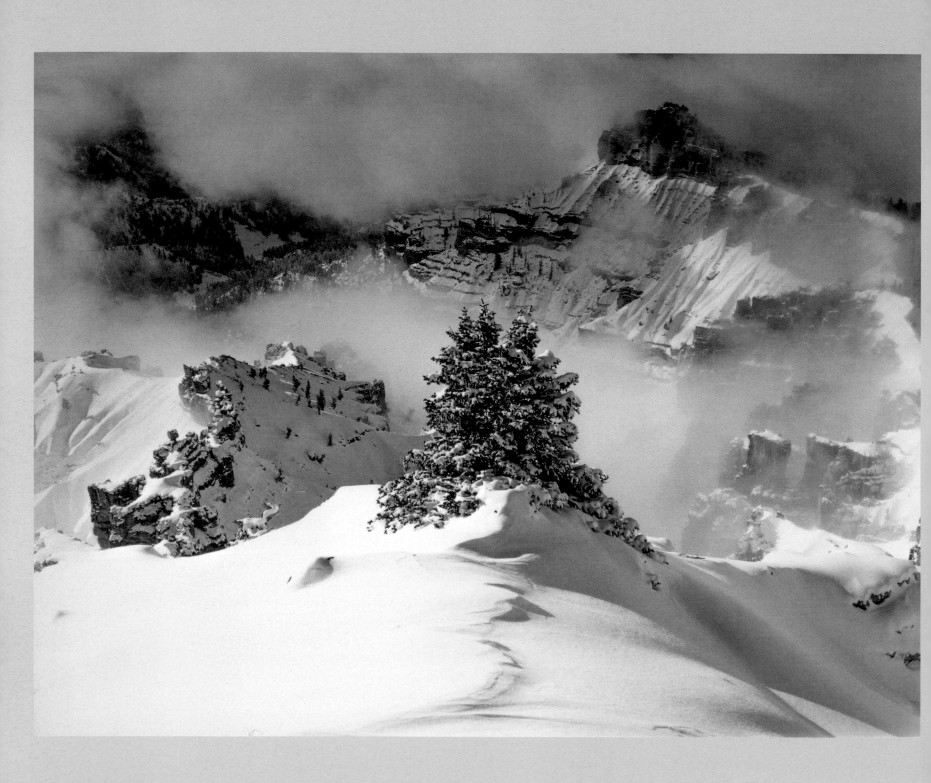

rises up to the tree on both sides. But look again—the lower left portion of the image has no detail whatsoever. It's pure white. When you first looked at that portion of the image, you likely read a soft slope into that area, mimicking the partially shaded slope leading up to the tree from the right side. Only now that I've pointed out the lack of detail in the lower left do you really notice that there's nothing there.

Now, it would be logical to assume that if a major portion of a landscape image is lacking any detail it would surely destroy the image, especially if that portion goes into a corner and is not the sky. Avoiding an element like this might be a "rule" of composition, but here it seems to have no destructive effect on the image. In fact, it's likely that before I directed your attention to that portion of the image, you actually saw sloping lines leading up to the tree. In other words, your brain may have supplied detail that didn't exist. Think of Haiku here, which conjures up a picture without explicitly describing it. That's what your brain does in this case: it causes you to see detail that isn't there.

So let's review a few rules that have been broken in this example. First, it's a landscape photograph made at midday. Many photographers implore you to photograph during the first hours of sunrise and the final two hours of sunset, saying that's when you'll find the good light. They're absolutely right about that. They'll also tell you to put your camera away in the hours between those times. They're absolutely wrong about

that. There are wonderful photographic opportunities at all times of the day; you just have to find the subject matter that conforms to the light. In a studio you can create the light you want; in the landscape you have to work within the confines of the light that you encounter. *Cedar Breaks, Winter,* which was made between noon and one o'clock, demonstrates that good light for landscape can be found throughout the day.

Second, although the main subject matter was the cliffs of Cedar Breaks interacting with the clouds, it's not the first thing you notice. Your eye meets the tree first, then quickly puts it in relation to the landscape and cloudscape beyond.

Third, the tree is virtually in the dead center of the image. Many camera clubs and instructors warn against placing anything of importance dead center. But I think it works, and I think it works quite well. This is simply another instance of ignoring the so-called rules of composition, and going with my gut feeling of what would work best. (Notice that the moon in *Moonrise, Hernandez, New Mexico* is virtually dead center.)

Finally, the pure white area of sunlit snow in the lower left corner defies all rules, and even some logic. It simply works, and it seems to work well enough that the eye supplies the missing detail. After printing and selling the image several times, I began to wonder if that blank area was really a problem that I was internally rationalizing as acceptable. So I returned to the darkroom, intent on darkening that corner to provide some detail. It turns out that the sunlit snow was absolutely even in lighting, so that by the time I burned (darkened) that area enough to obtain gray tonality, it was evenly gray with no tonal variation whatsoever. The print looked dim and dingy. I proved to myself that it was better left as I initially printed it: without any detail or tonality, allowing the viewer's eye to fill in the details.

◄ *Figure 8–3: Cedar Breaks, Winter*
Photographed at midday, with a major object dead center, and no detail in the sunlit snow at the lower left, this image breaks any number of "rules." It works for me. Does it work for you?

Rooftops, Heidelberg

The second example I offer here is a digital color image made from the observation point high in the tower of the Heiliggeistkirche, or Holy Ghost Church, in Heidelberg, Germany (figure 8–4). The view of the old buildings was stunning, but there was no way I could set up my tripod and 4×5 camera to look straight down on the geometric abstractions of the rooftops below. Due to the thickness of the wall, the camera would have needed to be nearly three feet out from the center of the tripod, an obvious impossibility. The only option was to use my digital camera. But unless I were to hang myself out there along with the camera (not a terribly safe idea), I couldn't possibly see what I was composing.

So with this image, I had to break my own rule—actually more of a dislike than a rule—and make the image first, then look at the monitor to see what I had done. I've long railed against the typical procedure of digital photographers who snap the shutter so quickly that they rarely compose before shooting. I strongly endorse the idea of carefully looking before reflexively shooting. Too many digital photographers shoot and then look, turning the idea of composing first on its head. I've criticized that practice in this book. But in this case, that's exactly what I had to do to avoid risking my life.

I wanted the image to be perfectly rectilinear, completely squared up with its edges on all four sides. Of course, that would have been impossible unless I were directly above the center of the image looking straight down. So I made the bottom of the rooftops exactly parallel with the bottom of the frame. And of course, in order to do that, I had to make several exposures by hand-holding the camera well over the edge of the tower's walls before I aligned the bottom perfectly. Later, I was able to square up the left, right, and top edges using the perspective crop in Photoshop.

So, while I may not have broken any rules in making this image, I had to overcome my own dictum, my personal rule, of always looking carefully—even if it's done quickly—before snapping the shutter. In this case, it simply couldn't be done, so I resorted to the only means at my disposal to obtain the image. It worked, and that's what counts. And I had fun doing it.

These two examples both break rules. The first, a set of standard rules that so many people view as unbreakable. The second, my own self-imposed rule. There is an old saying that records are made to be broken. The same should apply to rules of composition. In fact, I believe it's best to never even learn the so-called rules of composition so you don't have to consciously break them. That, in itself, can be an impediment. Concerning my basic self-imposed rule of looking before snapping the shutter: I'll still champion it, but I recognize there are times when even that one has to be ignored.

Early in your photographic career you may have to give a lot of thought to things like relationships between forms to optimize the visual intent of your composition. You'll give a lot of thought to the intensity of colors, the range of contrast, and all the other variables of an image's composition. After some time—maybe years, maybe decades, but never weeks or months—seeing those relationships, those colors, those contrasts, and all the other variables becomes so ingrained that you don't really *think* about them; instead, you do them reflexively. It becomes part of you. It's like driving a car—at first you're thinking about every move, but after years of driving (and not crashing too many cars too often) you think about all sorts of other things while you're driving. Hopefully you're paying attention to your driving, but in essence, you're not really *thinking* about it, just as you're not thinking about walking when you're walking. It becomes a natural act.

Composing an image becomes a natural act. But there will always be times when things are different, maybe very complex, and you are forced to seriously think about the composition. It's like walking uphill on a rocky slope; that's when you have to really think about walking. If you have the tools—not

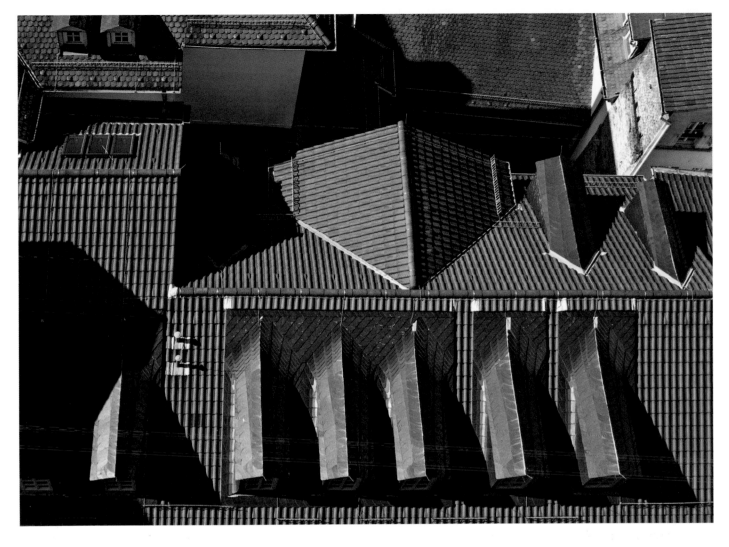

◄ *Figure 8–4:*
Rooftops, Heidelberg
In order to take this photo-graph, I had to hold my camera as far out from the thick tower wall as possi-ble, making it impossible to see the composition before I pressed the shut-ter button. After several attempts, I was able to square up the image as I wanted, highlighting the abstract geometry of the rooftops below me.

the rules—you'll figure out how to start that photographic process in the best possible way. But you'll find that most of the time, a certain composition simply feels right. When it does, go with it.

Photographing My Passion; Finding Yours

In addition to being a photographer, I'm an environmentalist. I've been involved with environmental issues from the mo-ment I became interested in photography. It was inevitable because my prime photographic interest was initially, and solely, the landscape, so protecting it and photographing it

went hand in hand. I remain deeply involved in environmen-tal issues today.

Years ago a student at one of my workshops approached me during a photography field session with the following question: "You have shown us a lot of wonderful photographs of the landscape, but almost none of people. Why not?"

I thought about it for a moment, then answered, "You can treat me like hell or I can treat you like hell, but life will go on. You can kill me or I can kill you, but life will go on. However, if we kill the planet, we'll all die."

After a very brief pause, he simply said, "Oh, I see."

That's how I felt years ago; I feel exactly the same way today. That is part of the reason I photograph the landscape.

Photographing the landscape is photographing the earth, and most of my landscape photographs are of pristine, untouched land, the land without manmade alterations.

My environmentalism is driven by the obvious fact that if we don't protect the planet that nurtures us all, we have no future. I see an overwhelming amount of evidence that we are failing to protect our planet, and thus creating a future that is bleak, indeed. But I have done little photographically to express my thoughts and concerns. Why not?

I recognize that photography has been quite effective at encouraging the creation of national parks and other protected land. Photographs made in the 1860s and early 1870s by William Henry Jackson were instrumental in the creation of Yellowstone National Park, the world's first national park. Many of Ansel Adams's early photographs of the central Sierra Nevada were instrumental in the creation of Kings Canyon National Park. Despite such sterling examples of photographic success, I have seen too many magnificently produced exhibits and books fall short of changing the actions of the public and politicians who exploit the land for its resources rather than protect it for its natural values.

Nick Brandt has made some of the most stunning photographs I've ever seen of wildlife in Africa, including elephants and other large mammals of the continent. Part of his intent is to help stop the slaughter of elephants, rhinoceroses, lions, and other magnificent creatures, whose tusks and horns and claws and teeth are sold in East Asia as aphrodisiacs or art objects for the ultra-wealthy. But the killing continues, and has dramatically increased in the past several years. There's simply too much money in it for the poachers to ignore. Soon, all of these great animals will be exterminated from the wild, perhaps to be kept only on display in zoos. This is almost too painful to bear.

Seeing such failures of intent over the years, I have largely confined my environmental activism to writing about issues or getting directly involved in working on specific issues, rather than using photography to bring attention to those issues. Yet, on occasion, I have also attempted to produce photographs intentionally designed to tell a story about our mismanaged environment, only to find that the message wasn't getting through; not so much because of the failure of the imagery itself, but because of the lack of environmental knowledge on the part of a high percentage of viewers.

The image I felt made the most complete and obvious case is one titled *What Was...What Is* (figure 8–5). Made less than a mile from my home, across the river on the lower slopes of Mt. Pilchuck in the state of Washington, it shows an ancient Western Red Cedar stump, logged a century ago, amidst the forest of tall, skinny trees that has grown up since the complete removal of that old growth forest. I felt that anyone who saw the image would compare the 14-foot diameter of the logged giant with the 14-inch diameters of today's trees, and quickly see how our poor management has diminished and devastated the forest. But I was wrong. Too many viewers saw that there were new trees that had replaced the old—a positive thought. Few noticed that none of the newer trees were the same species as the stump. Few noticed that the total amount of wood in all the standing trees combined failed to equal the amount in the single tree logged a century ago. Few knew that the young, skinny trees would again be logged before they had a chance to get much larger. A few got the message I intended to convey, but it was far too few.

▶ *Figure 8–5: What Was...What Is*
This image, also made on the lower slopes of Mt. Pilchuck near my home, was intended to show the ravages of industrial logging. The huge Western Red Cedar stump is roughly 14 feet in diameter, typical of old growth cedars long ago. Today, hundreds of tall skinny trees stand in its place in a dead zone with no foliage on the forest floor—not a suitable habitat for wildlife. This mismanagement on a grand scale is little understood by most viewers who simply see new trees replacing the old. The reality is far deeper, and far more disturbing.

It was a key disappointment for me, for I thought this would be the perfect image to counter the true but grotesquely misleading statement made by timber companies that there are more trees in today's forests than ever before. Yes it's true, but only because so many skinny trees have taken the place of the grand giants that once inhabited our forests. Few viewers noticed that the sterile forest floor is devoid of undergrowth—the shrubs, ferns, mosses, and young trees that provide necessary habitat for wildlife.

What we're seeing here is not a forest, nor is it even a "tree farm" (to use the pleasant sounding euphemism given to us by logging companies); it is a raw lumber factory. It is a cluster of trees lacking an ecosystem. In fact, it's not even a cluster of trees, and it's certainly not a forest; it's simply wood wait-

▲ *Figure 8–6: Cut Oak Tree, Agoura*
This beautiful tree was cut down on Christmas Eve, when nearby residents were likely at home, oblivious to the nearby destruction taking place. I discovered it, and many others lining an intermittent streambed, the next morning when I jogged in the area.

▲ *Figure 8–7: Two Cut Oak Trees, Agoura*
This was part of the string of trees cut down for a new development of suburban tract homes. On Christmas morning, shortly after I photographed the devastation, all cut trees were removed, the stumps were pulled out of the ground, and the ground was scraped, hiding all evidence that the trees had ever existed.

ing to be cut down for human use. The photograph's title was designed to point to the fact that what was once a forest is now an industrial lumber factory. This is painful to me, but I haven't made the proper photographic breakthrough to end today's devastating logging practices. I haven't even slowed them down, nor has any other photography had the desired effect.

What Was...What Is wasn't the only direct attempt I've ever made to photograph for purely environmental purposes. In the early 1980s I was living in a typical suburban tract of homes in Agoura in Los Angeles County, just east of the Ventura County line, north of Highway 101. It is pleasant, gentle oak, savannah landscape with rolling grassy hills dotted with oak trees, and oaks and sycamores lining the intermittent, seasonal streambeds. I would jog on trails in that countryside adjacent to the tract in which my wife and I lived.

On Christmas morning in 1981 I went for a typical jog with my dog. Something felt weird, different. But as I huffed and puffed along, I couldn't determine what it was. Upon my return, it suddenly became clear: all of the oak trees adjacent to the nearby streambed were lying on their sides, having been cut down the evening prior to my jog. The cutting of those trees took place on Christmas Eve, when everyone in the area

would have been in their homes with family, oblivious to the destruction taking place nearby.

I quickly went home, grabbed a camera, and made photographs of the fallen trees (figures 8–6 and 8–7). Most people were now at home, likely unwrapping presents under their Christmas trees. My wife was out that morning, so when she returned home several hours later I told her about the tree cutting and took her there to see what was done.

There was nothing to see. Between the time I had photographed the cut trees and the time I took Karen there, the trees had all been removed, the stumps had been pulled out, the ground had been scraped and roughed up, and there was no indication that the trees ever existed! This was all accomplished on Christmas Eve and Christmas morning, carefully timed to avoid being noticed. It was a clandestine exercise.

I was probably the only one who ever saw it. The cutting of trees in that area was against the law, but the developer saw the fines as little more than a business expense. With the trees out of the way, he was free to lay out his tract with utmost efficiency for maximum density and profit. Furthermore, he would name the streets Shady Oak Lane and other such pleasant names, to the rapture of young couples buying their first homes on these streets. In a triumph of semantics over substance, the name had replaced the reality, to the joy of everyone, especially the developer with his expanded wallet.

To the joy of everyone except me. I saw what happened. Yet I realized afterwards that devoid of recognizable landmarks within the photographs to determine the location, they would have been unlikely to serve as legal evidence of the destruction.

My photographs of the cut oaks in Agoura were documentation of clandestine destruction. But one final example that shows unexpected destruction is the photography I did over a period of nearly ten years along the Altamaha River in South Georgia, all the while thinking that the magnificence I was photographing was permanently protected (figures 8–8 and 8–9).

Starting in the late 1980s and running through much of the 1990s I held photography workshops annually in south Georgia. One of the field session sites was along the Altamaha River, about 45 miles inland from Brunswick, located on the Georgia Coast. Each year I brought 12–15 students there to visit this wonderfully pristine area. It was a fantastic area that served as a great workshop field site for years.

Today it would be useless. It was clearcut several years ago. Not a single tree remains standing in that area today.

These are just some of the natural degradations I have experienced over the years. I have seen spectacular mountain vistas ruined by trophy homes built at the base of the mountains, such as those on either side of I-15, north of Las Vegas and just south of the entry into the spectacular Virgin River Gorge. The once untouched, flat desert land that abruptly ends at the base of cliff-like mountains converging from either side of the highway toward the narrow gorge is now dotted with sprawling homes. It is an undesirable visual intrusion. Of course, the biggest atrocity is the highway running through the awesome gorge that should have been off limits to any manmade development whatsoever.

At the north end of the gorge I've watched the small, pleasant town of St. George, Utah, grow into an ugly behemoth of well over 100,000 residents today, sprawling over the adjacent landscape. In the process, I have seen small-scale but wonderful geological formations disappear before bulldozers that flattened the land to put in new, boring tract housing developments miles from the town I first saw. Today the landscape is unrecognizable compared to the land I first encountered in the mid-1970s. A flat expanse of suburbia has replaced the charming landscape of synclines, anticlines, and other unusual features that once existed. It is quite discouraging.

Perhaps within my general landscape imagery there may be a message about recognizing the natural values of our planet, and the importance of protecting it. I hope that to be the case. That's part of the reason I've been drawn to the

▼ *Figure 8–8: Sunrise Mist, Altamaha Cypress Swamp*

On a cold December morning, this area turned to magic at sunrise, as steam rose up from the swamp waters and sunlight streamed through it. I had taken workshop groups to this magical area numerous times. Today, all the trees have been cut down.

◀ *Figure 8–9:*
Morning,
Altamaha Swamp
Another morning, another time. Color, not black-and-white. The swamp was magnificent at all times, but somehow even more so in the early morning, when a slight fog almost always pervaded the atmosphere. It's all gone now, having been clear-cut. Not a tree remains standing today.

landscape photographically, and to environmental activism simultaneously. I can't imagine photographing the land with such love and intensity for over 40 years without noticing the progressive destruction of the natural environment nearly everywhere, leading us to the very brink of irreversible disaster.

But I have not felt that photography used strictly for environmental enlightenment and salvation is enough to turn hearts and minds around. Maybe I've just missed the boat on this issue. It seems to me that the only thing that changes the minds of politicians, who have a large say in the matter, is money, not photographs. But this involves another lengthy discussion tangential to the goals of this book.

I've read that a person will defend the things he loves. He'll fight for those things. If someone attacks your wife or your

child, you'll fight for them, literally. You love them and you won't sit by idly watching them attacked. So ask yourself, how much do you love the things you're photographing?

It turns out that I love the natural world. That's undoubtedly the reason it drew me into photography in the first place, and it's the reason I've photographed it so passionately for over 40 years. It's undoubtedly the reason that I've been involved in environmental organizations, causes, and battles throughout that same period. Our planet means so much to me that I can hardly imagine people who will not fight for it. So even though I photograph primarily for artistic purposes when I'm up in the mountains, down in a canyon, in a forest, at the seashore, or on the sand dunes, I harbor a hope that somewhere within the imagery, there is a message that the land is worth a lot, and that viewers will see that message.

My most cherished review was for an exhibit I had in the Los Angeles area in 2000, in which the *Los Angeles Times* reviewer included the following sentence, "In short, it's an exhibition that might have the persuasive power to give developers pause before ravaging special corners of our planet." It felt good to see that in print, despite the fact that none of the photographs were made with the thought of protecting the natural environment as a primary concern of mine. Apparently, in the aggregate, that message was conveyed. Perhaps because it's an overriding concern of mine at all times.

I look to the concerned readers of this book to plumb the depths of your imagination, insights, and creativity to see how photography can be used to more effectively make the statement that I have tried but largely failed to make with my imagery. In *What Was...What Is* I thought the intended message was indisputably clear, but I failed to realize how few among us are cognizant of the complex natural processes in an untouched forest, or in any untouched natural environment. It appears we're becoming progressively less aware of natural processes as we become more urbanized. Today, most of us living in cities and suburbs believe food comes from supermarkets and water comes from the faucet. I fear that we are removing ourselves further and further from the natural environment that supports us all. We need new thinking about how photography can be used to convey the importance of nature to the people and the politicians.

This is an area in which I have not done well, and I urge others to try to convey the correct message better than I have been able to do.

Of course, if your passion lies elsewhere, you have to identify that passion and determine how to apply your photographic skills to make it come alive for the viewer. You want to make the strongest statement you can about people, or architecture, or food, or sports, or whatever draws you in. It starts with identifying your passion; it ends with making the visual statements that cause others to take note.

Photography as a Creative Art Form

However you choose to express yourself photographically, keep in mind that you are part of an absolutely necessary aspect of the human spirit: the need to express oneself through art. Every society that has ever been studied engages in visual arts and music—from the ancient cave dwellers at Lascaux or Altamira in Europe to the Inca, Aztecs, Maya, and Anasazi of the Americas; to ancient people throughout the world; to people living today in such remote jungle areas that they have never had any contact with the modern world; to those of us living in the most modern, interconnected regions of the world. This is so universal that it can only be looked upon as a human need, perhaps on par with food and water. It is clear that art is a human necessity, and it may be the only thing that separates humanity from other species. That and the human ability to store and pass on knowledge through such inventions as libraries and other storehouses of information.

Photography is part of the art world. Just as most art critics balked at the new visionary way of seeing brought about by the impressionists in the mid-1800s, most balked at photography as an art form for decades, dismissing it as mechanical and simplistic. Those objections have long since been laid to rest. Today photography is universally accepted as a valued art form, and is regularly displayed in museums. Digital imagery has been accepted into that pantheon with almost blinding speed compared to the century-long reluctance to accept traditional photography, a reluctance that finally disappeared in the last quarter of the 20th century. It is an isolated critic or artist who still scoffs at photography as a fine art.

Photography has unlimited potential. Like the sciences, other arts, or business, it is limited only by lack of imagination, lack of insight or depth, and lack of creativity. Both traditional and digital photography offer as much or more within their arsenals of capabilities and "tricks" than you'll ever need to accomplish your expressive goals. Within your own limits of imagination, insight, and creativity, you can do anything you can think of doing. I urge every reader, every photographer, to push those limits beyond what you thought they could be. There is more to be done by digging deeper into areas that have been mined before, and there are always new areas to delve into for the first time.

Perhaps the preceding chapters and all the words and photographs raise more questions than answers in response to the question of "what is creativity?" It turns out that creativity probably involves many things—time, effort, dedication, thought, enthusiasm, experimentation—each of which is important by itself, and maybe even more important in combination with others, leading to even more creativity.

People who create a whole new way of seeing—think Monet and the French impressionists—are often credited with being highly creative. The same can be said of musicians, where the greatest names changed the direction for both subsequent composers and the audience. Monet, van Gogh,

Beethoven, Stravinsky, and other innovators were generally vilified by critics and the public alike for their innovations, but in time they won out. When Stravinsky's now-popular *The Rite of Spring* was first performed in Paris, it led to a true riot.

But not all innovators ever gain true acceptance. Schoenberg's atonal twelve-tone scale, for example, has reached a level of partial acceptance with critics, and apparently a somewhat lower level of acceptance with general audiences, but his music still has not achieved the same level of acceptance as that of Stravinsky or Copland or his other contemporaries.

Man Ray, as I noted in chapter 3, was exceptionally creative in his photographic experiments in the sense that he probed visual ideas that never occurred to others, producing imagery that was entirely new. But according to my aesthetic tastes, little of it is appealing. I give Man Ray high marks for creativity and low marks for beauty. As such, I think his influence on photography was severely diminished from what it could have been.

Edward Weston, Ansel Adams, and a small group of other photographers, largely clustered in and around Carmel, California, banded together in the 1930s to form Group f/64 in response to the "pictorialists" of the day, who were led by William Mortensen. Mortensen and his group produced images that were slightly or greatly out of focus, intended to be dreamlike and evocative, and they had a degree of public popularity. Perhaps their style was based on the ideas of the impressionist painters, where a close viewing shows brushstrokes but no detail. Group f/64—which took its name from the closed-down aperture that produces exceedingly high depth of field, making virtually everything in the image appear crisp and sharp—fought against the pictorialists with the idea of revealing everything in exceptionally rich detail. Eventually, it seems, Group f/64 won the battle. Not too many people today sing the praises of Mortensen and the pictorialists, but Weston, Adams, and the others are often considered icons.

► *Figure 8–10:*
Meadow, Trees and
Mountain Slopes, Winter
Heavy snow covers
Mt. Pilchuck (elevation
5,342 feet) each winter,
and even reaches our
home at an elevation of
980 feet. Following such
snow, the scene is magical,
a true winter wonderland.
I stood on our driveway to
make this exposure,
viewing the trees and
mountain slopes across
our front meadow.

These photographers are honored today not so much for their crisp, detailed, innovative way of seeing, but for the images themselves. Whether it's Weston's *Pepper #30* or Adams's *Moonrise, Hernandez, New Mexico*, we tend to focus on the image, not on the fact that it's sharp and detailed. So while developing a new way of seeing may make the work stand out, and may make the artist stand out as a creative innovator, it seems to be the strength of the image and the emotional depth it conveys that ultimately becomes the standard by which it is judged.

Defining My Goals; Defining Yours

I have chosen to work in the tradition of the silver print that is similar to those produced by Group f/64. My photographs tend to have sharpness and clarity throughout, with only a few exceptions. I like the look of the traditional silver print, and never sought to come up with a new way of producing a print, though I have created some different ways of developing a negative. I enjoy color as well, and today I spend about equal amounts of time with color imagery and black-and-white.

▲ *Figure 8–11: Storm Cloud Panorama*
We've had some rough storms at our abode over the years, so when I saw these clouds spread across the sky, I grabbed my digital camera to photograph them quickly, and then headed for cover, expecting the worst. But little happened. Although it looked fierce, it led to nothing more than a few drops of rain and a little bit of a breeze.

▲ *Figure 8–12:*
Mt. Pilchuck Ridge,
Winter Sunset
Living up in the mountains
is quite wonderful, for I
never know what beautiful
occurrances will happen
next. There is a rugged
ridge leading to the
summit of Mt. Pilchuck
that I find particularly
attractive, especially when
newly fallen snow has
covered it (notice some
snow on the lower,
forested slopes below it)
and a soft pink, sunset
glow envelopes it.

Hopefully the images I have produced have some depth of creativity, whether it's new subject matter I photographed that had never been photographed previously (the slit canyons or my colorful polished rock details); or different ways of creating whole new worlds that I would like to see through my imagination and the combination of negatives (my ideal landscapes); or simply the pursuit of a deeper understanding of subject matter that has long been investigated (general landscapes, sand dunes, architectural subjects, the "Darkness and Despair" series); or anything else I may have photographed. I cannot judge the level of creativity of my own work. Furthermore, any such value judgment on my part would be wholly immaterial, for it is others who will render that determination, either today or in the future, should my work be looked at in the future.

I have not striven for creativity as a goal in itself. Instead, whatever level of creativity I have achieved has been the inevi-

table product of my deep love of photography; my keen interest in always looking for new and different subject matter, and new ways of seeing that subject matter; and my many years of photographing. I try to keep my mind open to anything and everything, though I'm sure that I have unknowingly blocked things off that I should have been open to. I suspect we all do that. I've looked primarily for beauty and for the pleasure of simply making images. I have enjoyed doing just that. I've traveled and photographed in a number of places on this planet, but there are many, many more that I have never seen and never will see. I've enjoyed my travels immensely. I've enjoyed going back to some of the same places time after time. My goal has been primarily to enjoy the day, the place, the ambience, and if possible, to make a good photograph along the way.

Fortunately for me, I also enjoy working in the darkroom. And over the past several years, I've found that working digitally in the field and on the computer is also extremely rewarding. Sometimes I'll grab my little digital camera to carry on one of my several daily dog walks and find some of the loveliest, most unexpected things along the way. Sometimes I

▶ *Figure 8–13: Sunbeams Through Trees*
Cold, wet conifer trees were warmed by intense winter sunlight, sending plumes of steam outward and upward from the trunks. I was fortunate enough to have time to run home, grab my 4×5 camera and tripod, and race back in time to photograph the sunbeams bursting through the forest behind our home.

run back to the house to grab the little Canon G10 upon seeing an ephemeral wonder that I'll never see again but may be able to record quickly before it disappears. Many photographs have been made on our typical morning, midday, or evening walks around our open frontyard meadow, which affords us magnificent views in all directions (figures 8–10 through 8–12).

One of the dog walks on our "back 40" forest trail in late winter of 2013 was especially notable. It was a cold but bright, sunny day. As we were walking toward the sun on our way back to the house, it was impossible to miss the brilliant rays of sunlight streaming through the steam that was coming off the tree trunks under the intense sun. With no camera in hand I began running to the house to get my trusty G10, but I quickly realized that the contrast would be too much for it to handle. I also realized that the situation would last, since the brilliant sun was still warming the wet trees. So I opted for my 4×5 film camera, grabbed my tripod and my backpack containing all my 4×5 equipment, and ran back (if you can call that running) with enough time to make the photograph (figure 8–13). It was extraordinarily exciting.

Every form of photography I engage in has proven to be a source of great pleasure, an escape from the real world that dominates the news and the degradation of our planet that seems inexorable. I will say without hesitation that whenever I can spend a day hiking in the mountains, canyons, forest, seashore, desert, or an ancient town, it is a day of great pleasure and reward for me. If I can produce a photograph along the way that pleases me, it's icing on the cake. But the cake is always the day spent in any of those attractive and important places. When I have the time to spend a full day in the darkroom bringing my negatives to life, or on the computer bringing my RAW files to completion, it's a day of equal pleasure, and even of personal triumph.

To me, that's what counts, no matter how creative or noncreative my photography is thought to be in the present or the future. I'm simply having a lot of fun with it. I believe that enthusiasm and fun have to be the first prerequisites of photographic success, and perhaps of success in any field. I urge you to look inward to see how much fun you're having with your photography. I hope yours equals mine. As I explained in the introduction, much of this book is filled with personal anecdotes, with the hope that within those anecdotes there are some tidbits of information that you can apply to yourself, your way of seeing, and your passion for the subject matter that means the most to you.

If you are going to be successful in your photography, it will have to be because you're enjoying it immensely. You can never do it through assignments. Instead, assignments have to come from within. You have to follow your passion, whether you have the opportunity to do it once a week or once a month, or whenever you can. I learned that in 1972 when I opted to drive to the Sierra Nevada for personal photography instead of taking a lucrative commercial rush job. Now, more than 40 years later, it's still just as electrifying to me to photograph something that really rings my chimes.

You'll have to find your own passion. You'll have to devote some serious time to learning the technical aspects that articulate your statements. Then you'll find the time to do some extraordinary things. It will happen because you'll make it happen.

Best of luck...and more importantly, best of fun.

Technical Information

- The term LT (under "camera"), indicates my 4×5 Linhof Technika camera
- All shutter speeds are in seconds or fractions of seconds, unless otherwise indicated
- After shutter speed, if a filter was used, its color and the number of stops needed are noted (for example, if I used a red filter that required an opening of 3 stops, it would show (red 3) after the shutter speed)

Image	Camera	Lens (focal length)	Film (if applicable)	Aperture	Shutter Speed	Year
1	LT	Fujinon 210mm	KodakTri-X	f:32	1	2002
1–1	Hasselblad	Zeiss 250mm	Ektachrome D	f:22	1/30	1974
1–2	LT	Schneider 360mm	Ektachrome D	f:32	1/15	1975
1–3	LT	Schneider 150mm	Ektachrome D	f:8	1	1974
1–4	Pentax 35mm	Pentax 135mm	Kodachrome 25	f:4	1/60	1972
1–5	LT	Schneider 360mm	Kodak Tri-X	f:32	6 (red 3)	1976
1–6	LT	Fujinon 150mm	Kodak Tri-X	f:32	3 1/2 minutes	1980
1–7	LT	Schneider 47mm	Kodak Tri-X	f:32	3 1/2 hours	1998
1–8	LT	Fujinon 90mm	Kodak Tri-X	f:32	11 minutes	1980
1–9	LT	Fujinon 210mm	Kodak Tri-X	f:32	3	2009
1–10	Canon G10	Internal Zoom	Digital RAW	f:2.8	1/40	2011
1–11	Canon G10	Macro Mode	Digital RAW	f:2.8	1/800	2011
2	Canon G10	Internal Zoom	Digital RAW	f:3.5	1/1000	2011
2–1	LT	Fujinon 300mm	Kodak Tri-X	f:32	1/4	1986
2–2	LT	Fujinon 210mm	Kodak Tri-X	f:32	11	2003
2–3	LT	Fujinon 300mm	Kodak Tri-X	f:32	1 (orange 2)	2013
2–4	LT	Fujinon 300mm	Kodak Tri-X	f:45	8	1990
2–5	LT	Nikon 500mm	Kodak Tri-X	f:45	6	2011
2–6	Mamiya 645	80mm/w extension	Ilford FP4	f:22	3	1998
2–7	LT	Fujinon 90mm	Ektachrome T	f:32	5	1995

Image	Camera	Lens (focal length)	Film (if applicable)	Aperture	Shutter Speed	Year
2–8	LT	Schneider 150mm	Ektachrome D	f:28	1	1983
2–9	Ansel Adams photograph					
2–10	LT	Fujinon 150mm	Kodak Tri-X	f:45	15	1987
2–11	LT	Fujinon 90mm	Kodak Tri-X	f:32	1/15	1983
2–12	LT	Schneider 150mm	Kodak Tri-X	f:32	3	1977
2–13	LT	Fujinon 150mm	Kodak Tri-X	f:24	10	2000
2–14	LT	Schneider 47mm	Kodak Tri-X	f:32	16 (green 3)	1996
2–15	LT	Schneider 360mm	Kodak Tri-X	f:28	1/8 (yellow 1)	1973
3	Canon G10	Macro Mode	Digital RAW	f:5.6	1/5	2012
3–1	LT	Schneider 360mm	Kodak Tri-X	f:22	2 (red 3)	1972
3–2	LT	Fujinon 90mm	Kodak Tri-X	f:32	12 minutes	1981
3–3	LT	Fujinon 90mm	Kodak Tri-X	f:32	10 1/2 minutes	1981
3–4	Two negatives (top and bottom), each exposed identically, one after another:					
	LT	Fujinon 90mm	Kodak Tri-X	f:32	4	1998
3–5	Calumet 4×5	Schneider 75mm	Kodak Tri-X	f:32	3	1977
3–6	LT	Schneider 150mm	Kodak Tri-X	f:32	2	1978
3–7	Two Negatives, each exposed differently (upper half first; lower half second):					
	LT	Fujinon 90mm	Kodak Tri-X	f:32	1 (red 3)	1991
	LT	Schneider 150mm	Kodak Tri-X	f:32	2 (red 3)	1976
3–8	Two Negatives (left and right), each exposed differently (left side first; right side second):					
	LT	Fujinon 75mm	Kodak Tri-X	f:22	7 minutes	1990
	LT	Fujinon 75mm	Kodak Tri-X	f:22	19	1993
3–9	Craig Richards photograph					
3–10	LT	Fujinon 75mm	Kodak Tri-X	f:32	2 3/4 minutes	1994
4	Canon G10	Internal Zoom	Digital RAW	f:3.5	1/1000	2010
4–1	LT	Nikon 500mm	Kodak Tri-X	f:42	1/15	2004
4–2	LT	Schneider 58mm	Kodak Tri-X	f:32	1/2	2005
4–3	LT	Fujinon 90mm	Kodak Tri-X	f:38	1/4	2007
4–4	LT	Nikon 500mm	Kodak Tri-X	f:45	1/8	1990
4–5	LT	Fujinon 150mm	Kodak Tri-X	f:24	1 (orange 2)	2012
4–6	Calumet 4×5	Schneider 75mm	Kodak Tri-X	f:32	1/4	1972
4–7	LT	Schneider 150mm	Kodak Tri-X	f:32	1/10 (red 3)	1973

Image	Camera	Lens (focal length)	Film (if applicable)	Aperture	Shutter Speed	Year
5	LT	Fujinon 300mm	Kodak Tri-X	f:64	1/2 (orange 2)	2012
5–1	LT	Nikon 500mm	Kodak Tri-X	f:45	1/8	2010
5–2	LT	Fujinon 75mm	Kodak Tri-X	f:32	1/8	2010
5–3	Mamiya 645	80mm/w extension	Ilford FP4	f:22	4	1998
5–4	Mamiya 645	80mm/w extension	Ilford FP4	f:22	4	1998
5–5	Mamiya 645	80mm/w extension	Ilford FP4	f:22	4	1998
5–6	Canon G10	Internal Zoom	Digital RAW	f:2.8	1/20	2011
5–7	Canon G10	Macro Mode	Digital RAW	f:4.0	1/4	2013
5–8	Canon G10	Macro Mode	Digital RAW	f:4.0	1/4	2013
5–9	Canon G10	Macro Mode	Digital RAW	f:5.6	1/2	2013
5–10	LT	Rodenstock 300mm	Kodak Tri-X	f:32	14	1978
5–11	LT	Schneider 150mm	Kodak Tri-X	f:32	1/2	1979
5–12	Clay Blackmore photograph					
5–13	Clay Blackmore photograph					
5–14	Pei-Te Kao photograph					
6	LT	Fujinon 150mm	Kodak Tri-X	f:32	4	1996
6–1	LT	Fujinon 150mm	Kodak Tri-X	f:20	3 (green 3)	2011
6–2	LT	Fujinon 150mm	Kodak Tri-X	f:24	1/2 (red 3)	2011
6–3	LT	Schneider 58mm	Kodak Tri-X	f:36	5	2011
6–4	Canon G10	Internal Zoom	Digital RAW	f:2.8	1/200	2010
6–5	Two Negative Dyptich (left image first; and right image second):					
	LT	Fujinon 150mm	Ilford HP5	f:45	4 1/2	1991
	LT	Fujinon 150mm	Kodak Tri-X	f:45	1/2	1988
6–6	LT	Fujinon 150mm	Kodak Tri-X	f:32	3	1999
6–7	Don Kirby photograph					
7	Canon G10	Internal Zoom	Digital RAW	f:5.6	1/125	2012
7–1	LT	Fujinon 150mm	Kodak Tri-X	f:32	1 (green 3)	2000
7–2	LT	Schneider 150mm	Ektachrome D	f:8	1/8	1974
7–3 to 7–6	Don Rommes photographs					
7–7	LT	Fujinon 75mm	Kodak Tri-X	f:32	7 minutes	1980
7–8	LT	Schneider 58mm	Kodak Tri-X	f:22	11	1996

Image	Camera	Lens (focal length)	Film (if applicable)	Aperture	Shutter Speed	Year
7–9	LT	Fujinon 90mm	Kodak Tri-X	f:22	70 minutes	2012
7–10	LT	Nikon 500mm	Kodak Tri-X	f:45	1/8	2003
7–11	LT	Nikon 500mm	Kodak Tech Pan	f:32	1/30	2009
7–12	LT	Nikon 500mm	Kodak Tech Pan	f:40	1/30	2011
7–13	Canon G10	Internal Zoom	Digital RAW	f:2.8	1/80	2010
7–14	Canon G10	Macro Mode	Digital RAW	f:2.8	1/8	2009
7–15	Canon G10	Internal Zoom	Digital RAW	f:2.8	1/50	2010
7–16	Canon G10	Internal Zoom	Digital RAW	f:2.8	1/2000	2010
7–17	Canon G10	Internal Zoom	Digital RAW	f:2.8	1/2000	2012
8	LT	Fujinon 75mm	Kodak Tri-X	f:32	1/2 (1 yellow)	2002
8–1	Canon G10	Internal Zoom	Digital RAW	f:5.6	1/30	2013
8–2	Canon G10	Internal Zoom	Digital RAW	f:2.8	1/200	2013
8–3	LT	Fujinon 150mm	Kodak Tri-X	f:32	1/8	1979
8–4	Canon G10	Internal Zoom	Digital RAW	f:2.8	1/400	2012
8–5	LT	Fujinon 210mm	Kodak Tri-X	f:38	2 minutes	2003
8–6	Hasselblad	Zeiss 80mm	Kodak Plus-X	f:16	1/30	1978
8–7	Hasselblad	Zeiss 80mm	Kodak Plus-X	f:16	1/30	1978
8–8	LT	Fujinon 210mm	Kodak Tri-X	f:40	3	1995
8–9	LT	Fujinon 300mm	Ektachrome T	f:45	6	1993
8–10	Canon G10	Internal Zoom	Digital RAW	f:2.8	1/200	2010
8–11	Canon G10	Internal Zoom	Digital RAW	f:2.8	1/60	2011
8–12	Canon G10	Internal Zoom	Digital RAW	f:2.8	1/100	2011
8–13	LT	Fujinon 150mm	Kodak Tri-X	f:32	16	2013